THE ACRYLICS BOOK

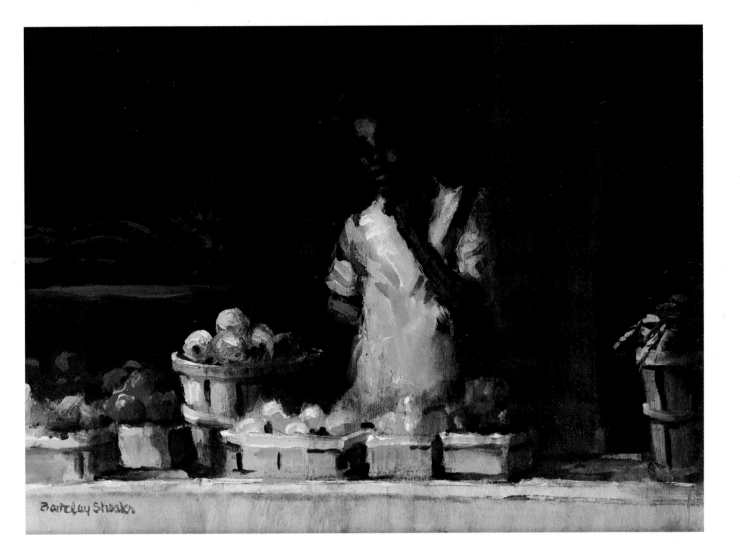

THE ACRYLICS BOOK

Materials and Techniques for Today's Artist

BARCLAY SHEAKS

WATSON-GUPTILL PUBLICATIONS/NEW YORK

BARCLAY SHEAKS is a successful artist whose work is owned by numerous museums, including the Butler Institute of American Art and the Virginia Museum of Fine Arts. His paintings also appear in distinguished university, corporate, and private art collections, and he has participated extensively in juried exhibitions sponsored by the American Watercolor Society, National Academy of Design, Corcoran Gallery, and Smithsonian Institution, among others. He has served as an artist-in-residence for both the Virginia Museum of Fine Arts and the Richmond Humanities Center, Virginia, and has hosted his own public television series, *Acrylic Painting with Barclay Sheaks*.

Currently, Sheaks is distinguished resident artist and associate professor of art at Virginia Wesleyan College in Norfolk, and teaches an on-location summer painting workshop called "Barclay Sheaks' Art Odyssey." He is also the author of *Drawing Figures and Faces* (Davis, 1987) and *Stretching the Eyes' Distance: Reflections on the Chesapeake Bay* (Bleecker Street Publishing, 1981), a volume of poetry. He resides in Virginia, dividing his time between his winter studio in Newport News and his summer studio in Poquoson on the Chesapeake Bay.

Art on page 1:
SUMMER WARES
Acrylic on Upson board, 9 × 12" (22.9 × 30.5 cm).

Art on page 5:
LOWLAND AUTUMN (detail)
Acrylic on Upson board, 18 × 24" (45.7 × 61 cm).

Copyright ©1996 Barclay Sheaks

First published in 1996 in the United States by Watson-Guptill Publications, a division of VNU Business Media, Inc., 770 Broadway, New York, NY 10003 www.watsonguptill.com

The Library of Congress has cataloged the hardcover edition of this book as follows:

Sheaks, Barclay.
 The acrylics book : materials and techniques for today's
artist / Barclay Sheaks.
 p. cm.
 Includes index.
 ISBN 0-8230-0063-X (hc)
 1. Acrylic painting—Technique. I. Title.
ND1535.S49 1995
751.4'26-dc20

 95-44106
 CIP

ISBN (pbk) 0-8230-0062-1

Manufactured in Hong Kong

First paperback printing, 2000

5 6 7 8 / 07 06 05 04 03

The creation of a book such as this is never a solo venture by the author. In my case, it was the result of much invaluable help and support from others, all of whom deserve much thanks. I am very grateful to Dale Ramsey, who set the wheels in motion by introducing me to Candace Raney at Watson-Guptill. My deep appreciation goes to Candace for her insight and guidance and to my editorial, design, and production team, specifically Marian Appellof, Alisa Palazzo, Areta Buk, and Ellen Greene, for their efforts.

My thanks also goes to Barbara Hodges, who typed the longhand first draft and many rewrites. I am especially grateful both to my "first reader," Nancy Gotwold Harris, and to photographer Joe Schultz for their important contributions, as well as to Edith Edwards for her typing and computer skills. I would also like to acknowledge the many contemporary artists who generously contributed their paintings and insights: Betty Anglin, Ken Bowen, Robert Burnell, Arthur Carter, Bob Holland, Sue Bartley Myers, Alex Powers, Bill Scott, Stuart Shils, and John Alan Stock.

And finally, I would be remiss as an author and artist if I did not thank the art suppliers, manufacturers, and their representatives, who were all most cooperative, not to mention generous with their time and products: Chris Henderson at Chroma Acrylics; Michele Betis at Crescent Cardboard Company; Marc Golden at Golden Artist Colors; Art Graham at M. Graham & Company; Ed Brickler at Grumbacher; Barbara Cattano at Loew-Cornell; Dee Silver at Silver Brush Limited; June Lee at Windberg Enterprises Inc.; and Lynn Pearl at Winsor & Newton; as well as all the people at Dick Blick, Fabriano, Liquitex/Binney and Smith, Royal Brush Manufacturing, Savoir-Faire, Strathmore Paper Company, Utrecht, and Tara Materials, Inc.

*This book is dedicated to my students, both past and present—those singular individuals
who have chosen the paths of creative expression as a way of life and who,
through discipline, experimentation, and discovery, have ultimately found, or will find,
that the elusive achievement of artistic vision, like that of virtue, must be its own reward.
Reticent or ready, they are, or will become, true keepers of the creative flame.
For a teacher this is reward enough.*

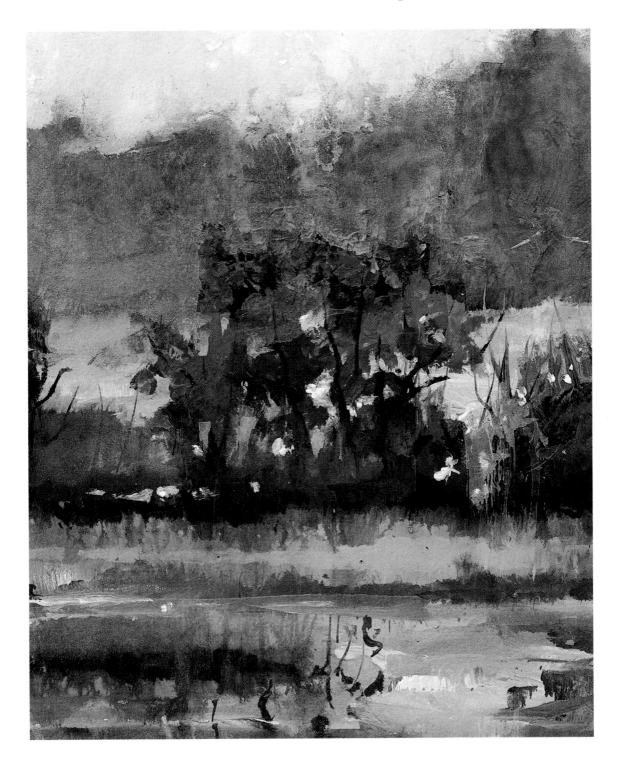

CONTENTS

INTRODUCTION

Since primitive man first took color and smeared it on his body or some other surface, only to find that it washed off, faded, or cracked, the search for the ideal binder began. There have been many; the most enduringly successful are tree sap (gum), wax (encaustic), egg yolk, oil, milk (casein), and, most recently, synthetics. Among these last is acrylic, which to date has proven to be the most practical binder for artists' paints.

From the beginning, the goal was to find a medium or vehicle that would prevent paints from discoloring and cracking with age and allow ease of application. Through trial and error various mediums evolved, with the most durable and easiest to handle finding popular use. The physical characteristics and limitations of a given binder dictated the development of painting techniques specific to that medium, and each medium found its advocates.

Until the advent of acrylics, the three types of paint in widest use were watercolor, oil, and egg tempera, each of which employs a different binder. Thus, an artist seeking multiple means for expression would have to make use of more than one medium, as there was no single, universal binder that would permit all possible painting techniques and effects.

The ideal binder or medium is one that can bond to most materials and remain flexible over time. It should not discolor with age. It should be versatile, allowing both transparent and opaque applications, from thin washes to heavy impasto. It should be self-sealing and not cause deterioration of the support.

All of these characteristics—and more— describe acrylic paints and the acrylic system. At this point in the history of art materials, acrylic is the ideal binder. This does not, of course, mean that artists using older, more traditional mediums will throw out their watercolors or oils and flock to art supply stores to buy acrylics. Each medium has its own characteristics and aesthetic value, its unique handling qualities, its history, tradition, and mystique. A painter who is open and receptive to the range of art materials available invariably finds the medium that most suits his or her personality; this is the way it has always been, and should be. However, what it *does* mean is that with just one set of paints and one set of brushes, an artist can work with ease and assurance of permanency on diverse surfaces and supports,

varying the viscosity of paint applications as desired. From a creative point of view this is a compelling idea—one that the increasing popularity of acrylics confirms.

When acrylics first became widely available, it was difficult for painters steeped in the traditions of watercolor, oil, and egg tempera to comprehend just what these new paints were capable of, and how very versatile they were. Here was a medium that was water-soluble when wet and waterproof when dry, and that could simulate all the traditional mediums. Artists who have worked only with acrylics accept all of this without question, but for others, the revelation of such versatility can be almost overwhelming.

My initial experience with acrylics took place with a portrait study from life. The first hour was frustrating. Because my background was in watercolor and oil painting, I did not know what approach to use, so I tried everything. During the second hour I began to realize just how responsive the medium was and that it could do anything I wanted it to do. By the third hour I became convinced that finally I had found my medium of choice. For me this was a liberating experience; it is what gave this book its impetus and focus, while my working knowledge of and fondness for other painting mediums dictated the approach and format.

Every artist in his unique way seeks liberating experiences. This book is an invitation to discover just what acrylics themselves are capable of, and what the artist is capable of creating with them. In all probability most readers will have some familiarity with other mediums, and should find the book an easy introduction to the versatility of this one by employing and adapting techniques they already know to working in acrylics. Artists who have already tried acrylics will find this book a means for broadening their experience and an invitation to try new approaches. For the interested beginner, step-by-step demonstrations provide clear instruction and stimulation for creative growth. No matter what your skill level, you are encouraged to continue the search for your uniquely creative self—and acrylics may just help you do that!

"How can I find my creative self, a way of painting that is really mine?" All artists ask this question, but only the individual who asks it can answer. Some artists never find their own way; they fear being different and choose to paint like everyone else, following whatever direction is currently popular. Every artist desires public

acceptance of his work, a sympathetic audience for his expression. It should be easy to understand, then, why art as a discovery of self is not always an easy path to follow. All artists are influenced by other artists and by tradition, but there is nothing negative about this, for art is a natural learning and growing process. Simply thinking about what technique and style might best suit you is not sufficient. Work, trial and error, and evaluation—the kinds of experiences offered through the exercises presented in this text—must follow. Good use of them should open some doorways.

"Finding the way" is more than choosing to paint realistically or abstractly; it is discovering the combination of ingredients that allows a subjective uniqueness to emerge and grow. This does not happen in an instant of inspiration or through one successful experience. Unformed artists must try on styles and techniques as one would try on a coat or hat to see whether it fits. Wear a particular approach for a while. If it suits, some of it will adhere and will become incorporated into your personal style. The same is true of studying the work of other artists.

Individualizing your approach to painting is more than adopting a technique or style. It is understanding your preference for certain mediums, feeling color, perceiving form, and combining these and other expressive design elements to interpret personal experiences. It is seeing the world through your own eyes, not those of a teacher, a friend, or another artist. It is, above all, in finding joy in the process that self-expression will come. Others will notice it first; the process is gradual and internal. With personal growth comes artistic growth. True expression is a mirror of the self and, as with life, is an ongoing process. At this point you have now taken the first steps on that journey; bon voyage!

MIGRANT
Acrylic on Upson board,
18 × 24" (45.7 × 61 cm).

Transparent and opaque washes, wet runs and bleeds, and impasto paint applications used in combination allow the artist an expressive latitude that is not physically practical in the traditional mediums of oil, egg tempera, and watercolor. The plasticity and versatility of acrylics make this possible.

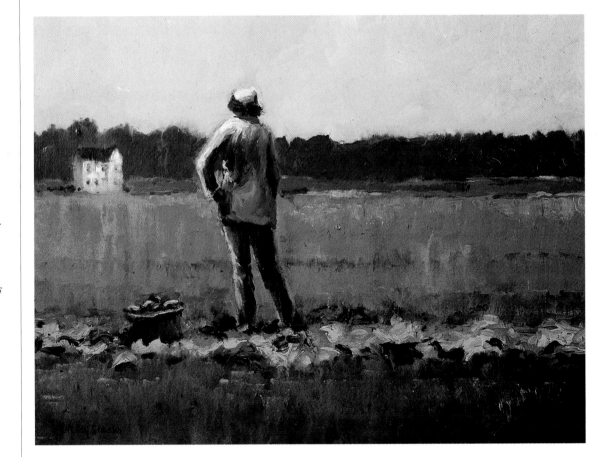

No. 5308
Net 8 Fl. Oz. (237 ml.)

Materials and Tools

Knowing about the materials and tools that make up a particular medium's painting system is essential to the painter's craft. The acrylic system consists of four basic components: paints, mediums and varnishes, modeling paste, and gesso. All four come in diverse types and consistencies, and some are formulated for special purposes. At the heart of the system are the paints themselves; the other components function to extend, modify, and support them.

While differing chemically from other types of paint, acrylic can behave very much like watercolor, gouache, oil, and egg tempera, and so its system employs many of the same accoutrements used with these traditional painting mediums. Presented here is a selection of the vast range of paints, mediums, varnishes, brushes, palettes, supports, grounds, and other materials that will enable the acrylic painter to work in a wide variety of traditional styles and techniques as well as those that are unique to acrylics.

For the uninitiated there are suggestions for selecting a basic palette of colors and an all-purpose brush set. Included also are demonstrations of how to stretch and prime a canvas and how to prepare hardboard panels for painting. This should set the stage for the enriching experience of painting with acrylics.

ACRYLIC PAINTS

In layman's terms, acrylic paint is an emulsion consisting of acrylic resin, water, and pigment. As long as the paint is wet, it is water-soluble. When dry, it becomes waterproof and remains flexible. Because the acrylic binder does not discolor with age, colors retain their hue and intensity through time.

The paints are produced in two basic consistencies: paste and liquid. The liquid paints are generally made with higher concentrations of pigment and binder than the paste paints; they thin down, or disperse, easily when mixed with water. Used undiluted, they flatten out when dry. There are liquid acrylic paints formulated especially for use with an airbrush, and still others formulated specifically for use as transparent watercolor.

Acrylic paints are available in a wide range of colors, including fluorescent, metallic, iridescent, and interference colors; the latter, depending on the angle of illumination and view, give the optical effect of refracting, and thus alternating in hue with, their complementary color.

When acrylic paints first came on the market, formulations were in the experimental stages. Each manufacturer was striving to find the ideal, stable synthetic binder. Many brands were not compatible with one another, and mixing them sometimes produced strange results. Today, however, this is no longer true. While formulations do differ from brand to brand, they are similar enough that an artist may select acrylic paints from any of the many manufacturers, whether for specific handling qualities, hue, or viscosity, and intermix them without problems.

Because acrylic paints are so versatile and may be used for such a variety of techniques, no single viscosity is totally ideal. This can be bewildering for the artist just getting started with acrylic painting. Until the beginner has acquired enough experience to make informed decisions on the best type of acrylic paint for his or her expressive purposes, the paste consistency colors are the best selection for all-purpose use. They may be used undiluted for impasto applications or thinned with water and/or acrylic medium to make thin mixtures and washes. The advantage here is that applications of any consistency may be easily employed in the same picture at the command of the artist without shifting from one kind of paint to another. I enjoy painting in this manner, and because of this, my primary working stock of colors are of the paste consistency.

Both quality and economy are of concern to most artists when selecting paints. Naturally, the highest quality acrylic paints are more expensive than those of lesser quality. To make less costly paints, manufacturers dilute the pigment with fillers or dye-inert pigment to create colors. This results in hues with less intensity, color power, tinting strength, covering quality, and fade resistance than those made with pure pigment. In a highly competitive market, paint makers work hard to provide quality products for students and professionals alike. Many manufacturers offer several grades of paint tailored to fit as many needs as possible. While the quality of the various paints I worked with in preparation for this book did vary from outstanding to satisfactory, all brands performed very well. For the beginner, my suggestion is that you buy the best you can afford, learn *about* paint as you learn *to* paint, and experiment to find what is best for you. The experienced painter, because of choice or circumstance, will already have come to grips with these decisions.

Presented here is a good cross-section of most—though by no means all—of the popular brands of acrylic paint that are easily available to artists. Four other manufacturers worthy of note but not included here are Daniel Smith, Daler-Rowney, HK Holbein, and Schmincke, all of whom produce very high quality acrylic paints and mediums.

CHROMA ACRYLICS

Jim Cobb, the founder and technical director of the Australia-based firm Chroma Acrylics, is also a painter and very much concerned with making quality products that fit the varying needs of practicing artists. This concern has contributed much to the rapid growth of his company, which has had a manufacturing and distribution facility in the United States since 1979.

Chroma Acrylics offers three lines of acrylic paint: Atelier Impasto Artist's Acrylics, which are of paste consistency; Jo Sonja's Artist's Colors, the firm's brand of acrylic gouache; and Chromacryl students' acrylics. The Atelier Impasto Artist's Acrylics come in 42 colors packaged in plastic tubes or jars. The color power is strong and the pigments used for these paints are both vibrant and permanent. With the addition of water and/or acrylic medium, the paint mixes and thins efficiently, moving from thick, impasto consistencies to washes, thus giving the artist a wide choice of techniques from one set of paints.

CHROMA ACRYLICS ATELIER IMPASTO ARTIST'S ACRYLICS, JO SONJA'S ARTIST'S GOUACHE, VARIOUS MEDIUMS, MODELING COMPOUND, AND GESSO

I like the plastic tubes because they are less puncture prone than traditional metal tubes. (Whenever I go on a painting trip, I can usually count on at least one metal tube getting punctured in my tote bag from contact with other painting equipment.) To help prevent paint from drying in plastic tubes, squeeze the air from the tubes as the paint is used and put the cap on tightly when you are done.

Jo Sonja's Acrylic Gouache Colors were formulated for craft purposes. Having the consistency of a soft paste or heavy liquid, they flow easily and blend smoothly. Their fluid quality has won over many professional artists who formerly used traditional gouache (opaque watercolor), and handling them makes it easy to understand why: these paints respond superbly to all opaque watercolor techniques, and, because of their acrylic binder, they can be layered over one another without lifting. Washes applied to a wet surface bleed smoothly without clotting. Traditional gouache, which dries to a brittle film, is usually painted on paper, but Jo Sonja's Acrylic Gouache works well on most any surface that is not slick, oily, or shiny. Opaque watercolorists seeking permanence in their works should give these paints a try. The 54 colors come packaged in convenient plastic squirt bottles or tubes.

Chromacryl Colors, the firm's economy, student-grade line of acrylic paints, have a soft

paste/thick liquid consistency. Sixteen carefully selected colors make up the palette, providing a practical range of possibilities. These paints handle well in most painting techniques and are reasonably priced. They come packaged in tubes, squirt bottles, and bulk gallon containers.

DICK BLICK

Dick Blick is an art supply mail-order company that stocks and sells every kind of artist's material, including its own line of paints, which are manufactured in the firm's plant at Galesburg, Illinois. Artists have a choice of 50 acrylic colors, including five that are iridescent and metallic. Besides paints made with traditional pure pigments, Dick Blick offers less expensive modern "hue" colors that closely match the originals.

Dick Blick's paste consistency colors go on smoothly with brush or knife; I particularly like their buttery feel in impasto applications. They mix well with other brands and have strong color power.

All the components of Dick Blick's acrylic system that I have used—paints, gesso, modeling paste, liquid gloss and matte mediums, gel medium, and acrylic varnish—are good products and economically priced.

DICK BLICK ARTIST'S ACRYLIC PAINTS, GLOSS AND GEL MEDIUMS, AND MODELING PASTE

GOLDEN

Mark Golden learned the craft of making acrylic paints from his father, Sam, who learned his trade working with a major paint manufacturer in the early days of synthetic materials. Out of this came Golden acrylics, which have evolved through constant contact with professional artists and their requested needs. In a time when some manufacturers are decreasing the quality of their

paints by adulterating pure pigments with fillers, Mark Golden is heightening color power and using pigments that have extended permanence. It is no wonder that so many professionals and teachers endorse his paints and other top-of-the-line materials, or that these products have enjoyed such a rapid increase in popularity.

Golden's Heavy Body Acrylics, the company's paste-consistency paints, are made from pure pigments with no fillers or extenders added. Among the 63 colors available is an amazing array of 23 iridescent, interference, and metallic hues to expand the painter's creative capabilities. As an artist who enjoys moving from washes to impasto, I was impressed with the smooth consistency of this paint; it thins into washes with ease, while impasto applications hold the mark of the brush and painting knife with good clarity and sharpness when dry. Such handling qualities make Golden's Heavy Body Acrylics the ideal multipurpose paint.

Also available are Golden Fluid Acrylics, a line of highly intense, permanent colors that have about the same consistency as India ink. Made with lightfast pigments (rather than dyes, which are often used in inks) suspended in a 100 percent acrylic polymer vehicle, they are specially formulated to prevent the pigment particles from settling. For watercolor-type use they are outstanding performers. Washes are clear and smooth, and the color power is truly amazing! The Fluid Acrylics are available in 32 colors and come in 4- and 8-oz. squirt bottles or larger bulk quantities. These paints are ideally suited for spraying, brushing, and staining, and they mix easily with other lines.

Golden Matte Acrylics are formulated for the artist who prefers paint that has a matte finish and is thick enough to hold edges and brush and knife marks with fidelity when dry. This line consists of 56 colors; they mix well with other types of acrylic paint to yield a variety of finishes in thick or thin applications.

Still another line of paints Golden offers are its High Load Acrylics, which were developed at the request of artists who had worked with the firm's black gesso and wanted a range of colors possessing its intensity of hue and velvety surface. These paints make ideal grounds (for which they were designed), or may be used when more opaque color is needed. Their covering quality is outstanding.

Golden also manufactures acrylic colors that are formulated specially for airbrush, ink, watercolor, and staining techniques. They can be thinned with water and/or Golden Transparent Extender, as well as mixed with acrylic mediums and gels. They can be applied to almost any receptive surface, though they are not recommended for use on clothing.

The firm produces an extensive, all-inclusive line of gels, mediums, and varnishes (see the section on these materials below), as well as acrylic gesso and modeling paste of the same high quality as the rest of its products.

M. GRAHAM & CO.

Until the early 1990s, Art Graham worked as a color maker for a major East Coast manufacturer of artists' paints. Upon visiting Oregon, he found it so beautiful that he decided to stay, having tired of the fast pace of city life back East. His goal—to make really good paints—is borne out by the pride his company takes in using only pure, full-strength pigments to manufacture colors that are free of adulterants and possess permanence, clarity, and richness. All 20 hues available are made slowly, one at a time and with care. (The firm also makes quality oil paints in the same 20 colors.)

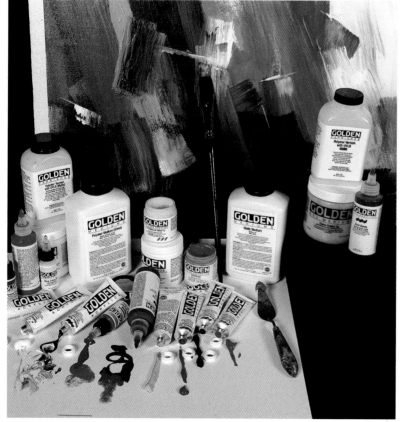

GOLDEN HEAVY BODY, HIGH LOAD, MATTE, AND FLUID ACRYLICS, AIRBRUSH COLORS, MEDIUMS, AND VARNISHES

M. GRAHAM & CO. ACRYLIC ARTISTS' COLOR

The paints, which are of paste consistency and packaged in tubes and jars, are highly pigmented and have strong tinting power. I like the way they dissolve freely into thin mixtures and washes, yet hold their body in impasto applications. I enjoyed working with the M. Graham paints; they are a quality product for a reasonable price, so it is not surprising that they are becoming an increasingly popular brand.

GRUMBACHER

The highly respected name Grumbacher has been associated with quality art products since 1905; today the company is owned by Koh-I-Noor Rapidograph, Inc. Grumbacher offers three types of acrylic paints: paste-consistency Artists' Acrylic Colors packaged in tubes; a soft formula packaged in jars; and Rotring ArtistColor, which is a liquid paint.

Grumbacher has recently worked hard to upgrade its acrylic paints by improving their adhesion and increasing their tinting strength through the use of more pure pigment. New colors—products of modern technology—have been added to the line, including cadmium black, nickel titanate yellow, and benzimidazolone orange, among others. For the artist interested in permanence, most of Grumbacher's colors are rated excellent for lightfastness.

The paste-consistency colors come in 72 hues, including iridescent, interference, and metallic colors. They have a good painterly "feel" when used undiluted in impasto techniques, and dried paint holds brush and knife marks. Colors dilute easily to make thin mixtures and clear, clean washes for watercolor techniques. Their excellent tinting strength and color power further recommend this paste formulation as an all-purpose acrylic paint. All colors are available in 2 fl. oz. (59ml) tubes; titanium white and ivory black are also available in large 5.07 fl. oz. (150ml) tubes. All colors in this line mix easily with the soft paste and liquid acrylic paints, offering a wide latitude of expressive possibilities.

Grumbacher's soft-paste formula Artists' Acrylic Colors, with 48 different hues to choose from, are packaged in 2 fl. oz. (59ml) and 8 fl. oz. (237ml) jars. I have always enjoyed working with jar colors and am glad to see Grumbacher offering an excellent line of them. Painting from the jar can be pleasurable and convenient. You can dip right into the jar with the brush for easy color mixing, and paint kept moist on the palette can be returned to the jar. Not simply a thinned-down version of the paste-consistency paints, the soft-formula colors are highly pigmented and made with a reinforced acrylic binder. Their consistency is like that of soft butter—liquid enough to pour slowly and pastelike enough to make brush loading easy. These paints can be diluted with water to create thin mixtures and washes with excellent adhesive qualities; luminous glazes are easily produced by mixing gloss medium with the colors to make them transparent. The artist who enjoys working with gouache will like the gouachelike results produced by combining the soft-formula paints with a 50:50 mix of matte medium and water. This creates a paint film that will not lift when dry. The soft-formula paints can also be thinned down for use in spray painting and are practical to use on fabrics.

Rotring ArtistColor fluid acrylics have a consistency resembling that of India ink. Made with pure, finely ground pigments, these colors are intense and nonfading. Artists can choose from among 24 transparent and 12 opaque colors, plus Effect Mediums in gold, silver, bronze, copper, and Pearl Gloss, which can be added to ArtistColors for a variety of metallic and pearlescent effects. Rotring liquid ArtistColors are ideal for watercolor techniques, fabric painting, and, with the addition of some water, are excellent for use in an airbrush or sprayer. They can also be used in pens. Watercolor-type washes made with these paints dry smooth and

GRUMBACHER ARTISTS' ACRYLIC COLOR, MODELING PASTE, MEDIUMS, AND VARNISHES

clear, with little or no granular spotting. Colors can be mixed with other acrylic paints and with liquid gloss acrylic medium or acrylic gloss gel medium for glazes. The liquid colors come packaged in 30ml bottles equipped with a dropper built into the cap for convenient transfer of paint to palette, brush, or pen.

LASCAUX

Lascaux is a famous cave in the Dordogne region of France where Paleolithic paintings were discovered. It is also the name of a brand of superb acrylic artists' paints produced in Switzerland by Alois K. Diethelm, who started making acrylic paints in the 1950s using the latest scientific advances in synthetic resin technology. Diethelm's professional dedication and close contact with working artists have garnered Lascaux a growing number of devoted and satisfied customers.

Lascaux acrylic paints are highly pigmented and have great tinting strength. They thin easily when mixed with water and make clear, clean washes. The paste-consistency Artists' Acrylics come in 46 hues packaged in 45ml (1.5 fl. oz.) and 200ml (6.8 fl. oz.) tubes, as well as in 750ml

(25.4 fl. oz.) bottles. For the artist who desires a paint for all purposes and painting techniques, Lascaux Artists' Acrylics are ideal. In impasto applications they hold the marks of the brush and knife with a minimum of "flattening out" when dry.

Lascaux Studio Acrylic Colors have a thick, liquid consistency and are made with the same high pigment content as the paste-form Artists' Acrylics. Packaged in 30ml jars and in 85, 250, and 500ml bottles, these paints come in 28 pure basic hues plus 8 metallics. They can be applied with a roller or brush, as well as dripped and poured, and they make good watercolor-type washes and excellent glazes. Studio Acrylic Colors are ideal for the artist who likes to dip the brush into the jar and paint fluidly without a lot of thinning.

The latest addition to the Lascaux line is Aquacryl, an acrylic watercolor that combines the advantages of acrylic paint with those of traditional transparent watercolor. Packaged in squirt bottles ranging in size from 30ml to 500ml, Aquacryl is available in 25 hues that have color power, high transparency, and handle like

traditional watercolors. Color becomes almost water-resistant when dry and so can be layered over easily without lifting the underlayer. Dried layers can be dissolved and lifted by scrubbing lightly with a wet brush. On the palette, colors are easily redissolved with water. They can be applied to almost any absorbent surface with brushes, sponges, spray guns, and many other tools.

Lascaux makes an acrylic gouache in 32 hues; like the acrylic watercolor paint, it can be redissolved with water and lifted after it has dried, but is water-resistant enough to allow for layering.

LASCAUX ARTISTS' ACRYLICS, AQUACRYL, AND SATIN MEDIUM

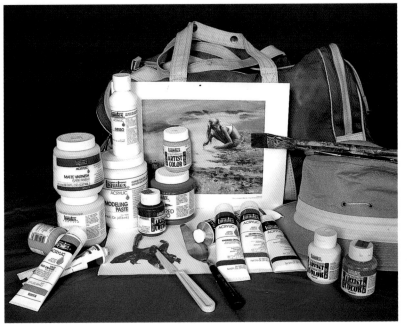

LIQUITEX ACRYLIC ARTIST COLOR, ACRYLIC CONCENTRATED ARTIST COLOR, VARNISH, GESSO, AND MODELING PASTE

LIQUITEX

Liquitex, now owned by Binney & Smith, was a front-runner in the development of artists' acrylic paints. In fact, the firm's research, technological advances, and broadening of the components for the acrylic system made Liquitex the generic name for acrylic paints.

Today the company offers three kinds of acrylic paints: Acrylic Artist Color (high viscosity) in 2 oz. and 4.65 oz. tubes; Concentrated Artist Color (medium viscosity, soft-paste consistency) in 2, 8, 16, and 32 oz. jars; and Basics Acrylic Color, an economy line packaged in clear plastic 4 oz. tubes. The high-viscosity tube paints come in 89 hues, including interference, iridescent, and metallic colors. They have a buttery consistency, and when applied undiluted with a brush or knife go down smoothly like oil paint. The colors, which are bright and made with permanent pigments, dilute easily with water or acrylic medium to make thin mixtures and washes. With its wide selection of hues and ease of mixing and thinning, this line makes for a good all-purpose, all-technique acrylic paint.

The medium-viscosity Concentrated Artist Color is made with a high pigment content and formulated to thin easily without loss of adhesion. It is thus good for watercolor-type techniques and, when thinned with Liquitex Airbrush Medium, can be used for airbrushing techniques. Jar packaging is convenient for artists who like dipping the brush directly into the container.

Basics Acrylic Color is a line of economy, student-grade paints available in 24 colors that are uniformly priced. They have a heavy viscosity and can be used for all painting techniques.

UTRECHT

Utrecht is an art materials mail-order and manufacturing company with a main office in Brooklyn, New York, and outlets in various locations around the United States. One of the first developers of artists' acrylic colors, the firm introduced its line in 1957 after much research and testing. The firm's acrylic paint, which goes by the name Utrecht New Temp, comes packaged in plastic pint jars and in traditional 2 oz. and 5.7 oz. tubes. New Temp is a high-viscosity paint of paste consistency. Made with pure pigments and completely free of extenders, the 28 colors are vibrant and have great tinting strength. This all-purpose paint can be used for all acrylic painting techniques. The Utrecht acrylic line also includes gloss and matte fluid

ACRYLIC PAINTS

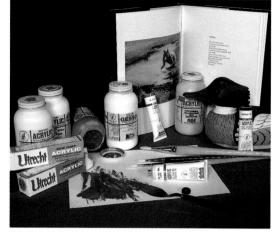

UTRECHT NEW TEMP ACRYLIC PERMANENT ARTIST'S COLOR, MEDIUMS, AND GESSO

and gel mediums, modeling paste, and acrylic gesso in 14 colors. This company's products are very economical and are an excellent buy for the money.

WINSOR & NEWTON

William Winsor was an artist, writer, musician, archeologist, and skilled color chemist. His boyhood friend Henry Charles Newton was a professional artist with a strong understanding of chemistry. In 1832 William and Henry set up business together in the heart of the artists' quarter in London, and thus was the partnership of Winsor & Newton formed. Inventive, creative, and enterprising, the firm was the first in Britain to sell colors in collapsible metal tubes. In 1841 Queen Victoria, who was a painter of some talent, granted Winsor & Newton a Royal Warrant, the first of many such appointments and honors. The painter J. M. W. Turner and other important artists of the day were regular customers. Since that time, many changes have taken place in art and the technology of color making, but one thing that has not changed is Winsor & Newton's dedication to producing art materials of the finest quality, and to maintaining constant contact with working artists—two factors that account for the popularity of its products around the world.

Winsor & Newton makes three types of acrylic paints: Artists' Acrylic Colour, which is of paste consistency; Galeria Flow Formula Acrylic Colour, with the consistency of a thick liquid or soft paste; and Designers Liquid Acrylic Colour, formulated for use in technical pen, airbrush, and pen and brush techniques.

The Artists' Acrylic Colours spread easily with either brush or knife (like a good oil paint) and

dilute effortlessly into thin mixtures and washes. Color power and tinting strength are excellent. Artists have a choice of 75 colors, some of them unique to Winsor & Newton; most are rated according to the firm's classification system as extremely permanent (Class AA) or durable (Class A; generally sold as permanent). These paints are sold in 60ml tubes, with many colors available in larger-size tubes. They can be mixed with Winsor & Newton's other types of acrylic paint as well as with other brands.

The Galeria Flow Formula Acrylic Colours, packaged in 500ml plastic squeeze bottles, come in 25 strong, vibrant hues, most of which are rated as extremely permanent. These paints were specially formulated using modern alternatives to some of the more expensive pigments to produce free-flowing colors at an affordable price, making them a good buy for the budget-minded artist. Galeria Flow Formula paints are responsive when used in any technique except heavy impasto applications; the paste (tube) colors work best for this purpose.

Winsor & Newton Designers Liquid Acrylic Colours are packaged in ready-to-use dropper-cap bottles and are suitable for use with brush, pen, and airbrush. They have excellent lightfastness and are made with the highest-quality pigments.

WINSOR & NEWTON ARTISTS' ACRYLIC COLOUR, MEDIUMS, AND VARNISHES

ACRYLIC MEDIUMS AND AUXILIARY MATERIALS

Beyond the paints themselves, there are many other important components of the acrylic system. All of the paint manufacturers mentioned previously offer a variety of these additional products.

MEDIUMS

There are two forms or consistencies of acrylic polymer medium: liquid and gel, both of which can be thinned with the addition of water if needed. Liquid medium comes in matte and

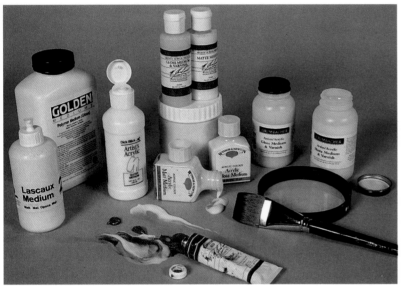

LASCAUX, GOLDEN, DICK BLICK, M. GRAHAM & CO., WINSOR & NEWTON, AND GRUMBACHER LIQUID ACRYLIC MEDIUMS

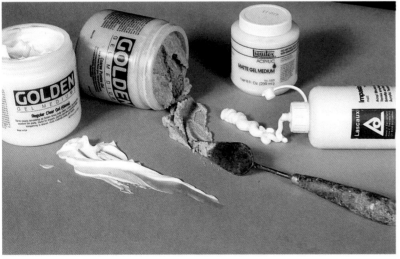

GOLDEN GLOSS GEL AND COARSE PUMICE GEL MEDIUMS, LIQUITEX MATTE GEL MEDIUM, AND LASCAUX MATTE IMPASTO MEDIUM

gloss, the matte medium drying to a flat finish and the gloss medium to a shiny finish. Multipurpose in nature, liquid mediums can be used to extend paints, improve adhesion, and create luminous transparent glazes. They are excellent adhesives, making them useful in collage and craft applications, and some of them can be used on completed paintings as protective varnishes. Most brands of liquid acrylic medium are quite similar to one another, varying a little in viscosity and tendency to foam.

In addition to the traditional liquid matte and gloss mediums, a number of manufacturers also offer specialized formulas designed to meet certain specific artists' needs. Golden, for example, makes several varieties of an acrylic polymer medium/varnish called GAC. One of these is GAC 200, designed to provide a very hard film on rigid, inflexible supports; another, GAC 500, is the hardest acrylic for flexible supports. Still other products meant for use with the acrylic system are flow-control mediums to enhance paint flow, retarders to slow paint drying time, thickeners, printing paste (such as Lascaux's) that can be mixed with acrylic colors for silk-screening, and even a product made by Liquitex called Iridescent Tinting Medium.

Gel medium ranges in consistency from soft and pourable to heavy-bodied and moldable, and is available in matte, gloss, and, depending on manufacturer, semigloss finishes. It is used to extend paints and to make thick, transparent glazes, and serves as an adhesive. Heavier-bodied gels can be used in creating impasto, sculptural, and textural effects. There are also gels that contain texturing substances; Golden, for instance, makes pumice gels in fine, coarse, and extra-coarse grits that can be used alone or mixed with paint; Liquitex offers gels with such additives as sand, fiber, glass beads, and black lava.

VARNISHES

A number of acrylic varnishes are specially formulated for use as protective coatings on completed paintings. These usually dry to a harder, more abrasive-resistant finish than the regular medium/varnishes. Like the latter, finishing varnishes can be mixed with the paints and thinned with water. They are available in gloss, matte, and, depending on brand, satin finishes. Many are removable to allow paintings to be cleaned and restored. Among the possible choices are Liquitex's flexible Soluvar Picture Varnish, which can be used on both acrylic and

oil paintings and is removable at any time with mineral spirits. The firm also makes two rigid varnishes—High Gloss and Satin—that provide a hard, permanent surface that will not yellow or crack. Winsor & Newton's removable acrylic varnishes include its superior-quality Conserv-Art varnish, which is removable with mineral spirits or turpentine (these will not dissolve acrylic paint).

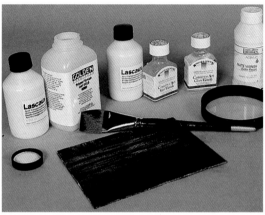

LASCAUX, GOLDEN, WINSOR & NEWTON, AND LIQUITEX ACRYLIC VARNISHES

Artists with archival concerns should be pleased to know that today on the market there are acrylic varnishes that block ultraviolet rays, which can fade and alter colors. Among them is Lascaux Transparent Varnish 575 UV, which is lightfast, resistant to age and stress, and easy to clean. Golden's Polymer Varnish with UVLS (ultraviolet filters and light stabilizers) is a waterborne varnish removable with ammonia; tougher and less permeable, and removable with turpentine, is the firm's MSA (mineral spirit acrylic) Varnish with UVLS, which produces an extremely level film with less tendency to foam. Varnishes that guard against harmful ultraviolet rays should be an asset for outdoor mural painters and for artists who for whatever reason use colors that light is likely to alter, such as collagists who incorporate materials in their work that are not lightfast or contain fugitive color.

MODELING PASTE

Acrylic modeling paste is a puttylike compound that can be used to build sculptural forms and create a relieflike underbody of texture on a painting surface. It is specifically formulated to retain its texture and form after it has cured, and can be painted over with acrylic paints when dry. There are several types of modeling paste

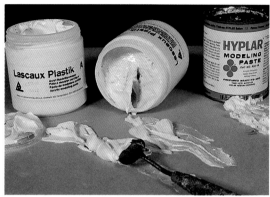

LASCAUX AND GRUMBACHER HYPLAR MODELING PASTE

available; some are smooth and dense, while others are lighter and more flexible, and some have textural additives. Depending on type, modeling paste can be used on canvas as well as rigid supports. Most if not all of the paint manufacturers listed above offer one or more kinds of acrylic modeling paste; one of those offered by Liquitex is a nonwet, permanent compound called Model Magic, which can be used on any surface that will accept traditional acrylic mediums.

GESSO

Acrylic gesso is a paint—most typically, white—formulated to seal and prime any support material that is compatible with the acrylic system. It dries with a semiabsorbent finish. Gesso can be thinned with water and tinted with acrylic color. Some manufacturers make acrylic gesso in several colors; Liquitex, for example, offers 7 different hues besides white, and Utrecht has 14. Grumbacher offers acrylic gesso in two viscosities, one very thick and the other a thinner, economy paint.

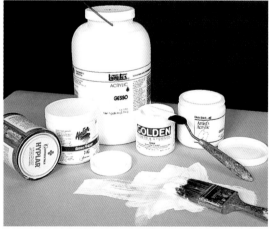

GRUMBACHER HYPLAR, CHROMA ATELIER, LIQUITEX, GOLDEN, AND DICK BLICK ACRYLIC GESSO

BRUSHES AND KNIVES

Artists who have brushes for oil or watercolor can use them for painting with acrylics as well. Brushes of any kind will not be damaged by acrylics if they are properly cleaned after use. Soft-haired watercolor brushes perform well with wash techniques and other watercolor-type applications but are not good for heavy impasto work. Stiff-bristled, oil-type brushes can be used to apply both washes and paste-consistency paints. Palette knives of any kind, whether designed for mixing paint on the palette or applying it to the painting surface, will work with acrylic paints.

The experienced painter is understandably familiar with which brush to use for which purpose or technique and has favorite ones that he or she would be virtually lost and helpless without. For the knowledgeable artist, the purchase of new brushes to replace worn-out ones is a matter-of-fact affair, and even selecting different, special-use brushes is a simple matter of matching type and size to purpose. The beginner or the uninitiated, on the other hand, can find brush selection an intimidating and confusing experience because there is such a large array of types and sizes. For anyone who is about to embark on painting with acrylics for the first time, whether you are an artist who has worked extensively in another medium and already own a collection of brushes or a student who has little or no experience with brush selection—here is some useful information on the various kinds that are available and appropriate for use with acrylics.

Brushes can be grouped loosely into two large categories based on the texture of the fibers used in their construction: stiff or soft. Fibers may be natural animal bristle or hair, man-made synthetic fibers, or a combination of the two. Natural fibers used to make soft brushes include the hair of sable, squirrel, monkey, ox, goat, pony, or various other animals; for stiff natural-fiber brushes, hog bristle is generally used. Synthetic fibers made of nylon or polyester (Taklon is the trade name for one such type of fiber) are tapered, abraded, flagged, dyed and baked, or processed in various other ways to make them simulate the behavior of natural hair and bristle. They are made in a variety of diameters and degrees of rigidity ("spring") for different purposes. The best synthetic brushes are made from fibers that are strong and durable—ones that will retain their shape and character through long usage.

Brushes come in essentially two basic shapes: rectangular and flat, and round and pointed. Brush sizes are designated by numbers or by width measurement. Here is a simplified view of brush size in proportion to painting size: in the context of a 24 × 30" painting format, a 1½"- to 2"-wide flat brush would be considered large; a ¾" to 1" brush, medium; and a ⅛" to ⅜" brush, small.

BASIC BRUSH SET

I have selected eight brushes to recommend as a basic, "bare-bones," all-purpose starter set for acrylic painting; it can be added to as needed.

Objectively speaking, painting a picture involves a lot of the same kind of brushwork used in painting a house. The type of brush suited to that purpose is one with a rectangular head. Artists' brushes shaped like this are called flats and brights, which are very similar in appearance except that the bright is shorter and stubbier than the flat. For general painting purposes, these brushes are the most versatile and frequently used. The starter brush set includes at least five flats or brights, starting with one measuring ¼" wide and progressing toward a brush with a width of 1¼" or 1½".

Because soft-haired brushes are mostly limited to applying thin paint mixtures and washes, the best all-purpose brush is one with stiff or, better yet, semistiff bristles, which are good for working with any consistency of paint. While hog-bristle oil painting brushes can be used with acrylics, leaving them in water for long periods softens the bristles and causes them to lose their natural shape. For this reason, with acrylics, synthetic-bristle flat brushes are the best choice.

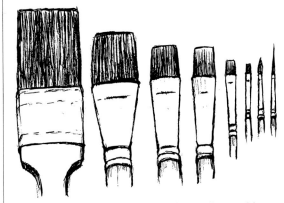

A basic set of brushes for painting in acrylics would consist of (from left to right) a 2" to 2½" flat varnish or gesso brush, five flats or brights ranging in size from 1½" or 1¼" down to ¼", a #4 or #6 pointed round watercolor-type brush, and a rigger, liner, or script brush.

Flats or brights serve for most painting tasks, but at least three more brushes are needed to complete the starter set. First, a smallish, size 4 or 6 pointed round watercolor-type brush is essential for painting details; a semistiff synthetic or natural hair (such as sable) will work for this. Next, for fine lines you need a long, narrow, pointed brush with a head measuring about ⅛" or less thick and about 1" long, made of either soft synthetic fibers or soft natural hair. Brushes with this general shape are known variously as script brushes, liners, long-points, and riggers; I call them trailers because they can trail long lines of paint. To complete the set, add a rectangular flat that is at least 2" or 2½" wide for painting large areas of your pictures and applying gesso. Artists' brushes this large are ideal but very expensive; however, you can substitute a good synthetic housepainter's brush with exploded-tip bristles. Select one that is not too thick.

In addition to the brushes I recommend as a basic set, there are some others (illustrated below) that I find useful for special purposes. These include a small, natural-bristle brush that is notched to facilitate stippling; a fan brush (in this case, a synthetic one) for blending and texturing; a large natural-bristle flat brush for roughing in large areas, applying gesso, and varnishing; and a few medium-size flat natural-bristle brushes for creating texture and especially for simulating grass, foliage, and other vegetation.

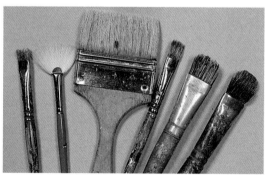

SPECIAL-PURPOSE BRUSHES

PALETTE KNIVES

Knives for mixing and/or applying paint come in many sizes and several shapes. Triangular knives that look like small masons' trowels are the most useful; two is enough for most purposes. Select one that is about 3" long and ¾" wide at its widest point, and another that is about 1" long and ½" wide. Stainless steel knives are the easiest to take care of because they will not rust.

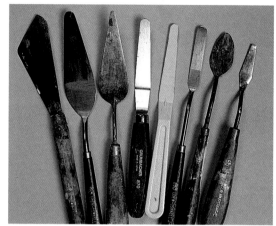

PAINTING KNIVES

MANUFACTURERS

A fine, artists'-quality brush is aesthetically pleasing in both appearance and handling. Making a good brush of any kind requires much work that can be done only by hand by those skilled in the craft. Fibers must be sorted and selected, shaped and cut, and then fitted and glued into the ferrule. The handles have to be milled, shaped, varnished, or painted and then fitted to the ferrule. Premium natural hair and bristle have become increasingly difficult to procure, and synthetic fibers of the kind used for artists'-quality brushes are not cheap. Considering the materials, amount of handwork, and number of preparation and assembly steps necessary to end up with a quality finished product, good brushes are remarkably reasonable in their cost, especially with respect to what they are worth to the artist. And, if used for their intended purpose and given proper cleaning and care, brushes will give many years of service. I own a number of brushes that I have used regularly for more than 20 years, and they are still in reasonably good shape.

Presented here is a listing of several brush manufacturers with descriptions of some of the artists' brushes and palette knives they offer.

DICK BLICK

This company's catalog lists artists' brushes of every description for any purpose in a variety of grades, all of them manufactured to strict specifications. The Wonder White brights are soft enough to apply smooth washes and firm enough to pick up the thickest paste paint, making them a versatile choice. The bristles are formed so that they "toe in" toward the center of the brush, which keeps them self-shaping and contributes to their durability. The #6 round brush and #2

Master Stroke liner are both well-shaped to come to a fine point when wet and loaded with paint. The #16 Golden Nylon extra-wide brush is a good all-purpose brush that serves equally well for wash and impasto applications. Its square-cut end and sharp corners also suit it to creating hard edges and thin linear strokes. The 2" natural-bristle, chisel-end flat brush is appropriate for applying gesso or acrylic varnish. Its high-quality construction ensures minimal bristle shed—an important consideration when varnishing a painting.

Dick Blick has every shape and kind of painting knife imaginable, with blades made in a choice of regular tempered steel, stainless steel, or plastic. Although plastic painting knives are fine because they do not rust as traditional steel ones do, they lack the crisp spring and durability of steel. For efficiency and durability, stainless steel blades give the best service, even though the initial cost is greater than what you would pay for plastic.

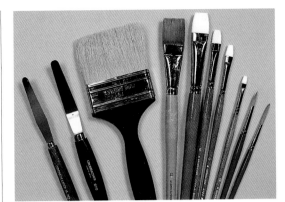

GRUMBACHER PALETTE KNIVES AND BRUSHES

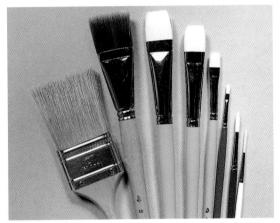

DICK BLICK BRUSHES. Left to right: 2" natural-bristle gesso brush, #16 Golden Nylon flat, Wonder White synthetic brights, #6 round, #2 Master Stroke liner.

GRUMBACHER

The firm Grumbacher has been in the business of making and selling quality brushes since 1905, offering natural-hair and synthetic brushes for every purpose from sign painting and hobby work to watercolor, oil, and acrylic painting. The two lines designed for painting with acrylics are the white nylon Bristlette series and the synthetic Golden Edge series.

The Bristlette flats and brights are nicely balanced, all-purpose brushes that can be used for laying on heavy impasto paint as well as thin applications and washes. I like the fact that the bristles are tapered and set in the ferrule so as to "toe in," and that they hold their shape. These brushes make it possible to create ("cut") a sharp

edge, and they also do a good job of texturing. They are durable and should withstand long use.

The Golden Edge series is a line of watercolor-type brushes made with synthetic bristles that hold a point when loaded with paint and have almost the spring of natural sable. The #6 round holds a lot of paint and is good for detailing and fine lines. The #6 liner is an ideal brush of its type—dense enough to paint lines that move from thick to thin with smooth continuity, and sharply pointed enough for very fine linear detail work. This brush lets you apply a long trail of paint without reloading, an advantage in many kinds of painting situations.

LANGNICKEL

Langnickel Select Artists' Brushes are made by Royal Brush Manufacturing, Inc., a company with 45 years' worth of experience in the field. The brushes in Langnickel's Snowhite series are specially constructed with larger-diameter white Taklon fibers that look and work like brushes made with traditional, premium white, natural bristles, except that they have sharper edges and finer points. This makes them ideal for applying paint mixtures of any viscosity, from washes to heavy impasto. The bristles have more spring and snap than natural ones, enabling better control. Snowhite brushes also come in jumbo sizes; the size 20 bright is a full 1³/₄" wide—ideal for painting larger areas and varnishing. It is full enough to hold ample amounts of paint, but thin and sharp enough for making sharp edges and lines. These large brushes are well constructed. The ferrules are fastened to the handle with both glue and steel escutcheon pins, a feature many large brushes of this type do not have.

Among the brushes in Langnickel's Combo line, which are made with a blend of natural and synthetic fibers, are the small round and liner

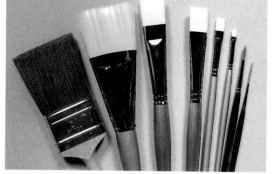

LANGNICKEL SELECT ARTISTS' BRUSHES

shown here; both are good performers for painting fine lines and details. The flat, full-bodied varnish brush illustrated is made with Chinese ox hair. The bristles are thick enough to have some spring yet thin enough to spread paint, gesso, or varnish evenly without leaving excess brush marks.

LASCAUX

Lascaux brushes are manufactured in Switzerland and imported to America by Savoir-Faire of Sausalito, California. They are made with high-quality synthetic fibers that are the result of the search for just the right combination of spring and firmness for paint loading and delivery, as well as shape retention.

If ever there were brushes that appeared almost too beautiful to use, it would be these. The deep bronze-brown bristles, which have more spring than usual, are stiff enough to pick up paste-consistency paint crisply, yet can mix and apply washes just as easily, making them ideal all-purpose brushes. The matte black handles are well-proportioned and feel balanced in the hand; the ferrules are seamless and made of nickel. Flats come in 16 sizes, rounds in 10 sizes. Beautiful to look at and to hold, these brushes are also beautiful to paint with.

LASCAUX SYNTHETIC BRUSHES

LOEW-CORNELL

Loew-Cornell has been making quality artists' brushes of all types for around 30 years. For painting in acrylics, the firm offers two popular, well-crafted lines, Arttec and La Corneille.

Arttec brushes, made with white nylon bristles, hold their shapes well and perform a variety of uses. They are firm enough to pick up and lay on any paste-consistency paint and yet can apply smooth washes as well. They responded admirably to vigorous texturing and slapping applications.

The beautiful La Corneille brushes are made with golden Taklon bristles. When I tried them I was surprised how their spring and firmness made it possible to pick up even the thickest paint. When used for vigorous, "slap-bang" texturing, they performed surprisingly well, although their Arttec counterparts are perhaps better for this type of paint application. The 2" 7750 La Corneille flat is a honey of a brush any painter could fall in love with, because it can do almost anything, from applying paint in various viscosities to varnishing. The round brushes hold lots of paint and come to excellent points. The liner brushes are unusual in that the larger sizes are capable of creating fine lines as well as thicker ones, a quality not often found in other brushes of this type.

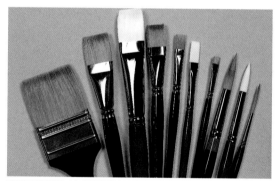

LOEW-CORNELL LA CORNEILLE AND ARTTEC SYNTHETIC BRUSHES

Loew-Cornell has every kind of painting and palette knife the discriminating artist might require. With solid hardwood handles and machine-forged steel blades, these knives handle efficiently and are durable.

SILVER BRUSH LIMITED

This young, rapidly growing firm brings to the craft of brush making a rich background of technical knowledge combined with an understanding of the needs of artists and craftspersons. Based in Princeton Junction, New Jersey, and headed by company president Deirdra Silver, the family-

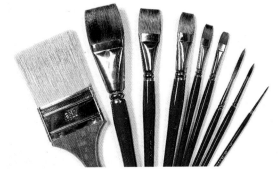

SILVER BRUSH LIMITED NATURAL-BRISTLE GESSO/VARNISH BRUSH AND RUBY SATIN SYNTHETIC BRUSHES

owned and -operated business makes quality brushes for every artistic purpose and need at fair and competitive prices.

The brushes illustrated above are from the Ruby Satin line, designed especially for the acrylic painter. With distinctive reddish-brown fibers made of a new synthetic in the Taklon family, they are manufactured like pure hog-bristle brushes, with a special, interlocking blend of hairs of different diameters to aid in brush loading and holding capacity. The bristles are tight in the ferrules and have a good, deep crimp where they are fastened to the handle. In construction, looks, and performance, Ruby Satin brushes are ideal for all acrylic painting purposes.

The brights can pick up the thickest paint with ease for impasto applications yet are capable of flowing on smooth washes. They can cut sharp edges, and they flatten down nicely for certain kinds of linear effects. These brushes do an excellent job of delivering paint in a variety of application methods and are resilient enough for rough slapping and texturing techniques. The round and liner brushes also perform well. I especially like the liner; it holds a lot of liquid and will trail paint forever, it seems. It will even flatten out to make razor-thin lines.

The gesso or varnish brush is made from all-natural bristle. The bristles are bound tightly in the ferrule, a construction feature that helps keep shedding to the minimum—an especially important quality when you are applying varnish.

WINSOR & NEWTON

The firm Winsor & Newton has long been known for the manufacture of fine-quality artists' products, and its brushes are no exception; they are well made, attractive to look at, and a pleasure to use. Those illustrated here are selections from three of Winsor & Newton's many lines: University Gold, Monarch, and Regency Gold.

University Gold brushes have dark brown heads made from a blend of synthetic fibers of varying diameters to emulate the stiffness of natural hog bristle. The long, maroon handles are made of hardwood and the seamless ferrules of gold-tone nickel plate. With University Gold brushes you can pick up and apply thick, paste-consistency paint using impasto brushwork of the most rigorous kind, as well as lay down flawless washes. The bristles have good spring and snap, and they hold a lot of paint. Tapering tips make for accuracy in painting sharp edges and certain kinds of linear effects. In short, the University Gold line is a fine selection for all-purpose acrylic painting.

Monarch is a new line of synthetic brushes with light brown bristles that simulate the appearance and performance of natural mongoose hair. (The mongoose is a small, weasel-like animal that has been designated an endangered species in many countries.) Artists who like using sable brushes for heavy-bodied paints will enjoy the Monarch. The brushes in this line are more resistant to abrasion than those made with real mongoose hair, and considerably less expensive. They work well for pushing heavy paint around and are good for glazing.

Winsor & Newton offers two lines of Regency Gold brushes, one made with pure, natural red sable and the other with golden Taklon. The sable brushes have matte black handles (see the round and script brushes in the illustration), while the synthetic ones have matte turquoise handles. As good sables do, the natural-hair Regency Gold brushes perform admirably.

For applying varnish or gesso, there is Winsor & Newton's 2"-wide Series 432 varnish brush (not shown), made with a double-thick blend of ox hair and China bristle that is hand cupped to a square edge.

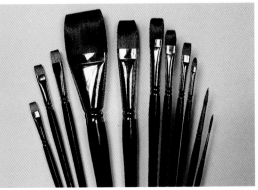

WINSOR & NEWTON MONARCH AND UNIVERSITY GOLD SYNTHETIC BRIGHTS AND FLATS; REGENCY GOLD RED SABLE ROUND AND SCRIPT BRUSH

AIRBRUSHES AND SPRAYERS

Another means of applying paint to a support is to spray it on using either an airbrush or a professional paint sprayer. To operate an airbrush such as the one illustrated below (a Badger model), liquid paint is placed in the glass canister, to which the nozzle of the unit is attached for spraying. The amount and size of the spray stream is controlled by adjusting the nozzle. An airbrush is coupled to a hose that is attached to an air compressor; for short-term use as a substitute for a compressor, portable gas cartridges are available. Airbrushes of this type are suitable for rendering fine details and for painting small to medium-size areas.

A professional paint sprayer (the larger of the two units in the illustration) is self-contained and does not require a compressor. In the model shown, the long tube nozzle and the two smaller ones by the base of the sprayer are used to control the size and amount of the spray stream. This unit is good for painting very large, medium, and even small areas, but is not suitable for fine detail work.

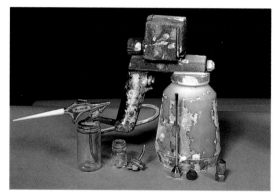

LEFT: BADGER AIRBRUSH; RIGHT, PROFESSIONAL PAINT SPRAYER

CLEANING AND CARING FOR BRUSHES AND KNIVES

Clean brushes with soap and water after use. Rinse the paint from the bristles with water and then scrub them on a cake of soap until they are filled with a creamy lather. Using your thumb and forefinger, squeeze the soap from the bristles with a sliding motion starting at the ferrule and moving to the tip. Repeat the soaping and squeezing process until the lather comes out perfectly clean. Then lather the brush one final time, but do not rinse out the soap. Shape the bristles with your fingers and let the brush dry. The dried soap acts as a sizing to keep the bristles in place while the brush is not in use. It will dissolve when you wet the brush in water prior to mixing paint. Brushes should be stored flat or standing with the bristle end up.

To clean bristles of dried acrylic paint, soak the brush in alcohol overnight and then proceed with the soap-and-water treatment. Combing or scrubbing the bristles with a stiff toothbrush or nailbrush will help remove any last stubborn traces of paint.

Painting knives should be cleaned with soap and water and then polished with a cloth or paper towel. Use a single-edge razor blade to remove oxidation and dried paint from knives, then polish them with fine steel wool.

Rinse excess paint. Fill brush with lather.

Squeeze lather from bristles. Repeat lathering and squeezing until lather is clean.

Allow clean lather to remain in the brush. Shape bristles and let dry.

SUPPORTS AND GROUNDS

A support is the physical material, such as canvas, hardboard, or paper, to which paint is applied. A support may be prepared with an initial (prime) coating known as a ground; this layer, usually of gesso, isolates the support from succeeding paint layers and is the surface you actually paint on. If you paint on unprimed paper or raw canvas, the surface of the support itself is the ground.

Canvas and wood are two supports that have proven their durability over the course of time, and thus they are considered traditional. But acrylic paints will bond to almost any surface or material that is not shiny or oily, meaning that you can work on far more kinds of painting surfaces than would be possible with any other medium. Also, acrylics have a preservative quality and can be used to prepare an array of supports for painting that otherwise would be considered impermanent or too fragile.

To determine whether a support material is compatible with the acrylic system and ensure that paints will adhere to it, firmly apply undiluted paint to a small area and let it dry. Then scratch or cut through the paint to expose the support surface underneath. Put water on the scratch marks and allow it to dry naturally. Wet the scratch-marked area again and rub it firmly with your finger or a stiff brush. If the paint rubs, brushes, or peels off, the material should not be used to paint on.

Support materials can be purchased at art supply, hardware, or even building supply stores, and sometimes come preprimed and ready to use. (Before painting on a commercially prepared canvas board, panel, stretched canvas, or the like, take care to determine that the ground that has been applied to it is suitable for use with acrylics.) Below is a survey of the most readily available choices.

CANVAS

Woven fabrics made of natural fibers that can be used for painting supports include cotton muslin, raw, untreated cotton canvas duck, and jute or burlap. Linen and cotton fabrics are both very popular supports. Linen, which is preferred by many painters, is slightly stronger and more durable than cotton because of the nature of the individual fibers. However, cotton is probably the most widely used because it is more reasonably priced. None of these materials is particularly durable in its raw or natural state—burlap

certainly is not—and all should be sized and primed to improve if not ensure permanency. Raw surfaces left exposed will rapidly deteriorate and discolor, and for this reason should not be used to represent colored areas in a composition.

Polyester canvas appears to be more durable than canvas made of natural fibers, and a few manufacturers offer it. To date, however, this synthetic has not gained much popularity, perhaps due to a preference for the traditional and a natural skepticism toward the new. I have tried polyester canvas, and it works quite well. It doesn't feel the way traditional canvas does when you apply paint to it, but its superior durability is a compelling reason to use it.

UNPRIMED LINEN. This traditional fabric comes in various textures, weaves, and colors.

RAW AND PRIMED LINEN

RAW AND PRIMED COTTON DUCK

RAW BURLAP

Prestretched and primed canvases are convenient, available most everywhere, and manufactured in a variety of sizes and shapes, including ovals and circles. They are primed with acrylic gesso to which the acrylic paint forms a strong bond, and they are good choices for general painting requirements. Another ready-made support, canvasboards are cardboard panels over which cotton canvas has been glued. While not available in very large sizes, they are serviceable and economically priced. However, the cardboard backing deteriorates quickly, and so you should coat the back with a 50:50 mixture of acrylic medium/varnish and water. This solution will

CANVAS BOARD, TRADITIONAL STRETCHED CANVAS, AND GALLERY-WRAPPED CIRCULAR CANVAS

penetrate the board fibers, increasing strength and durability. For additional protection, I always top this application with a final layer of acrylic or latex house paint. Some artists prefer the give and bounce of stretched canvas, while others favor the firmness of canvasboard; you should experiment to discover what works best for you.

WOOD AND HARDBOARD PANELS

Panels made of oak, cedar, walnut, and other hardwoods make excellent painting supports, though they can be expensive. A more economical choice is furniture-grade plywood, which is smooth on one side and rough on the other. Use $1/4$"-thick plywood for panels measuring up to 4×5'; panels larger than that should be $3/8$" thick and require support framing on the back. Plywood should be prepared and treated in the same manner as hardboard (see below), although sanding the raw surface is usually not necessary

UNPRIMED UPSON BOARD AND MASONITE

unless the wood grain is raised or the finish is too rough to accept paint.

Another good option is a hardboard such as Masonite, a molded board made of sawdust and glue that is both durable and inexpensive. Both tempered and untempered finishes are available and both are compatible with acrylic paint; tempered Masonite is harder and denser than the untempered kind, which is more fibrous and absorbent. For picture formats measuring up to 4×4', use $1/8$"-thick hardboard. Panels much larger than this should be $1/4$" thick and supported on the back with framing.

Masonite and other hardboards should be sanded before painting or priming. After sanding the surface all over, wash it with scouring powder and rinse it to remove dust, dirt, and any impurities. When dry, the panel is ready to be painted on or primed with acrylic gesso.

WINDBERG MULTIMEDIA PANELS

For the sake of convenience, you might wish to try Windberg Multimedia board (produced by Windberg Enterprises). Made of Masonite, these smooth hardboard panels come preprimed with an acrylic ground and are available in three different colors plus white.

PAPER AND PAPERBOARD

Paper makes a fine support for acrylic painting and is available in a wide array of weights, sizes, textures, and colors. Archival-quality artists' papers are generally made of natural fibers such as cotton or linen, and are acid-free and pH neutral, making them reasonably permanent. Makers of fine watercolor papers include Arches, Strathmore, Lana, and Fabriano; the latter also offers Pittura, a paper created especially for acrylic painting that is made from high-quality cellulose and is acid-free. Its sizing makes it ideal for oil and tempera also.

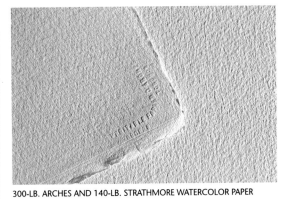

300-LB. ARCHES AND 140-LB. STRATHMORE WATERCOLOR PAPER

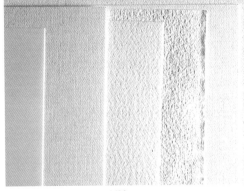

FABRIANO WATERCOLOR PAPERS

STRATHMORE WATERCOLOR PAPERS

LANA WATERCOLOR PAPERS

CRESCENT WATERCOLOR BOARDS

Watercolor board and illustration board, made by laminating a sheet of watercolor or drawing paper to a piece of heavy board backing, make excellent rigid supports. They are available in a variety of textures, including hot-pressed (smooth), cold-pressed (medium), and rough. If you are concerned about permanence, be sure the board the paper is mounted to is acid-free. Makers of quality watercolor and illustration boards include Arches, Crescent, Whatman, Strathmore, and Bainbridge.

Other, nonarchival types of paper and board can also be used, as long as you prepare or finish them properly. To make these materials both more durable and permanent, coat them with acrylic gesso, paint, or matte medium prior to painting. (Gloss medium creates a slick, shiny surface that is difficult to paint on.) Use the medium either undiluted or mixed with a 50:50 medium and water solution. I use the diluted mixture because it penetrates these absorbent surfaces and seeps into their fibers. If you like working on untreated material because of the way it receives paint, protect and preserve your finished picture by applying a coat of acrylic varnish to its front, back, and edges.

One support that I personally enjoy working on because of its absorbent quality is construction paper; it holds water for wet-on-wet opaque watercolor techniques better than any watercolor paper I have found to date. It also has a tinted surface, which I like for this kind of painting. Because impermanent papers that are not acid free usually discolor and turn brittle very rapidly, they are not suitable for transparent paint applications in which the paper will show.

CONSTRUCTION PAPER

Opaque paintings on this kind of paper should be coated with acrylic varnish on their front, back, and edges for preservation.

One rigid support I like is Upson board, an inexpensive paneling like thick mat board that is used for wallboard, window display, pattern making, and constructing stage sets. Sometimes called "easy curve," it can be purchased in building supply stores. Upson board comes in $4 \times 8'$ sheets that you can cut using a handsaw or by scoring repeatedly with a utility knife. Panels for painting should be $3/16"$ thick; formats larger than $24 \times 36"$ need a frame support on the back. Cardboard is another possible support but not a strong one; for this reason you should not paint on cardboard panels larger than $18 \times 24"$. Because Upson board and cardboard are not acid-free, before you can safely paint on them you must coat them with acrylic gesso front, back, and edges for preservation. This also helps prevent bowing. If you paint on the raw, untreated surface, you should seal your finished picture with a coat of acrylic varnish to front, back, and edges.

METAL AND PLASTIC

Metals like aluminum, zinc, copper, and stainless steel, as well as plastics like Plexiglas and nylon, are not popular as painting supports. To ensure paint adhesion, the surfaces of these materials must be roughed up with an abrasive such as steel wool, emery, or sandpaper, or by sandblasting.

USING IMPERMANENT MATERIALS

A material described as impermanent is one that changes noticeably in physical characteristics and appearance within two to 20 years. For example, untreated newsprint, cardboard, construction and tissue paper, Upson board, and other paperlike products that are not acid free become brittle and turn yellow within a few years; fabrics such as burlap and jute deteriorate rapidly as well. But acrylics make it possible to use materials like

these that in the past were considered unsuitable for artwork because of their fugitive, impermanent nature. Now, if prepared and finished properly, they can be made reasonably durable, meaning that they will last longer than 50 years without showing signs of deterioration.

Acrylics act as a preservative, drying quickly and sealing the surface they are applied to and thus protecting it against degradation. Preparing otherwise impermanent materials in this manner has proven acceptable to most conservators, technicians, and artists.

Any material that is compatible with the acrylic system can be incorporated into it. By *compatible* material I mean anything that acrylic will adhere and bond strongly to. In other words, you can paint on most anything and use almost any material in combination with acrylics. But with so many permanent supports available, why would an artist want to use anything impermanent? Economy, for one; keeping down the cost of materials is an important consideration. For many artists, the time and effort it takes to prepare less expensive supports for painting is worth the monetary savings realized. Another answer to the question is that a particular impermanent material may accept paint in a way that is better for a certain technique than something permanent. As described above, this has been my experience with construction paper and Upson board, both of which can be made permanent when you are done painting by coating the front, back, and edges with acrylic varnish. Finally, perhaps the material has an aesthetic quality—a certain color or texture, for example—that will enhance the appearance of a painting by becoming an integral part of it. Impermanent materials can be employed as supports or incorporated in pictures (as in collages) where any number of such items may find use, as long as care is taken in preparing them and preserving the finished works.

An important aspect of creative growth is experimentation, and one of the major purposes of this book is to encourage just that. Artists are always in a state of becoming, finding through trial and error what is unique and exciting to them. In that context, every artist has to decide for himself what his expectations are for the permanency of his work. If there is no reason to use impermanent materials, one might as well use those that are by nature more durable. Either way, it is essential that you be aware of the durability of anything you use with the acrylic system, and know how to make materials as long-lasting as possible.

Priming Supports for Painting

Historically speaking, the reasons for sizing and priming a painting support are to protect it against deterioration, prevent paint from leaching back into the material, and create a surface that is receptive to paint. Acrylics eliminate the need to prime and size because they dry quickly and seal the support. Their chemical nature is preservative, unlike oil paints, which dry slowly, penetrating unprimed surfaces and thereby accelerating their deterioration. With acrylics it is possible to paint on raw canvas, unprimed wood or hardboard, and other unprepared surfaces, but some artists don't like the way it feels to do this. There could be too much brush drag and not enough paint flow. Priming a support eases paint application and allows you to create a colored ground.

You can greatly increase the durability and longevity of absorbent materials by coating them on both sides with a 50:50 mixture of matte medium and water. The thin solution is absorbed into the pores of the material, acting as a seal. Once this protective coating has dried, you can either paint directly on it or apply a gesso ground first.

The various brands of acrylic gesso differ from one another in absorbency when dry. To ensure a less absorbent surface, mix acrylic medium with the gesso before applying it, or coat the dried gesso with a half-and-half mixture of matte medium and water.

When using a brush to apply gesso, stroke paint on in an interlocking crisscross pattern to prevent unsightly brush marks that could show in the finished picture. For a smooth finish, thin the gesso with a 50:50 mixture of matte medium and water. Avoid thinning with water only, which can weaken the gesso and cause poor adhesion to the support. More than one coat may be required to achieve the desired surface quality. Dried gesso can be sanded with fine sandpaper between coats if needed to lessen brush marks. For a textured surface, apply the gesso with a paint roller (available at hardware and paint stores). Use whichever type of roller lets you create the texture suited to your painting purpose; the possibilities range from almost smooth and slightly beaded to rough and pebbled. Textural additives like sand or pumice can be mixed with the gesso for interesting surface treatments.

To serve as painting surfaces, fabrics can be stretched on a frame or glued to a hardboard or plywood panel using acrylic medium as the adhesive, then prepared for painting with a coating of acrylic gesso or a sizing of matte medium. Before applying gesso, as with any absorbent material I always saturate the canvas with a 50:50 mixture of matte medium and water and let it dry. This protective coating penetrates the fibers to strengthen the cloth. When you are priming fabric, it is best to apply gesso with a brush. The moisture in the gesso may raise the fibers in the fabric, causing the first coat to dry with a rough, hard finish, but this can be eliminated by sanding. Apply as many coats as needed. Thin the gesso with undiluted matte medium or with a 50:50 mix of the medium and water, so as not to impair its adhesion and elasticity; this is critical.

Demonstration: Stretching and Priming a Canvas

Canvas stretched over a wooden frame is a traditional painting support for oils and acrylics. Here, then, is the basic method for preparing this type of support.

Assemble the stretcher strips into a frame and make it square. Staple the corners to keep the frame from warping out of square during the stretching process. Cut the canvas several inches larger than the frame. This gives you a margin of fabric to grip while stretching.

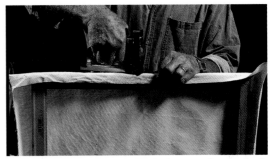

Fold the canvas loosely around the frame and put a single staple diagonally in the center edge of one side of the frame.

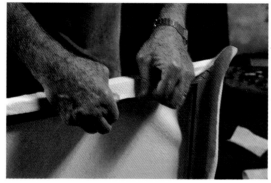

Turn the frame so the stapled edge is on the bottom. Stretch the canvas over the top edge of the frame, pulling it gently until it is tight. Secure it with a single staple in the center of the frame edge, just as in the preceding step. Repeat the stretching and stapling process on the remaining two sides of the frame so that the canvas is held by a single staple on each edge. Continue stretching and stapling the canvas, working from the center out toward the corners of each frame edge. Again, secure the fabric with a single staple on one side of the frame, turn the frame upside down, stretch the canvas over the edge, and staple. Space the staples about 2" apart from each other. Going from side to opposing side as you work creates an even pull on the canvas from all directions and helps keep the frame from warping.

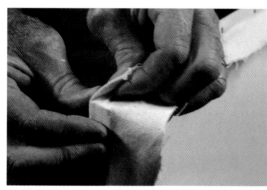

Fold the canvas around the corners of the frame with a straight-edged tuck.

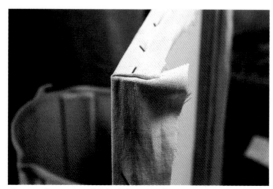

Secure the corner fold with a staple.

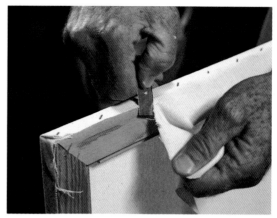

Remove the excess canvas by cutting with a sharp, single-edge razor blade or other similar instrument.

Apply gesso using interlocking crosshatch strokes. This ensures a smooth surface when the gesso dries. While one coat seals the fabric for painting, most artists prefer at least two. When the surface is completely dry, you can sand it for a smooth finish.

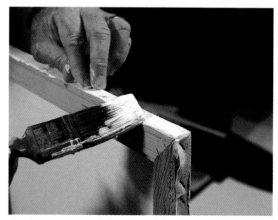

Apply gesso around the edges of the stretched canvas to seal the fabric and help prevent raveling.

If a stretched canvas begins to bag, insert wedge-shaped stretcher keys into the corners of the frame to provide additional stretching, using two keys per corner. Most commercially made stretcher frames have channels cut in them for this purpose. Use keys only if needed.

Tapping the wedges gently into the corner channels spreads the corners of the frame and tightens the canvas tension.

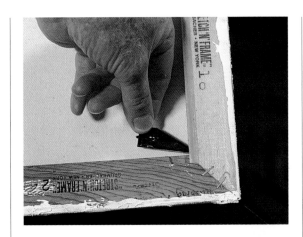

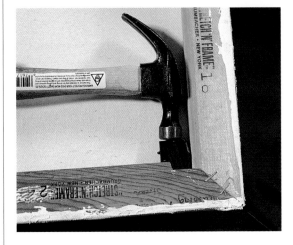

Next, I scrub the surface with powdered cleanser and water to remove sanding dust and impurities.

When the panel is dry I apply acrylic gesso with a medium-size flat brush using interlocking crosshatch strokes. This method prevents unsightly, linear brush marks from appearing on the surface and results in a smooth finish. (For larger panels, apply gesso with a larger brush.)

DEMONSTRATION: PREPARING PANELS

The method for preparing a hardboard panel as a painting surface is the same no matter what its size: abrading, cleaning, priming with gesso, and smoothing with sandpaper. For this demonstration I use a 9 × 12" Masonite panel.

First, I abrade the surface of the Masonite panel using medium-grit sandpaper. For small panels like this, hand-sanding is fine, but for larger ones a vibrating sander makes the process easier. Make sure every area is sanded.

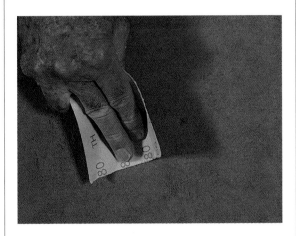

One coat of gesso is enough to seal the surface, but I prefer at least two thin coats. I sand the surface lightly with fine sandpaper between applications.

SELECTING A WORKING COLOR PALETTE

Ask a dozen artists to make a list of basic colors for a working palette and you will get a dozen different lists. Naturally, some of them will have colors in common, but because each artist has his own personal preferences, disparity is to be expected.

I believe that there is a logical approach to choosing the fundamental working colors—in other words, those that cannot be done without, starting with the primary colors—red, yellow, and blue—plus black and white. There are artists who use just these five colors, but working with such a limited selection is not especially practical. For one, it is difficult to mix clean, bright secondary and tertiary colors from these hues; mixtures easily become muddied or dull. This is because mixing pigment is different from mixing light. When pigmented colors are combined, the resulting hue is always somewhat less bright or intense than the individual colors used to create it. From this we must conclude that some hues and tints cannot be made satisfactorily by combining the primary colors. A pure orange, green, and violet are among the colors needed in addition to red, yellow, and blue.

A basic palette should consist of the brightest, strongest colors available. A lot of painters have difficulty understanding what brightness means in terms of color, associating it incorrectly with lightness. A bright color is one that is highly saturated, with a lot of power and tinting strength. With few exceptions, bright, concentrated colors are dark in value instead of light. A light-value color is produced by adding water or acrylic medium, white, or another light color to a dark one. Having mostly light colors on the palette makes it impossible to create lively dark values. Intense dark colors retain their hue and have less tendency to muddy when mixed with other colors. Also, because of their strength, they go much farther when tinted with white or thinned into transparent washes. Keep in mind that for mixing hues, *bright colors are best*.

THE BASIC HUES

The colors listed below constitute a serviceable working palette. It is a practical selection to add to and delete from as your painting style grows and changes, reflecting personal taste and creative discoveries. These choices represent the minimum number of strong, bright colors from which most other hues and values can be mixed without a lot of compromise. If you must make substitutions in the dark colors, always select the darkest you can find. The color should appear almost black straight out of the tube, before you dilute or mix it with anything.

- *Red:* cadmium red medium and alizarin crimson. It is difficult to find one red that will do it all. These two, plus cadmium orange, should fill most needs.
- *Yellow:* cadmium yellow medium. Yellow is a color that muddies very easily. Cadmium yellow lightens up nicely when white is added and resists the tendency of yellows to take on a soiled, greenish tinge.
- *Blue:* phthalo blue. This blue is one powerful color; I believe one spoonful would tint five gallons of white! It is transparent and makes excellent washes and glazes. Combined with burnt umber, it makes a rich near-black.
- *Green:* Hooker's green or sap green. Different brands of these colors vary in value and hue; select the darkest you can find. If those available are light or middle-valued, switch to phthalo green.
- *Orange:* cadmium orange. It is difficult to get a bright orange by mixing red and yellow. You will find a lot of uses for this color.
- *Violet:* dioxazine purple, mauve, Grumbacher purple, or phthalo purple. As with Hooker's green and sap green, these violets vary in hue and value according to brand. Pick a strong, dark violet, since a good one is hard to mix.
- *Brown:* burnt umber. This is a rich, dark transparent brown that no palette should be without. It makes good washes and glazes.
- *Black:* ivory black or Mars black—whichever seems to have the most concentrated pigment.
- *White:* titanium white.
- *Additional colors:* raw sienna and burnt sienna. If you paint landscapes, you will find a lot of use for raw sienna and burnt sienna; the latter is also good as a base for some skin colors.

Individual painters lay out colors on the palette differently. A good method is to put them close to the outside edge of the top and sides of the palette, leaving the center and bottom for mixing space. Make each color a self-contained unit. This will expose less paint to the air and keep it from drying so rapidly. An occasional misting with water from an atomizer will extend paint workability indefinitely. Position water containers and the medium cup within easy reach.

Other Necessities

Painting requires more than brushes and paints. A palette on which to mix your colors and additional items such as water containers and an atomizer are essential, as are a work space, table, stand, easel, and other accoutrements. Those who have experience with any painting medium will already have a feel for what they need to get started with acrylics; it's only a matter of shifting gears. Check over the "bare bones" list presented here to see if you're missing anything. Beginners and artists with limited experience will need all of these items to start painting.

Palette

Most artists use a piece of Plexiglas or glass as a palette because dried paint is easily removed from it with water and a palette knife. White is preferred as a palette color because it shows the paint colors to advantage; if you use clear glass or plastic, simply slip a piece of white paper under it. The one disadvantage of this kind of palette is that when you mix colors on it, any dried paint remaining on the surface may be loosened by the moisture from the wet paint and water as you scrub over it with the brush, forming particles and flakes that then appear in the wet paint mix. To avoid this problem, for a studio palette I use a piece of 16 × 20" cardboard or matboard coated on both sides with acrylic gesso and taped to my painting stand. Dried paint does not lift from this surface. Excess paint that is still wet can be wiped or scraped off the palette at the end of a work session and stored for later use. If you find that dried paint residue interferes with mixing fresh color, give the board another coat of gesso. Use this surface until it gets lumpy, then throw it away.

Paper palettes—tablets of shiny nonabsorbent paper sheets that you use one at a time per painting session, then tear off and discard—do not seem to work well for acrylics. They often buckle from moisture, and thin paint mixtures and washes have a tendency to bead up on the shiny surface.

Water Containers

I recommend that you have two water containers, one for rinsing brushes and the other for dipping your brush into when thinning paints. That way only the water in one container will get dirty enough to require frequent changing. Widemouth plastic containers or anything break-resistant are best. Household bleach bottles are excellent for this purpose; just cut off and remove the top portion. While you are securing water containers, find a smaller one with a lid in which you can store acrylic medium mix. A plastic margarine tub is good for this.

Atomizer

An atomizer or spray bottle filled with water is essential for keeping the paints on your palette moist and workable. It is also used to spray water on paintings in progress to extend drying time. An atomizer that produces a fine, even mist is best.

Rags and Towels

No matter what painting medium you work in—acrylics being no exception—you need to have material on hand for wiping paintbrushes and cleaning up spills. Use absorbent cloth rags

Here is a typical setup: brushes and knives are ready; paints are placed around the outer edge of the palette, leaving room in the center for mixing; paper towels, a water container for rinsing, and a tray for medium are conveniently placed. I am moistening the paints with an atomizer in preparation for painting.

or paper towels for this purpose. Unlike oil and lacquer solvents, acrylic paints and mediums do not create hazardous or combustible fumes, and to my knowledge, there are no dangers involved in storing and disposing of acrylic paint- or medium-soaked rags, as there might be with oil painting rags that have been dipped in turpentine.

WORK SPACE AND EQUIPMENT

Where you locate a space to paint in naturally depends on what space is available. A room or an area that is well lit and where you can safely leave work in progress set up is ideal. If space is tight, just scale everything down in size. I have a small outfit that I take with me when traveling that works fine in a motel or hotel room or on a boat.

A table or painting stand is necessary to hold your palette, water, paints, brushes, and other essentials. You also need this or another flat surface to lie paintings on when you are working flat. For working upright, an easel is a fundamental piece of equipment; an adjustable one that allows you to paint standing up is best, although tabletop easels are convenient if you prefer to sit.

A cabinet or chest of drawers (such as a taboret) to hold supplies completes the list of basic items. Of course, you can add more as need dictates. Hold off on investing in expensive equipment until experience teaches you what you really require; taking a class or talking with a seasoned artist can be helpful in this matter.

MISCELLANEOUS TOOLS

In addition to the basic items you need for working in acrylics, you might want to consider having on hand a few other things that can enhance your painting experience. Drawing implements such as soft lead, colored, and lithography pencils, charcoal, chalk and oil pastels, crayons, pens, and ink are all very useful in the context of painting. For masking purposes, tape and masking fluid are indispensable. A utility knife and single-edge razor blades come in handy for scraping techniques; sandpaper is good for smoothing out painting surfaces as well as for creating texture; and a blow drier can be used to accelerate the drying of wet paint. These tools and more can be added to your arsenal as needed.

These additional materials will aid in completing the acrylic painting experience: cellulose sponge, foam-rubber paintbrushes, masking fluid (Miskit) and tape, colored pencils, ink and drawing stick, single-edge razor blades and craft knife, blow drier, brayer, paper towels, atomizer, soft pastels, sandpaper, oil pastels, vine charcoal and charcoal pencil, and lithography crayons.

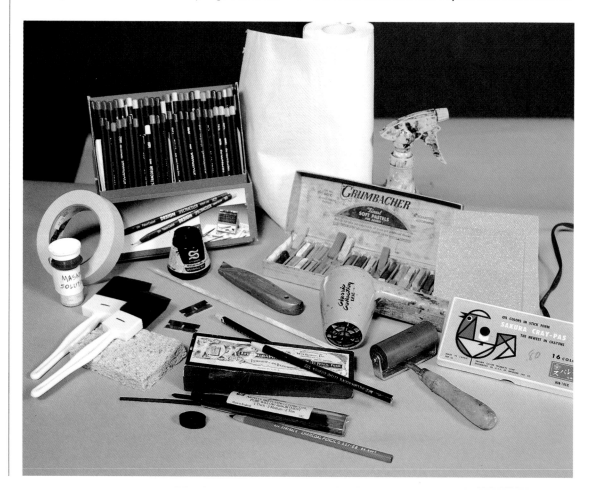

PROTECTING FINISHED WORKS

When inspiration and the creative process are over and a painting has been completed, is it really finished? Is it ready to be framed and to leave the studio for display? The answer, of course, is that it all depends on how the artist feels about protecting and preserving his or her work, and whether or not a varnish coating will alter a painting's appearance unfavorably.

In my opinion, if you do not plan to exhibit or sell your paintings, you can do entirely as you please. If, however, a patron invests interest and money in a painting because its appearance is appealing, then I feel that the artist is obligated to ensure as best he can that the work will maintain its original appearance and remain durable over time.

Recently I had a personal experience that dramatically proved to me beyond any doubt the importance of using protective coatings on paintings. In the 1960s I started a series of detailed paintings using an egg tempera approach. Working on tempered hardboard coated with acrylic gesso, I applied paint in thin layers, sometimes employing an airbrush. Upon completion, these paintings were sprayed with several thin coats of a mixture of matte and gloss medium/varnish, resulting in a satinlike finish.

Several of the works were purchased by patrons who, after owning and enjoying them for 30 years, decided to donate them to the permanent collection of a local university. The university asked me to evaluate the condition of these paintings. They seemed to be in good shape, but somehow appeared much darker and less luminous than I had remembered. I asked for and was given permission to clean the paintings.

The amount of dirt that had accumulated was surprising, almost beyond belief. You can see this for yourself in the example shown here. When I wiped a soapy cloth across a section of the picture, up came a deep olive-brown sludge. The painting had been exposed to 30 years of ordinary household dust and cigarette smoke. The sludge was easy to remove, but the nicotine stain required extensive cleaning and bleaching. Fortunately the stain was on the varnish coating and not on the picture itself. The surface proved remarkably durable, withstanding the scrubbing and bleaching required to clean it. Without the varnish coatings, it would have been impossible to restore the painting to its original appearance.

Before you varnish a painting, you should consider how best you can protect it while allowing the aesthetic qualities of the medium to be seen to advantage. The kind of varnish you use on a particular painting and the method with which you apply it depends in part on how and on what support the painting was executed. For example, by tradition, transparent and opaque watercolor paintings done on paper are matted and framed behind glass or plastic. This not only protects their fragile, easily damaged surfaces but also gives their matte finish some luster. Varnishes for traditional watercolors have been experimented with in the past but have not proven practical. Acrylic watercolors, however, can be given several coats of matte or gloss varnish (at least two or three for adequate protection) and framed without glass. Even though doing so does not drastically alter the appearance of such works, most artists prefer not to varnish their watercolor-type acrylic paintings, particularly those executed in a transparent style in which the white of the paper serves as the whites in the picture. Personally, I think that transparent watercolors of any kind that are painted on paper look best uncoated and behind glass for reasons both traditional and aesthetic. Opaque acrylic watercolors are a different matter; I always coat them with a satin-finish varnish, which gives color and value depth to their otherwise flat, dull surface.

This picture was covered with a brown veil of dirt, which you can still see at right and bottom left. The difference between these areas and the cleaned section at upper left is remarkable. Fortunately the painting had several coats of medium/varnish to protect it; otherwise, it would have been ruined.

PROTECTING FINISHED WORKS

Works on paper should be wet- or dry-mounted to a firm backing board for stability before you varnish them. I wet-mount my paintings with acrylic medium as the adhesive, using 3/16"-thick Upson board for pictures that measure up to 24 × 30" and 1/4"-thick Masonite or other hardboard for larger ones. Because Upson board is not acid-free, I coat it with acrylic medium/varnish on the front, back, and edges to completely seal and preserve both the panel and the picture to be mounted to it. (As mentioned earlier in the section on supports and grounds, this precaution is necessary when you work on any impermanent material—cardboard, paper that is not acid-free, or other materials that will become brittle and deteriorate quickly.) Another option is to dry-mount paintings on acid-free foam-core board and then coat them with medium/varnish, taking care to seal the edges.

Paintings with heavy brushwork, impasto applications, relief elements, or collage work require extra protection, because dirt and dust collect in crevices, cracks, and heavily textured areas. At the opposite end of the spectrum, it is a popular practice to paint on raw, unprimed canvas and leave large areas of it exposed without any protective treatment. But when left untreated, surfaces like these discolor and absorb dust and dirt that is practically impossible to remove. Sometimes the artist has to sacrifice certain aesthetic aspects of a picture in order to preserve it. Varnish coatings will alter appearances to some degree, but they do protect your work. You must make the choice.

Which type of finish—matte, gloss, or satin—is right for a given painting? In general, to preserve color depth you should use a coating that dries with some gloss or sheen. Middle-tone and dark colors become lighter and appear to lose depth—flatten out—when given a matte finish.

I applied a satin-finish varnish to all but the right-hand portion of this watercolor to show the effect of varnish on color depth. Note the brightness of the light hues and the depth of the darks in the varnished area, as compared to the flat, dull appearance of the unvarnished section.

APPLYING THE VARNISH

Just brushing acrylic medium/varnish onto a finished painting without some thought as to how to prepare and apply it could adversely affect the picture's appearance. Study the following information, then do some experimentation before attempting to varnish a painting.

- Some brands of acrylic medium are labeled for use both in paint mixtures and as a final protective varnish; others are specified simply as final varnishes. But all can be treated the same, and different brands can be intermixed when used as final, protective varnish coatings.
- Some undiluted medium/varnishes leave raised brush marks when applied. If your painting requires a perfectly smooth finish, mix the medium with water and apply it in several coats. Do not use mixtures any thinner than half water and half medium, because a weak coating may result. To get the right surface finish, experiment with combinations of matte and gloss medium.
- Undiluted medium usually works well on pictures painted on canvas and on those with heavy, impasto brushwork. When applying the medium, brush it on to follow or match the brushstrokes in the painting.
- A wide, flat brush that is not too thick works best for applying the medium. Use large (3" to 4") brushes for large works and smaller (1" to 2") brushes for smaller works. You can also use foam applicators for this purpose.
- Before varnishing, make sure that the picture is dry and clean. Check also to see whether the brush you plan to use is shedding bristles. Bristles embedded in dried varnish are difficult to remove, and even if you manage to extricate them, they leave an unsightly mark. Flex the bristles of the brush between your thumb and forefinger or strike the ferrule sharply against the palm of your hand to remove any loose bristles.
- Always brush gently when applying varnish; vigorous brushing can whip up tiny bubbles that will remain white or milky when dry. Take special care when coating collages, relief paintings, or paintings that have heavy, raised brushstrokes, palette knife marks, or any cracks or crevices; push the varnish gently into the cracks and edges of the raised portions.
- To achieve a smooth, satiny finish, you can use an airbrush or paint sprayer to coat paintings with thin mixtures of medium/varnish and water. This method is ideal for putting even finishes on thinly painted pictures on smooth

Here, I am applying undiluted liquid medium/varnish to my painting Outer Banks *with a 3" flat natural-bristle brush. I make long, blended strokes running from the top to the bottom of the picture to get smooth, even coverage that will dry to a satin finish. (See page 125 for the completed painting.)*

panels, but it requires proper equipment and much practice, as the process is tedious and chancy. Spraying procedures vary according to the type of sprayer you use. Some sprayers mix too much air with the varnish, causing it to appear milky when dry. To find the best mixture, start with two parts medium to one part water. If that does not spray properly, thin it down to a 50:50 mixture. I have had the best results by placing the painting upright on an easel. Taking care not to hold the sprayer too close to the surface, spray with a steady back-and-forth, side-to-side movement, working across the picture. Do not hold the spray too long on one area, as it will cause unsightly runs. Wear a mask when spraying; they can be purchased at a paint supply store.

- If you don't want to use the spray method, another way to achieve an even finish on smooth-surfaced panel paintings is to apply several coats of 50:50 medium/varnish and water mixture using a brush or foam applicator. For pictures painted on canvas or supports other than smooth-finished hardboard panels, this is the approach I prefer.
- How many coats of varnish are needed to protect a painting properly? I feel that at least two coats that cover the entire picture surface are required. The first coat seals by penetrating the pores of the painted surface and any areas of the support or ground that are exposed. Additional coatings provide assured protection. If thin mixtures of varnish are used, more than two coats may be required.
- If after varnishing a painting you determine that the image needs more work, you can simply apply paint right over the varnish. When the picture is dry, you can varnish it again.

- It is important to understand that acrylic medium/varnish penetrates the minute pores of the paint and bonds to it, becoming a part of the painting. So, it is almost impossible to remove without damaging the painting. Many artists seal and coat their pictures with medium/varnish first, then apply a final layer of soluble varnish (such as Liquitex's Soluvar or Winsor & Newton's Conserv-Art). This way, dirt will accumulate on the soluble coating, not the painting; the soluble varnish can be removed easily without damage to the picture.

When mature, acrylic medium/varnish forms a tough skin that will withstand vigorous cleaning—even the use of powdered cleanser. Surface dirt is easily removed with soap and water. Stains are another matter, and are often difficult to nearly impossible to remove. It would be safe to say that, under normal conditions, several coats of acrylic medium/varnish will offer adequate protection, but to be absolutely sure, give your pictures a final coating of soluble varnish. With as much air pollution as there is these days, the soluble varnish idea sounds better and better.

CARING FOR AND CLEANING ACRYLIC PAINTINGS

Acrylic paintings, properly executed and varnished, require relatively little care. The paint itself is probably more durable than some of the materials to which you have applied it. Nonetheless, paintings should be protected from extreme temperatures and kept in a dry place. Surface dirt can be removed from pictures coated with medium/varnish with warm, soapy water. If a painting is badly stained, however, I suggest seeking professional help from someone who has experience in this kind of work. There are also books available on the conservation and restoration of paintings. This work requires special skills and knowledge, and it is easy to damage paintings if proper procedures are not followed.

Acrylic paints and medium/varnishes are pressure sensitive, and so your painting surfaces will stick together if they touch. This condition lasts until these coatings cure. For this reason, you should *not* stack paintings on top of one another or even lean them against each other. Washing your surfaces with cold water will help to disperse the plasticisers that cause this problem, but my own disastrous experiences have convinced me to never allow painted or varnished surfaces to touch, regardless of how much time has passed since application.

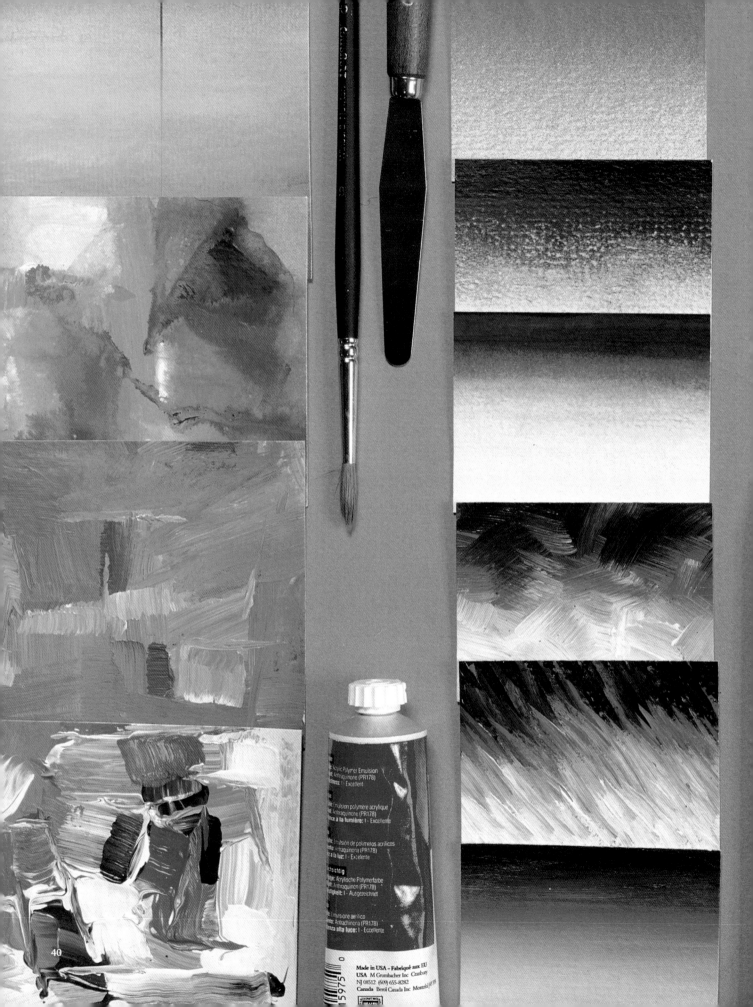

BASIC CONCEPTS

Prior to using acrylic paint, you should acquire an understanding of the medium and basic artistic skills so that your painting experience will be a truly satisfying one. If you are well equipped to express your visual goals, you are more likely to create successful pictures.

To that end, this chapter covers the different types of acrylic paint mixtures and application techniques—wet-in-wet, dry brush, and more—as well as methods for creating textural effects. Here, too, you will find useful information on painting surfaces and formats, and other important considerations in planning your pictures. Armed with a firm grasp of these essentials, you will be ready to tackle any creative challenge.

PAINT MIXTURES

There are three fundamental paint viscosities: washes, which are thin and runny like watercolor; thin mixtures, which have a thin and creamy texture similar to thinned oil paint or tempera; and heavy impasto, which is thick and pastelike. Artists can combine different paint mixtures in the same composition or use one exclusively. Since each consistency has its own unique expressive possibilities, learning to use and appreciate all three of them is an important part of the artistic growth process.

As explained in the preceding chapter, acrylic paint is manufactured in three different forms: paste, liquid, and a thin, inklike consistency. All must be diluted with water to produce washes, but the liquid acrylics appear to have more concentrated pigmentation than the paste paints and thin down into washes more easily. The liquid acrylics, acrylic gouache, and acrylic watercolors are excellent formulas for their intended painting styles. The paste paints, on the other hand, are multipurpose: they can be used as is or thinned to any viscosity desired with the addition of water and/or acrylic medium.

ABSTRACT THIN PAINT STUDY
Acrylic on Strathmore 140-lb. watercolor paper,
3 × 3¹/₂" (7.6 × 8.9 cm).

Most of the paint used to create this abstraction was thinned to a creamy consistency with a 50:50 mixture of gloss medium and water. It retains the brush marks but is not heavy in appearance. Some undiluted, paste-consistency acrylics were also brushed on thinly.

ABSTRACT IMPASTO STUDY
Acrylic on Strathmore 140-lb. watercolor paper,
3 × 3¹/₂" (7.6 × 8.9 cm).

This small abstract study is characterized by layers of heavy impasto and was created using both a brush and a palette knife. For this type of paint application, the brush and knife are loaded with paste-consistency paint, which is layered on rather than spread out thinly.

ABSTRACT WASH STUDY
Acrylic on Strathmore 140-lb. watercolor paper,
3 × 3¹/₂" (7.6 × 8.9 cm).

For this composition the paint was thinned with water until it was of wash consistency—very thin and runny. Both transparent and opaque washes were used to achieve the running and bleeding effects characteristic of such thin paint mixtures.

MIXING PROCEDURE

Paste-consistency colors are mixed using brushes or palette knives. It is important to have brushes with some firmness to their bristles. This stiffness facilitates picking up the paints and moving them around on your palette. Many painters prefer using the palette knife for this purpose; they pick up the paints on the blade of the knife and push and press them together to make a neat, compact pile on the palette. It is then easier to load the brush or knife with the mixture and apply it to the painting. For impasto applications, you can extend the paint by adding a gel medium to it. This will improve coverage, retain the paste viscosity, retard drying, and also give the paint a translucent luster. If the paint needs thinning, use liquid gloss or matte acrylic medium.

Creamy paint mixtures are made by thinning colors with water or undiluted gloss or matte medium. Gloss medium gives acrylics the luster and sheen characteristic of oil paints; using only water as a thinner results in a matte finish. Adding mixtures of both gloss and matte mediums to the paints can produce a variety of surface finishes, depending on the amounts used. To ensure a strong, flexible paint film when diluting colors, use a 50:50 mix of gloss medium and water. With this ratio, any consistency paint is easily achieved. Always keep in mind that the more water and/or medium you add to your paints, the thinner and more transparent they become.

For washes and watercolor-style painting, paints are thinned with water or a 50:50 mixture of medium and water. To do this, dip your brush in plain water or water-plus-medium mixture, then pick up some paint, stirring and thinning it against the palette until you achieve the desired consistency.

SMOKE
Acrylic on Upson board,
6 × 8" (15.2 × 20.3 cm).

Heavy acrylic impasto applied with a strong stroking technique can be employed in a traditional manner that simulates oil paint.

THE KID
Acrylic on Upson board,
24 × 18" (61 × 45.7 cm).

Thin paint mixtures used in combination with some impasto characterize this spontaneous, freely executed portrait study.

HAIR BRUSH
Acrylic on construction
paper, 7¹/₂ × 6¹/₂"
(19.1 × 16.5 cm).

To create this fluid-wash figure study, I applied the paint in the manner of watercolor, using the wet-in-wet technique described on page 48. Because of their versatility, acrylic paints open up creative possibilities that traditional mediums might not permit; here, for example, I was able to combine opaque and transparent washes easily in the same painting.

DEMONSTRATION: MIXING PAINTS ON THE PALETTE

The basic technique for mixing paint is outlined in this demonstration. Before beginning, moisten your brush and remove any excess water from it. You should always repeat this process after rinsing one color from the brush and before loading it with another to avoid muddying your colors. To keep stiff-bristled brushes moist while you are painting, stand them bristle end down in a container of water. Brushes with softer bristles should be rinsed and rested across the rim of your water container or on the edge of the palette until needed; standing them in water causes their bristles to warp, making them difficult to use. With practice you will develop a feel for your brushes and paints and how they interact.

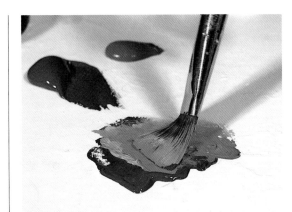

Mix these colors together on the palette.

Rinse your brush again and load it with whichever medium or medium mixture you are using.

Thin your new color mixture well with the medium so that it will form a good bond with the painting surface. It is advisable to use medium rather than water when you are painting in an oil-type manner, but you do not have to mix medium with acrylic paints when you are using them in watercolor-style washes.

After you have placed all your colors on your palette, you are ready to begin mixing them together to achieve more hues. Choose a color, moisten a clean brush with water, and load it up with paint.

Place the paint in a clean spot on your palette.

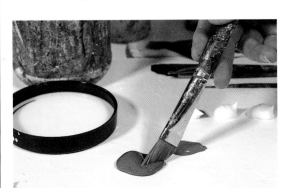

Rinse the brush in clean water and wipe off any excess moisture on a cloth or paper towel; then pick up another color.

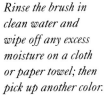

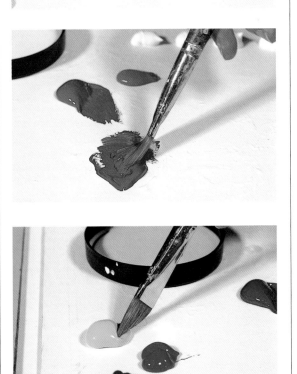

TRANSPARENCY AND OPACITY

Paints are also classified by their degree of transparency or opacity when applied to a surface. The three principal categories are opaque, semiopaque, and transparent, and they are the same in every painting medium. Learning about these paint consistencies and when to use them provides you with more control and a broader range of possibilities within each composition.

An *opaque* paint mixture covers what is underneath it without permitting any of the underlying surface to show through. *Semiopaque* paint partially reveals what is beneath it, just as a veil reveals a hint or glimpse of the face behind it. A *transparent* paint application clearly reveals the surface below. The ultimate appearance of a transparent paint mixture is directly influenced by any underlying colors and their values. (*Value* means relative lightness or darkness.)

Also important to artists when mixing paints are the ways in which colors can be made lighter and darker in value. Mixing white with a color is one simple way of lightening opaque paint preparations. Transparent mixtures on light-value grounds, on the other hand, are lightened by diluting them with water or acrylic medium. Colors are made darker by mixing them with darker hues. It is important to select the correct dark colors for this, so as not to create muddied or dirty dark values. (Color mixing is covered more thoroughly in the next chapter.)

All the definitions, categories, and information provided here about mixing paints will become meaningful only when put into use. Observing the mixing processes of experienced artists may also help you to incorporate this information into a broader understanding of practical artistic procedures.

To illustrate the three basic kinds of paints— opaque, semiopaque, and transparent—I applied washes of these various degrees of opacity over a black ink line. The transparent washes are on the top section, where the line is clearly visible through the paint. In the center section, white paint was mixed with a transparent wash to create a semiopaque mixture, which partially obscures the line. The opaque paint at the bottom covers the line completely so that it is not visible at all. A good understanding of the different characteristics of these washes enables the artist to employ them creatively in all pictorial situations.

SUMMER RAIN
Acrylic on Upson board,
18 × 24" (45.7 × 61 cm).

Here, semiopaque wash mixtures of water, white, gray, and blue were applied in vertical strokes over the finished painting to create the atmospheric effects of mist and rain.

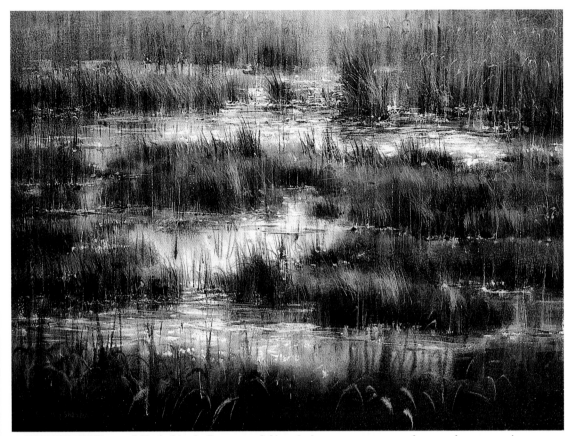

RAIN IN THE MARSH
Acrylic on Arches 300-lb. watercolor paper mounted on Upson board, 18 × 24" (45.7 × 61 cm). Collection of Christopher Newport University.

I blocked in the first stage of this painting on water-saturated watercolor paper using transparent washes for the grass and opaque ones for the water. As the painting surface became less moist, I worked details of grass and rain into and over the underpainting, covering any visible runs or bleeding. I then applied semiopaque washes over the completed background at the top of the painting to create the misty effect. When the painting was finished and completely dry, I applied several coats of acrylic varnish to the surface of the work as well as to the edges of the mounted board to seal and protect them.

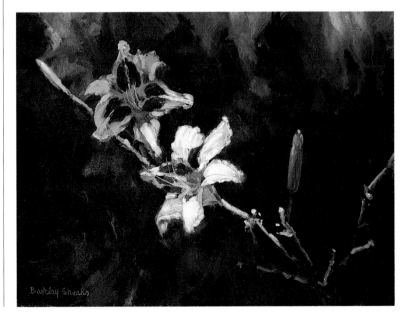

SUE'S LILIES
Acrylic on construction paper, 18 × 24" (45.7 × 61 cm).

I very much enjoy the contrast between transparent washes and opaque impasto. In this composition, I painted the transparent and semiopaque background first after saturating the paper with water. To discourage bleeding, I used a heavy, opaque paint for the lilies, which I painted directly into and onto this moist background. The finished painting was wet-mounted to an Upson board panel and coated with medium/varnish for protection.

BASIC BLENDING METHODS: THE SOFT EDGE

After you apply paints to a surface, you must manipulate them to achieve the effects you want. Some compositions might call for well-blended colors and soft forms, while others require crisp, clearly defined shapes, and there are different blending techniques that can be used to attain the desired results.

Acrylic paints dry rapidly, and for this reason beginners may experience some difficulty at first when attempting to blend colors and create soft edges in their paint applications. You can extend a painting's "open" time by spraying the work in progress with water using an atomizer, and also by combining the paints with an extender to retard drying. However, the blending time gained is marginal. It is the physical nature of acrylics to dry quickly, and this is a reality that must be acknowledged and accepted.

There are four basic blending methods for achieving a soft edge when you are using brushes, and they are essentially the same in any medium: wet-in-wet, the diluted edge, dry brushing, and stroking. Mastering these methods will enable you to overcome any apprehension about drying time and to solve any blending problems you encounter. They will also allow fuller appreciation of the creative versatility of the paint. Like many learned skills, brushing eventually becomes instinctive, and the right technique will come forth naturally when needed.

WET-IN-WET

This blending method is characterized by the working together or fusing of colors and values on the painting surface while the paints are still wet; the process can continue as long as the paints are kept moist. Wetting the surface with a 50:50 medium and water mix prior to applying any paint will extend working time, and spraying the painted surface throughout this blending process, if done frequently enough, can keep the paints workable almost indefinitely. For the best coverage, use brush sizes that match the sizes of the areas to be blended. The paints can be applied to achieve smooth, graduated blends or worked vigorously for a brushy, textural result.

THE DILUTED EDGE

The diluted-edge method involves the blending of wet paint on a dry surface. To do this, thin the wet edge of the applied paint with water or a mix of medium and water. Also apply the medium mix to the dry surface next to the wet edge, and blend one into the other with a brush. The more the wet edge is diluted, the more transparent it will become, giving the appearance of blending into the background. Using this method, you can blend dark colors into dry light areas, and light values onto dry dark areas.

DRY BRUSHING

Dry brushing is a texturing technique in which you drag or scrub wet paint over a dry surface using a brush with very little paint on it, or on which paint is partially dried. Breaking up a hard, wet edge in this manner produces a texture that creates the look of blending. For this reason, many painters like to work on a textured surface. When acrylic paint is brushed lightly over this type of surface, it adheres only to the raised portions of the texture, leaving the recesses uncovered and creating the effect of a gradual, soft edge. However, paint that is thin and runny will settle into the recesses of the surface texture, resulting in a solid wash of color. To avoid this, remove excess paint from your brush by wiping it on a rag, and then stroke the brush on a practice surface until it produces the proper marks.

STROKING

Stroking and stippling are similar to the dry-brush method in that the paint is applied in a "broken" manner in a series of marks that result in a soft edge. Strokes are long, linear directional marks made with a small brush in much the same way one might use pen-and-ink techniques to create transitional passages; stipple marks are dotlike. The two application methods may be used separately or in combination, and are used instead of a scrubbing or dragging action to blend one color or value into another that has already dried on your painting surface. To define and emphasize the form of an object, apply paint in strokes that follow the object's contours.

AIRBRUSH TECHNIQUES

Paint sprayers and airbrushes create soft edges naturally. Subtle blends and gradations of color and value are easily achieved with this specialized equipment. Many artists use the airbrush to create entire paintings; others use it in combination with more traditional brushwork. For more on the incredible blending and optical effects possible with the airbrush, refer to page 66.

As illustrated here, the wet-in-wet technique can result in a smooth and graduated blending of color.

Dry brushing is a means for creating texture by scrubbing color onto a dry surface with a brush that contains very little paint.

A brushy, more textural and painterly look can also be achieved with the wet-in-wet method.

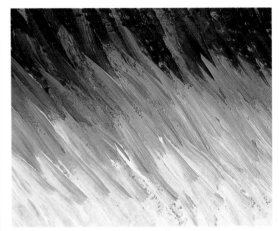

In the stroking method, brushstrokes are used to make the transition from dark to light values. Dots, rather than strokes, can also be used, and in this case the process is called stippling.

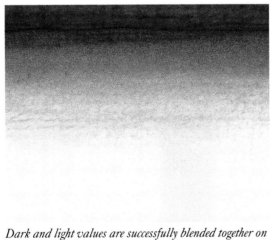

Dark and light values are successfully blended together on a dry painting surface using the diluted-edge technique.

Paint can be sprayed onto a painting using an airbrush or paint sprayer. The results are also soft edges and subtle gradations of color.

BASIC BLENDING METHODS: THE SOFT EDGE

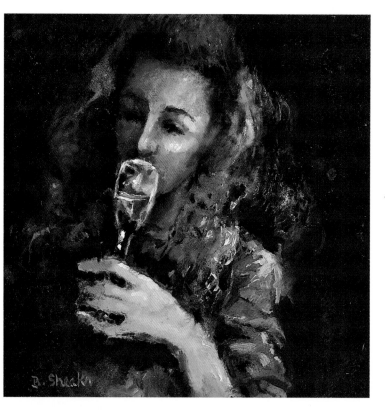

A SIP OF WINE
Acrylic on Upson board,
8¹/₂ × 8¹/₂" (21.6 × 21.6 cm).

When executing this painting, I employed wet-in-wet blending methods throughout. First, I sketched the subject on the board and then saturated it with water. I applied both opaque and transparent paint mixtures to this wet surface and kept it moist during the entire painting process. As a result, runs and bleeds are clearly visible; for example, a puddled blot of blending shows in the hair.

BUFFALO
Acrylic on Upson board,
8 × 10" (20.3 × 25.4 cm).

Because of their texture and appearance, certain subjects are especially well suited to specific types of brushwork. In this study, clearly defined strokes, along with dry-brush applications, simulate the cat's heavy fur.

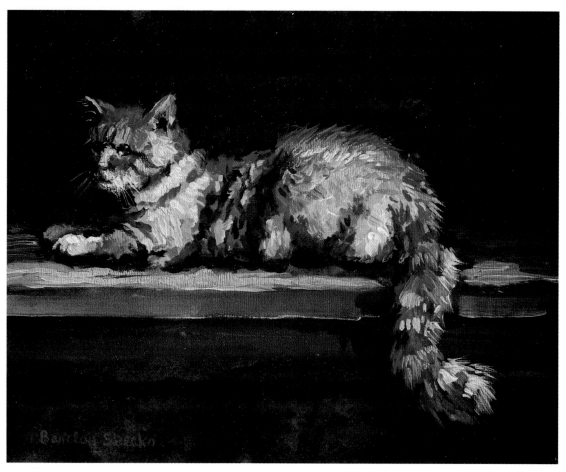

SAND BASKETS
Acrylic on Masonite,
30 × 40" (76.2 × 101.6 cm),
1979. Collection of Dr. and
Mrs. Glenn H. Shepard.

*For this picture, I
sprayed paint from
an airbrush to create
the softly modeled
shadow forms of the
sand. I employed
diluted-edge and dry-
brushing techniques
to achieve the subtle
color differences in the
wood of the baskets.*

MARSH WAITERS
Acrylic on canvas, 30 × 40"
(76.2 × 101.6 cm), 1974.
Collection of Dr. and Mrs.
Jerome E. Adamson.

*I built this detailed
composition by
carefully stroking on
paint in multiple
layers.*

THE HARD EDGE

Unlike the soft-edge methods, the hard-edge technique is characterized by the clean, sharp edges of shapes and forms within a composition. This technique has been employed by many modern artists, such as the Dutch painter Piet Mondrian (1872–1944), to create colorful, flat-pattern effects. To achieve this quality, use careful brushwork or, for precision, mask the edges of shapes and forms with tape.

For best results, use thin paint mixtures and work on a smooth, relatively nonabsorbent surface such as illustration board or primed canvas. Use flat brushes to paint long, straight edges and smaller, pointed brushes for corners and small areas.

Masking tape can tear and pull paint from some surfaces; for this reason never leave tape on a painted surface for more than 24 hours. Test the tape on various surfaces before deciding which one to use. Straight edges are easily taped. To create curved edges, cover the desired area with tape and draw your shapes on it. Then cut around the shapes with a sharp blade and peel away the excess tape. To prevent paint from bleeding under taped areas, burnish the tape edges with a smooth, rounded form such as a spoon, then seal them with a coat of clear acrylic liquid medium. When this is dry, apply the paint. After the paint dries, carefully remove the tape. This whole procedure may seem tedious, but if successfully done, the results are worth it.

DEMONSTRATION: CREATING A HARD EDGE WITH MASKING TAPE

In this abstract composition, which relies heavily on the strength and clarity of forms, the advantages of masking areas with tape become readily apparent. The success of the painting depends upon the crispness of the edges where one color meets another.

Using a sharp X-Acto knife, I make a curvilinear cut in the masking tape.

Here, I pull one side of the cut tape off the canvas board.

After placing the two pieces of tape exactly where I want them, I burnish them with a spoon to ensure that their edges are sufficiently sealed. This will prevent unwanted paint from seeping under the tape.

For my surface in this example I am using canvas board that has already been masked and painted magenta and orange. Here, I apply more tape, with which I will create additional forms as the painting progresses.

To further seal the edges of the tape, I brush acrylic medium over them. You can use either gloss or matte for this purpose, but I like matte medium because the paint seems to adhere to it better.

Once the medium seal has dried, I proceed with the next paint application, which covers the curvy edges of the tape.

You must wait for the medium to dry completely before continuing; a blow drier speeds this up.

When the paint is dry, I carefully remove the tape.

The result is a hard-edge design with clean, crisp forms.

THE HARD EDGE

SKY WATCHER
Acrylic on Upson board,
24 × 36" (61 × 91.4 cm),
1967.

*The clean, sharp
edges in this picture
are the result of
careful freehand
brushwork. When
you are working in
this detailed style of
painting, you will
find that thin paint
mixtures are the
easiest to control.*

WATCHER ON THE STERN
Acrylic on Masonite,
36 × 48" (91.4 × 121.9 cm),
1968. Collection of
Christopher Newport
University.

*Precise drawing
and clean, sharp
contours require
careful planning
and concentrated
rendering. This
example illustrates
how even edges
painted with a
brush can convey
sharp-focus reality.*

**Arthur Carter,
UNTITLED ABSTRACTION.**
Acrylic on composition board,
24 × 16" (61 × 40.6 cm).
Collection of Joyce Howell.

*Virginia artist Arthur
Carter's hard-edge
abstractions are widely
appreciated for their
precision and beauty of
pattern. He laid out the
hard-edge grid for this
Mondrian-inspired
painting with masking
tape, filling in the
resulting rectangles
with red, yellow, blue,
and white paint used
directly from the tube
and moistening his
brush occasionally to
smooth out the color.
When the paint was
dry he removed the
tape, a process
facilitated by a hair
drier. Using various
values of purple,
orange, and other
colors, Carter applied
dots of paint over the
entire composition in
the Pointillist style
of the French painter
Georges Seurat
(1859–1891). The
general idea behind
Pointillism is that the
eye blends the separate
dots of color to see a
resulting third color.*

MAKING THE MOST OF YOUR BRUSHES AND KNIVES

Every brush has its specific purpose and place. It is easy to get the idea that the artistic magic is in the brush, especially when you are observing a skillful practitioner. As a result, the beginning painter may become the owner of a profusion of brushes, only to find that they are merely tools, and that the magic is all in the artist.

Many painters fail to make full practical use of their brushes, mistakenly thinking that a different brush is required to create each individual shape, form, and detail in a composition. If you study the illustrations here, you will see the variety of lines, shapes, and patterns that can be achieved by making full use of only a few brushes. The edges and sides of brushes can be used, and brushes can be pushed, punched, dragged, and slapped across a surface. Big brushes can cover large areas quickly with paint, but they can also make fine lines and subtle textures, too. Smaller brushes can be pressed against a surface to produce wider strokes. Palette knives can be used to incise textures into the paint, push it around, and even create fine lines.

Becoming aware of the expressive potential of brushes and knives and putting this potential into practice will add to your enjoyment of painting and reduce the number of implements you need to just a few basic ones, plus a few for special purposes and situations.

DEMONSTRATION

As illustrated here, brushes are far more flexible than many artists imagine. Getting the most from your brushes helps broaden your expressive capabilities.

Pulling the brush creates different marks from pushing it. As you can see in this and the next illustration, making the strokes graduate from small to large as they move from the background to the foreground at the bottom of the picture helps suggest depth and distance.

Slapping the brush against your painting surface is another texturing technique. To successfully simulate tree foliage, I load the broad, flat side of a stiff-bristle #12 flat brush with paint and slap it against the watercolor board.

When flattened, a good flat or bright can pull a consistent, fine line. Use the end edge, as I am doing here, for tree trunks and limbs.

I begin the meadow with a 2" flat brush using an upward pushing stroke. For this exercise, I thinned the paint with water and, to avoid mistakes, first practiced my brushstrokes on a test sheet to make sure the viscosity of the paint was right.

I create the smaller tree by slapping the narrow edge of the brush against the board. Notice how these marks are different from those made with the broad, flat side of the brush.

The broad flat edge of the brush produces a sharp, straight edge for the cabin wall.

Using a punching motion to apply paint, as I do here, is sometimes called stippling. The resulting marks differ from those made using other brushing techniques. Here, I use a brush with stiff bristles.

Here, I use the dry-brush technique, dragging a brush from which most of the paint has been removed to suggest roofing material and define the plane and direction of the roof form.

I use the dry-brush technique again to render the shadows on the cabin walls. I created the window in just two strokes with a loaded bright brush of the appropriate width.

I use a liner or trailer brush for the bare tree branches.

The liner can also be used with the slapping method to simulate stalks of vegetation. Inventive experimentation with your brushes can lead to the discovery of other useful brushing techniques.

LAYERING

Paintings fall loosely into two broad categories: single-layer and multiple-layer. Very few paintings are completely single layer, and most layered paintings have some single-layer areas in them.

A single-layer painting is one that is painted, and basically completed, one area at a time. Pictures like this are often begun with a drawing on the working surface; the artist then renders each shape and form individually with little or no overlapping of paint. For pictures consisting mainly of large areas of color with a few smaller details, this can be an efficient way of approaching a subject. Paintings executed *alla prima*—in a single session with no preparatory stages—or wet-in-wet are also single-layer because the colors are mixed *with* one another rather than layered one *on top of* another.

Transparent watercolor lends itself to single layering and to a layering sequence of working from light to dark. Artists who practice this method gradually become used to thinking in terms of single-layering—of painting around, or masking, light or white areas first, to preserve the white of the paper, and then addressing the darker sections of the work. In the transparent painting technique, the layering sequence must proceed from light to dark because the light value of the surface provides the light values in the picture.

By contrast, the great majority of multiple-layer paintings are opaque in concept and the layering sequence is one of the artist's choice. It could be from light to dark, dark to light, or starting with a middle value and working either way. Dark tones may be painted over light-value areas and, conversely, light tones may be painted over dark-value areas. The exception to this is transparent layering, as in glazing—when one color is placed over another, rather than physically mixed with it, to achieve the final desired color (this is discussed further in "Acrylic Painting Techniques"). Out of necessity, the sequence here would be from light to dark so that the dark tones do not overpower lighter ones.

The general procedure for building a multiple-layer painting is to "rough in" the large areas of the picture, covering the entire working surface with the basic colors and values, and then paint the smaller shapes and forms over this primary layer. Modeling, shading, and fine detail are added in the secondary layer. Finally, if appropriate, transparent colored glazes are applied over the underlayers to enrich the paint colors and increase their luminosity.

LAYERING SEQUENCES

Few would deny that building a house or any other structure requires some planning, in part to establish a logical order in which work must proceed. If it were to be a two- or three-story house, the foundation and the lower floor would have to be constructed first. Planning the order, or sequence, in which areas of paint are to be applied to a surface is equally crucial if you hope to build a successful picture. Understanding the proper sequence and putting it into practice can make the painting process easier and more effective. Working in a logical order can prevent your having to start over and will eliminate some of the frustration that comes with not being sure of what to do next.

Failure to select the best working sequence for a picture can also cause unnecessary problems. For instance, suppose your subject is a bare tree silhouetted against the sky. The pleasure taken in first drawing the tree and then carefully painting every limb and twig (and there are many) soon turns to chagrin with the realization that you must now paint the sky around these delicate details, which means you probably will destroy some of them in the process. This is a sequence problem. Working in the proper order, you would paint the sky first and then layer the tree over it. Your order should be logical and practical.

THE BLUE BOOK
Acrylic on Upson board,
6¹/₄ × 7¹/₄"
(15.9 × 18.4 cm).

This single-layer picture was painted alla prima, *in one painting session with no preparatory sketches, using the wet-in-wet technique. While the paint applications vary in thickness, there is essentially no layering.*

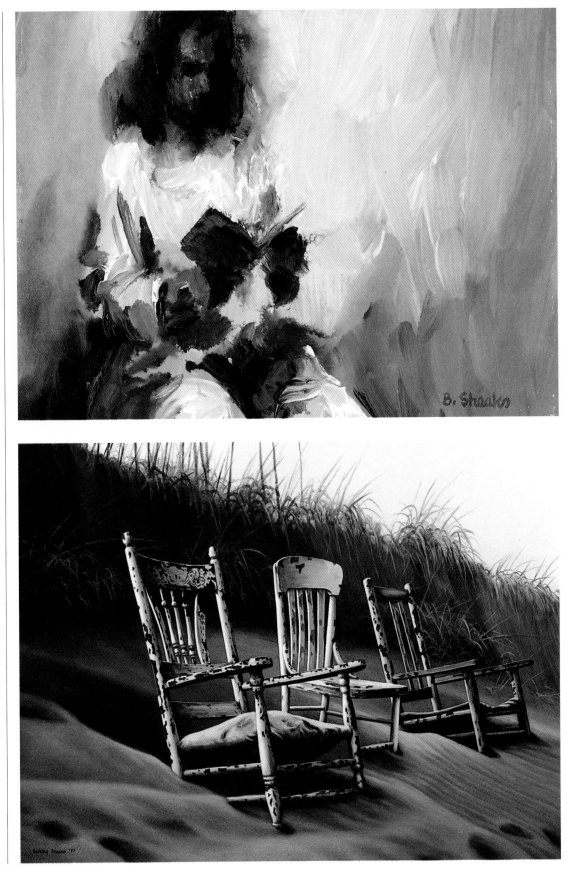

WATCHERS BY THE DUNE
Acrylic on Masonite,
30 × 40" (76.2 × 101.6 cm),
1977. Collection of Sue
Bartley Myers.

The layering sequence was important in the creation of this painting. The sky had to be completed before the dune grass could be painted against it. Sand and grass were then painted and allowed to dry thoroughly so that the chairs could be rendered over them. Layering was even involved in creating the chairs; they were first painted a flat white and then completed with the application of shadows and flaking paint.

USING SURFACE TEXTURE AND TONE

The use of surface texture within a composition can greatly enrich a painting, aid in the rendering of form, and simulate or suggest both natural and man-made textures. Experienced artists select their painting surfaces accordingly, watercolorists choosing rough-textured paper, for example, and oil or acrylic painters choosing coarse canvas.

Taking advantage of surface texture basically involves the dry-brush technique, in which paint is brushed or dragged lightly across the painting surface so that it adheres only to raised areas, without filling in recesses. This effect depends on the texture of your painting surface, which may be inherent (like the "peaks" and "valleys" characteristic of rough watercolor paper) or the result of brush marks in any underpainting. Where and when to use this technique will be dictated by trial, error, and experience.

Surface tone can also play an integral role in your paintings. Artists working in transparent watercolor customarily paint on white paper, letting its light surface serve as the lightest value in their compositions. But in other modes of painting, you can apply the same concept to working on a colored surface, incorporating its hue and/or value in your picture. For example, if your subject is an autumn landscape dominated by halftones, you might find it advantageous to work on a surface that has been toned with a medium-value brown, taking its color and value into account when planning the sequence for applying layers of paint. For artists who paint outdoors in the glare of the sun, working on a toned surface is a welcome relief for the eyes.

MOUNTAIN MEADOW (detail)

This detail illustrates how I highlighted the underlying texture of the meadow area by dry-brushing a lighter-value color over it.

MOUNTAIN MEADOW
Acrylic on Upson board,
18 × 24" (45.7 × 61 cm).

This painting combines a lot of textured layers, many of which are the result of my trying to find the right direction for the composition. I define the "right direction" as a successful compromise between what I wanted and where the painting wanted to go. Rather than waste this underlying texture, I emphasized it where descriptively appropriate. Here, the texture contributes to the natural, earthy feel of the meadow.

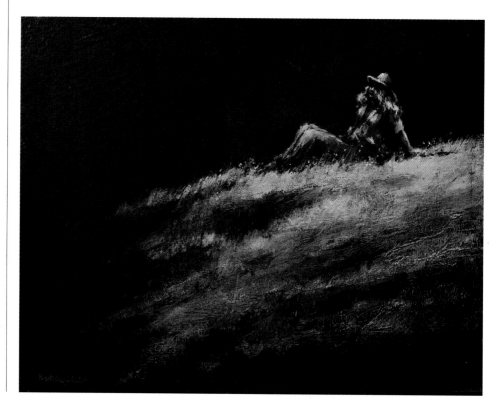

TABLE BY THE WINDOW
Acrylic and lithography crayon on Upson board, 9³/₄ × 13" (24.8 × 33 cm).

I primed my support for this painting, an Upson board panel, with acrylic gesso using a smooth roller, applying the paint from top to bottom with an up-and-down motion that left an interesting striated texture. I first sketched the subject with lithography crayon and then applied the initial layer of washes over this. For subsequent layering and highlighting, I dry-brushed paint over the ridged texture to create the vertical linear effect.

WALK IN THE SURF
Acrylic on Masonite, 36 × 48" (91.4 × 121.9 cm), 1983. Collection of Dr. and Mrs. Glenn H. Shepard.

Semiopaque washes and transparent glazes allow the brown tones of the unprimed Masonite to function as an integral color in this picture.

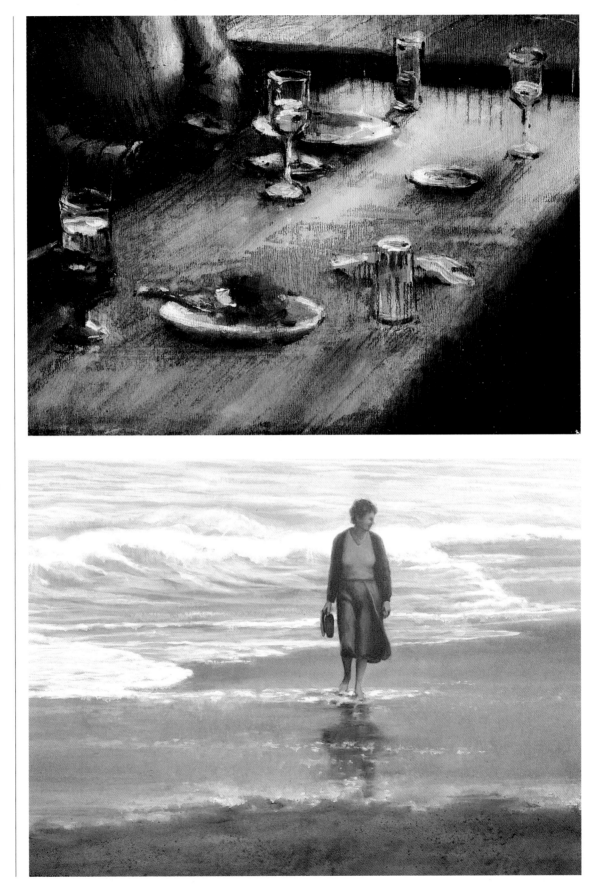

SCRAPING, SCRATCHING, AND ABRADING

These methods of manipulating paint on a surface can result in some interesting effects. Scraping is a technique in which you remove layers of paint to expose areas of underpainting or the support itself. A palette knife is perhaps the best scraping tool; you can use the tip of the blade to create linear effects and the long edge to make broader sweeps. Some artists even use a plastic credit card for this purpose. In order to work effectively, scraping must be done while the paint is wet and is best accomplished on a surface, such as paper, that can remain saturated for an extended period. For this reason, the technique is often associated with wet watercolor-style painting. Gessoed canvas and panels do not become saturated and acrylic paint dries quickly on them, thus limiting the time during which scraping can be done successfully. On such supports, the scraping technique works best with thick paint applications, which take longer to dry.

Scratching is similar to scraping but is done after the paint has dried. It is most effective when used to texture thin washes of color and does not work on thick layers of paint. A good tool for this technique is a utility knife, single-edge razor blade, or other sharp, pointed blade. (Make sure it is very sharp or it will drag, yielding poor results.) An excellent material to work on is hardboard primed with acrylic gesso; by scratching through color applied to this ground, you can produce strokes and fine lines in a manner similar to working on scratchboard.

Abrading, best accomplished with sandpaper, is a means for removing dried paint from a surface to soften the edges of forms or create texture. As with scratching, this technique is most effective when used on thin paint layers.

WATERSCAPE STUDY
(detail)
Acrylic on Strathmore 140-lb. watercolor paper, 18 × 24" (45.7 × 61 cm).

For this painting, I used acrylics in the manner of transparent watercolor. With a palette knife, I scraped into the paint while it was still wet to produce the lines, highlights, and texture you can see in the tree trunks, bushes, grass, and water ripples. After the painting was dry, I abraded the bushes with sandpaper to simulate the texture of their foliage.

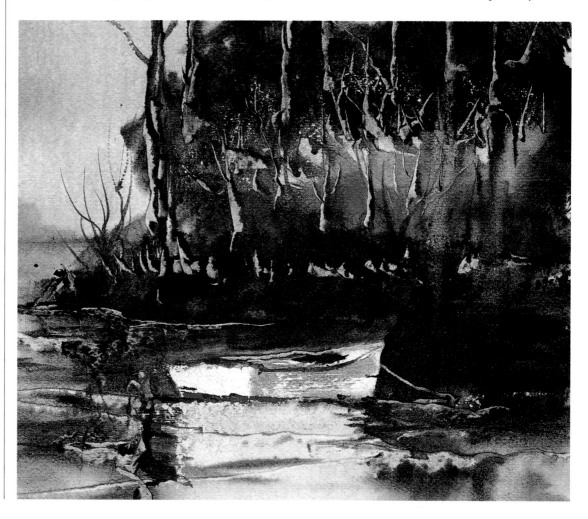

AUTUMN MARSH STUDY
Acrylic on canvas board,
6 × 8" (15.2 × 20.3 cm).

By scratching the paint with a utility knife, I was able to create the light sparkles in the sky and water. The thin paint layers were easily lifted, exposing the gesso-primed canvas board underneath. The effectiveness of this scratching technique is dependent entirely upon the color and value of the underlayer.

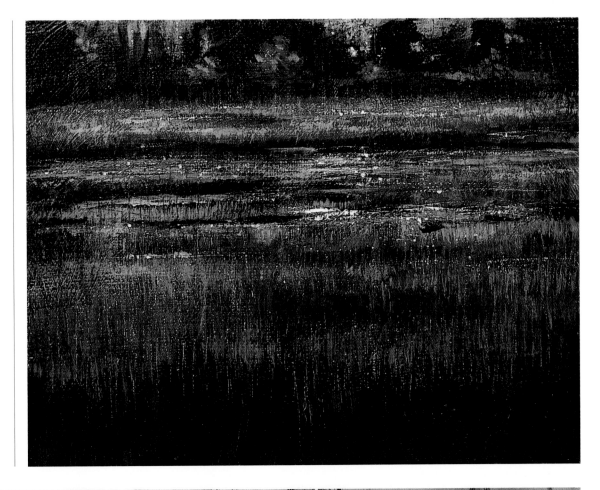

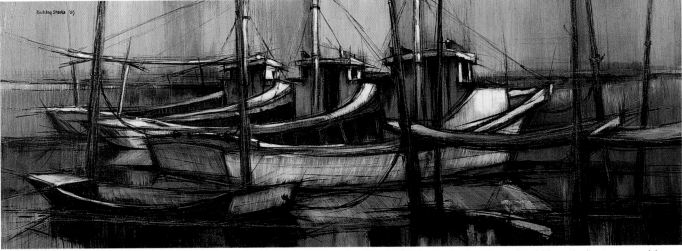

OYSTER BOATS
Acrylic on Masonite,
12 × 36" (30.5 × 91.4 cm),
1965. Collection of Dr. and
Mrs. Glenn H. Shepard.

In the late 1950s and early 1960s, I experimented with using the natural color of unprimed Masonite in my compositions. In this painting, it provides the brown tones. I also scratched and incised lines into and around my subjects using an ice pick. The light brown lines here were created in this manner after the paint was dry. The dark lines were made with a liner brush.

DRIPPING AND SPATTERING

As mentioned earlier, the most common method of applying paint to a surface is with a brush or palette knife. However, some artists incorporate more unusual procedures with beautiful results. Two examples of this are dripping and spattering, which are fundamentally the same process. The main difference is that dripping makes greater use of gravity, while spattering involves propelling paint by force. Pioneered in the 1950s by the action painter Jackson Pollock (1912–1956), these techniques can enrich a painting by creating interest and providing texture.

Dripping is accomplished by squeezing watery paint from a brush onto your surface. Another approach is to pour or dribble small amounts directly from a container; a jar with a lid that has holes punched in it works well for this. Spattering is done by flicking a stiff brush loaded with thin paint using your thumb or forefinger. You can also shake the loaded brush with a short, snapping motion of your wrist or strike the ferrule against a firm object, like another brush handle, to fling paint onto the surface. Still another method is to drag a stiff, loaded brush across a screen to produce small, even spatters. These techniques can be used on either wet or dry surfaces for interesting visual effects. Drips and spatters applied to a dry surface can be softened while still wet by spraying them with water from an atomizer.

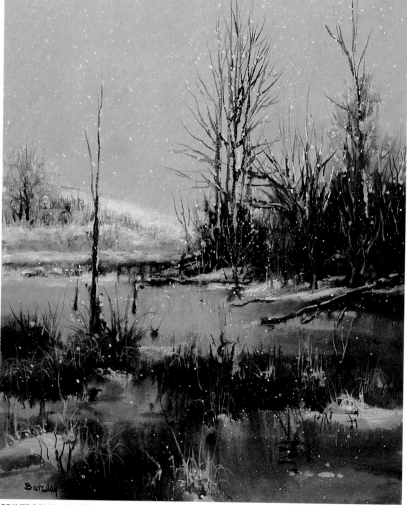

BEAVER POND—WINTER IN THE MOUNTAINS
Acrylic on Upson board, 15 × 18" (38.1 × 45.7 cm).

I rendered the falling snow in this study by flicking thin white paint onto the dried surface of the nearly completed picture.

Flicking is a way of applying droplets of paint to a surface. A slightly stiff brush that has some spring to its bristles is best for this purpose. Simply load the brush with thin paint, pull back the bristles with your thumb, and point them at the intended area, then release them with a flicking motion. It is best to practice this technique on a test surface before attempting to incorporate it in a composition.

Another way of applying droplets of paint to a surface is to strike the ferrule of a loaded brush against a solid object, such as another brush, as illustrated here. This technique is called spattering.

**Sue Bartley Myers,
BRIDGES**
Acrylic on 300-lb.
watercolor paper, 57 × 39"
(144.8 × 99.1 cm), 1994.

*A lifelong resident of
Norfolk, Virginia,
Sue Bartley Myers
considers herself
primarily an abstract
expressionist. Her
favorite medium is
acrylic paint because
it dries quickly and
lends itself well to her
style of fast action
painting.* Bridges *is
a good example of
the way she currently
works. First, she
soaked a sheet of
300-lb. watercolor
paper with water
and, while it was still
wet, applied a wash
of yellow-orange over
the entire pictorial
space. Working
quickly, she then
flung and spattered
paint onto this fluid
surface to find a
dominant rhythm
for the composition.
This technique,
combined with rapid
brushwork, was used
to develop the picture
to completion.*

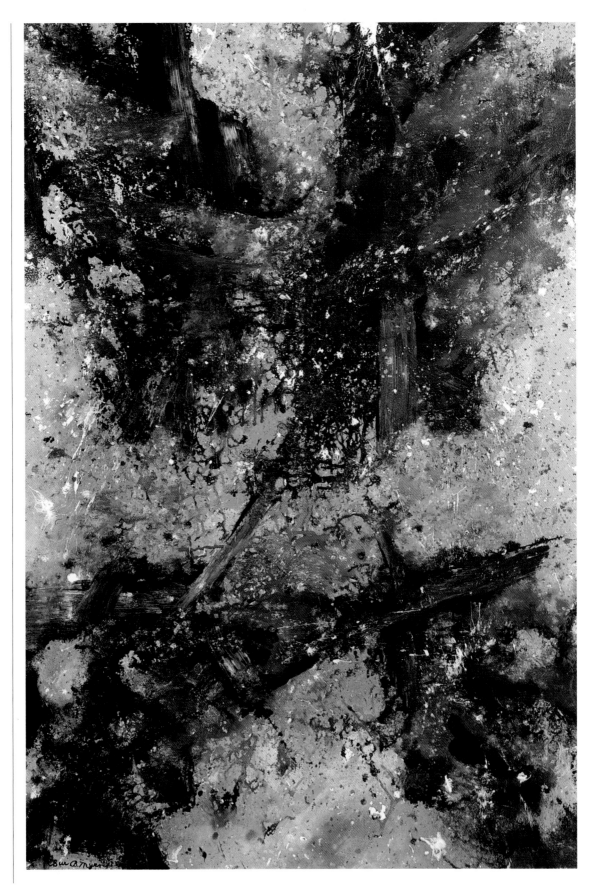

SPRAYING

When properly done, applying paint with an airbrush (or even with a regular paint sprayer, which is less versatile) makes it easy to attain subtle gradations of color and value, soft edges (as in rendering clouds), and certain atmospheric effects, any of which can be used in combination with traditional brushwork. There are acrylic paints made especially for airbrush work, but the regular liquid and paste colors can be used just as well, as long as you thin them with a 50:50 mixture of either gloss or matte medium and water. Thinning with water alone can result in a weak paint film that lacks adhesion and may crack or peel when dry. The consistency that your paint formula should have for spraying will depend somewhat on the airbrush (or other sprayer) you use, as these tools can vary in their requirements. The ideal mixture is one that is as thick as it can be and yet still go through the sprayer to create a fine mist. To help prevent clogging, it is a good idea to strain the mixture through a finely woven material, such as a piece of nylon stocking, prior to filling the sprayer's paint reservoir.

During the spraying process, the orifice of the sprayer might become clogged from a buildup of dried paint. When this happens, clean the sprayer by scrubbing it with a stiff brush dipped in soapy water. Spray fresh water through the sprayer at frequent intervals to avoid paint buildup that can cause clogging; an opportune time to do this is when you are changing colors. Always wear a mask when spraying to guard against health hazards posed by ingesting airborne paint particles.

Areas of a painting that are not to be sprayed should be covered with masking tape or frisket film. Upon completion, airbrush paintings should be properly finished with several protective coats of medium/varnish. Due to their thin, delicate paint films, unvarnished airbrushed surfaces are easily damaged and very difficult to repair, and a small scratch may require the repainting of an entire area.

As with any painting mode or technique, learning to paint successfully with an airbrush or a paint sprayer requires skill-building practice. For the artist who elects to learn these skills, the rewards are unique visual effects that are not attainable by any other means. Spray painting will open a doorway to new expressive possibilities.

MY CAR—BOBBY
Acrylic on Masonite, 36 × 48" (91.4 × 121.9 cm), 1970.
Collection of Dr. and Mrs. Glenn H. Shepard.

RUNNING ON THE DIRT PILES
Acrylic on canvas, 24 × 36" (61 × 91.4 cm).
Collection of Christopher Newport University. Gift of Sue Bartley Myers.

In this picture, I tried to keep any texture or painterliness from interfering with the image itself and the idea behind it. To that end, I chose to work on smooth, gesso-primed Masonite, carefully executing my forms with thin paint applications using both an airbrush and traditional brushes. The airbrush was ideally suited to my expressive purpose because it allowed me to render gently graduated shadows and create subtle variations in value in a way that no other method could.

Without question, the airbrush lets you create clouds and atmospheric depth and perspective in ways not possible with any other kind of rendering technique. For that reason, I chose to use this tool to paint the cloudy sky in this picture.

Bob Holland,
MOTHERHOOD ETERNAL
Acrylic on Crescent watercolor
board, 18 × 28" (45.7 × 71.1 cm).

Bob Holland is both an industrial designer and a fine artist who makes his home in Chesapeake, Virginia. For this painting, he first primed his surface (watercolor board) with black gesso. He then applied the first area of color in the flower blossoms, and this, in turn, dictated the hue for the pyramids and, indeed, the entire painting. The good coverage and quick drying time of the acrylic paint allowed Holland to easily change hues, values, or intensities as he worked. After finishing the foliage, he added the small planet to improve the composition and enrich the symbolism of his artistic statement.

At this point the piece was essentially finished, but Holland decided to use an airbrush to give the sky area a pinkish aura and subtle gradation of value. Before airbrushing, he saved the pyramids and plant details by covering them with masking fluid. The fact that no damage occurred when he peeled away this dried liquid is further proof of the strength and versatility of the acrylic medium. The final result is a subtly blended atmosphere attainable only through the airbrushing technique.

Nontraditional Paint Applicators

Brushes, palette knives, and airbrushes are not the only tools for applying paint, although they are by far the most popular. Sometimes other, less traditional applicators can prove useful for certain purposes. They can also facilitate the creation of unusual visual effects that would otherwise be difficult to achieve.

Years ago, an artist friend of mine was painting a sandbar covered with standing seagulls, the birds all facing into the wind and each a carbon copy of the other. In a moment of creative insight, he cut a flat gull-shaped silhouette from a potato, dipped it in paint, and stamped the bird shapes where needed in his composition. Then he used the brush to suggest the details. The results were surprisingly good, and, more importantly, an idea was born. Of course I tried it—not for birds but for flowers. I cut daisy shapes from cardboard, applied wooden handles to them, and used them as stamps. And, as you can see in the painting below, they worked! This type of tool has all sorts of creative potential.

Sponges dipped in paint are often useful for rendering tree foliage and sea foam. Crumpled paper towels or rags can also be stamped or pushed against the painting's surface to simulate foliage, vegetation, and clouds. Pieces of carpet can make a variety of marks and textures. The list of nontraditional painting tools is endless.

You can use these kinds of tools with both thick and thin paint mixtures. Which to use, and where and when, will depend on the nature of the applicator itself and the desired visual effect. A little experimentation is the best teacher.

I executed this tree foliage with a crumpled paper towel, which I coated with paint and pressed against the background in a stamping motion. I used a small piece of carpet as a stamp to create the ground beneath the tree.

DAISY FIELD
Acrylic on Masonite, 30 × 40" (76.2 × 101.6 cm).
Collection of the Honorable and Mrs. J. Warren Stephens.

There was a field not far from my summer studio in Poquoson, Virginia, that came into bloom with yellow daisies every autumn. It was so luminous that even on an overcast day it looked as if the sun was shining. I had to paint it. I began with the background and then applied the flowers over it. I made some flower-shaped stamps out of cardboard and spread undiluted paste paint in various yellows on my palette, then dipped the stamps in the paint and applied them to my composition.

A soft rubber roller is a versatile tool that can be used in both wet-on-dry or, as in this example, wet-on-wet techniques. I rolled on a magenta color, and, while it was still wet, applied white and purple over it. The white blended with the magenta, and the purple covered it. I achieved the linear texture by tilting the roller and pressing its sharp edge into the paint.

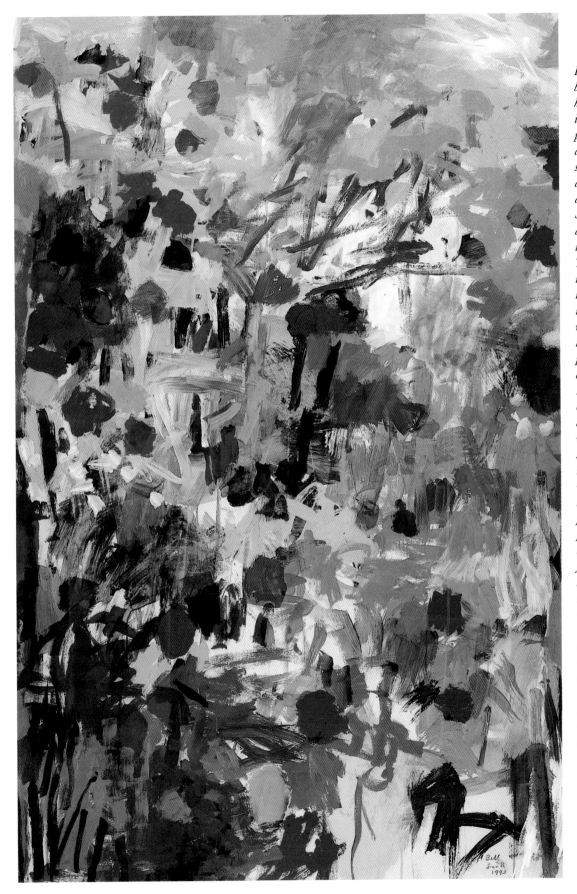

Bill Scott, MAY
Acrylic on museum mounting
board, 60 × 40"
(152.4 × 101.6 cm), 1993.

*Bill Scott, a Philadelphia-
based artist and writer,
had always painted
in oil, watercolor, and
pastel, but took up
acrylics in 1991 while
sharing studio space with
another artist who was
allergic to oil paint.
Scott found that he loved
acrylics and has been
using them ever since.
This composition, with
its lively spring garden
imagery, has the fresh,
improvisational feel of a
work executed quickly on
the spot, but in fact was
painted indoors over the
course of several months.
Its spontaneous quality
owes much to Scott's
approach to the medium,
which is to follow no
set methods, working
intuitively and using
whatever techniques and
tools serve his expressive
purpose. He uses his
paints (preferring Golden
acrylics) straight from the
jar with only water for
his mixing medium.
Besides brushes, he paints
with cotton swabs and,
as he works, often blots
excess paint with a piece
of newspaper to avoid
the texture of built-up
acrylic; any unwanted
areas that have dried he
wipes off with rubbing
alcohol.*

PLANNING PAINTINGS

Basic skills and techniques notwithstanding, an important aspect of every successful artistic project is the practice of advance planning. Even the most instinctively direct and impromptu approach to the creation of a picture requires some planning, which may be simply the mental activity of selecting the subject and painting surface, and determining the size and format. The amount of planning required will vary with the needs and objectives of each artist and project. Obviously, there is a major difference between the planning required for a small, quickly executed study and a large, more complex composition.

It is, of course, true that some artists work best by doing careful and extensive preliminary planning, while others find it a hindrance to the creative process. For me personally, it depends upon the individual subject and my overall intent for the finished picture. I do not like the outcome to be overly predetermined. Solving all of the pictorial problems beforehand, through detailed sketches, for example, diminishes my desire to continue; part of my creative joy stems from allowing for changes and adjustments as the picture progresses. During this process, I try to listen to what the picture tells me it needs.

A great number of artists who work in both realistic and abstract styles make extensive use of photographs as reference material for planning paintings. While serving as valuable aids, they are no substitute for on-site sketching and observation. They are, however, a convenient additional means for gathering information that might help in planning a composition. A single photographic image is almost never complete enough to translate directly "as is" into a finished painting. The subject or objects in a photograph seldom appear as clearly as they do in reality, and a candid snapshot usually lacks enough structural strength or definition. As useful as it may be, the visual information in photos (as well as that in on-location observations and studio situations) needs some organization and adjustment in order to convey the best aspects of the subject. Knowing and using basic design principles will vastly improve your finished product. While approaches to planning differ according to the individual, some deliberation can assist you in making certain decisions that will focus your thoughts and feelings about a picture, helping you to get off to a good start. To learn how to plan more efficiently, study the four prepainting considerations presented here. Experimentation will further enable you to determine which are most appropriate for a particular painting's needs.

SUBJECT AND MODE
The impetus for most realistic pictures begins with the subject, and the painting develops from there. In some instances you might not have a clear idea of your subject. Making preliminary subject sketches or color studies might bring a subject to mind. If not, then perhaps an abstract or semiabstract mode would serve you best. Sketches that establish the division of space, placement of forms, and compositional movement can bring a painting into focus.

FORMAT
The size and shape of a picture are important design considerations. They are often determined by various circumstances, including subject, painting style, and composition. The format should compliment the subject.

A quick, sketchlike painting might be best expressed in a small format. A complex, highly developed theme could require a larger format. Also, a small format might be more convenient when you are painting on location under difficult conditions. Size choice could also be prompted

**Study for
BORROWED LIGHT**
Acrylic on Upson board,
24 × 18" (61 × 45.7 cm).

My first idea for this composition was to use a vertical format with emphasis on the upward thrust of the tree. As the study progressed, I became increasingly interested in the luminosity of the water, the background trees, and the light coming through them. To show more of these aspects, I adapted the subject to fit a horizontal compositional format that became the final version at far right.

simply by the desire to create a painting of certain dimensions.

The human eye naturally follows shape. For example, a tall, vertical rectangle leads the eye upward; so, tall subjects such as trees, mountains, or even standing figures might be best presented in a vertical format, which accentuates their physical drama. Similarly, a horizontal pictorial space can convincingly express the breadth and distance of a panoramic land- or seascape. The square is a solid and sturdy shape; consider how it combines characteristics of both the vertical and the horizontal format. It can allow the thoughtful artist to suggest both height and width in one composition, as with high mountains in a broad landscape. The circle and the oval are more distinctive in appearance. The rounded contours of these targetlike shapes tend to focus the viewer's attention toward the center of a composition, which is why they are often used for portraits. Explore these possibilities in preliminary sketches.

STYLE AND TECHNIQUE

Establishing a satisfactory personal painting style is very important, and how you plan to interpret or present the subject will be a determining factor in the selection of this style. For example, the subject could be represented in sharp focus with exacting detail, or in a softer, less well defined manner. Ask yourself the following questions: Will the emphasis be on strong, three-dimensional shapes and forms, or on flat patterns? Will paint applications be thick like impasto, thin like a watercolor wash, or a combination of the two? Which color combination should I use? In posing and answering these questions, you are well on your way to determining the most appropriate painting style for any given project.

SURFACE

The support you choose to work on is often determined by the painting technique you use. Paper is appropriate for a picture to be executed in a watercolor style; thicker paint applications, mimicking oil painting, suggest canvas; and the egg tempera approach works best on hardboard. The texture of your surface can be an important factor because of its effect on the appearance of the paint and, therefore, the overall picture. For example, a canvas with a coarser weave may show through the paint more. Select a support that relates best to the kind of painting you envision.

BORROWED LIGHT
Acrylic on canvas, 36 × 48"
(91.4 × 121.9 cm).
Collection of Mrs. Harry E.
Ramsey, Jr.

As illustrated by this picture and the study for it at left, a finished painting often differs considerably from the original concept. Although the subject in both illustrations is the same, the two pictures lack similarity in style and execution. The study is rendered in a free and spontaneous manner, while this final version is more detailed and restrained.

PRELIMINARY SKETCHING

As mentioned briefly before, preliminary sketching can aid the artist in making important prepainting decisions, thereby clarifying subject matter and preventing errors in composition. This initial step will help eliminate much needless overpainting. Certain types of painting, however, require little or no

Color inspiration can easily come from nature and the environment. The bronze and black of a wild turkey feather is a harmonious color combination that could very well serve as a starting point for a painting.

COLOR SKETCH FOR A LANDSCAPE PAINTING
Acrylic on typing paper, 6 × 5³/4" (15.2 × 14.6 cm).

This small, abstract color study took only a few minutes to complete. It helped me in the selection of basic colors for a larger landscape painting.

preparatory sketching. For example, some pictures themselves are sketchlike in character; the visual evidence of trial and adjustment, search and discovery, and spontaneity is an important part of the final result.

Sketching can also serve different planning purposes. Compositional studies can be thought of as placement guides for subject and forms. Experimenting with basic format shapes helps you determine whether your painting should be vertical, horizontal, square, or round. Adding light and dark tones is a way to investigate possibilities for interesting value patterns. Color studies aid in the selection of color for mood and dominance. Subject studies lead to a greater understanding of details for authentic depiction. Most artists prefer sketches to be brief yet descriptive enough to capture the essentials. In this way, they avoid peaking (doing their best work) in the sketch. The painting is then the full climax rather than a repetitious rendering of a study.

Soft drawing pencils (numbers 2B, 3B, and 4B) and sketch paper or pads are the traditional materials for on-location sketching. Pastel, oil pastel, colored pencils, and paints can be used for color studies. Color studies may be quick miniature sketches of subjects or simple abstractions in which trial combinations of colors are placed next to each other and the results analyzed. Pieces of color torn or cut from construction paper or magazine illustrations are other, easily available resources for color experiments. Color charts from paint stores are yet another source of color samples.

In the interest of expanding creativity and expressive directions during the planning process, give some thought to working in a format whose proportions might not be the most obvious choice. It is easy to become conditioned to envisioning pictorial representations exclusively in tried and true formats such as 9 × 12", 18 × 24", and so forth. Why not try rectangles that are extremely long and narrow? They can be used either vertically or horizontally. The square, circle, and oval are also worthy of examination. The circular format especially offers a challenge and refreshing change from the tedious confines of the rectangular frame. As you experiment with these less widely used compositional formats, also study the illustrations in this section. They highlight just how invaluable prepainting planning and sketching are to the creative process.

This abstract color study, made from a photograph in a magazine, provided the palette for my painting Morning Exercise *below.*

MORNING EXERCISE
Acrylic on panel,
7¹/₄ × 7¹/₄"
(18.4 × 18.4 cm).

The similarities in color between this small nude and the abstract study above are easily recognizable.

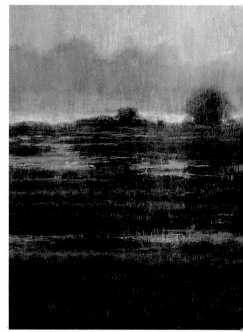

MORNING ON THE BIG MARSH
Acrylic on Upson board,
approximately 18 × 50" (45.7 × 127 cm).
Collection of the United States Navy.

The dimensions of this painting were dictated by its intended installation space—the bulkhead wall of the ward room on the nuclear attack submarine U.S.S. Newport News. I selected a subject that would offer welcome contrast from the confined and crowded environment of a modern, high-tech naval vessel. The narrow, wide format offered me the opportunity to create the appearance and feeling of a broad, open expanse of marshland and water as viewed through a wide window in a small room. Using the panoramic perspective of a view as seen from a great distance, I was able to accentuate the illusion of space and depth.

TIME EXPIRED
Acrylic on Masonite, 48 × 24" (121.9 × 61 cm), 1964.

A tall, vertical format was the most appropriate to emphasize the tall, narrow door and help suggest the crowded atmosphere of run-down tenement row houses.

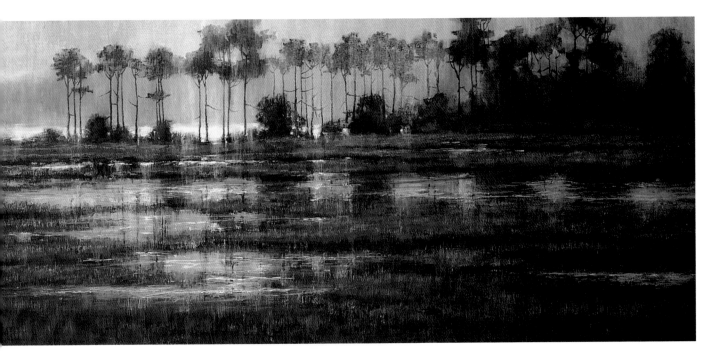

GENESIS I
Acrylic on Upson board,
18" (45.7 cm) diameter.

The round format has a tendency to focus the eye toward the center of the composition. It seemed ideal for a study of a killdeer nest I discovered near the beach at my summer studio.

DEMONSTRATION

The following demonstration breaks down the prepainting sketching process step-by-step to clearly illustrate what can be learned from the practice. Preliminary sketching takes only a few minutes and will not produce the kind of finished drawing that one would want to keep. It will, however, help you make a number of important design decisions.

When doing preparatory sketching to determine format, space division, and value domination (lights and darks), I always begin by drawing a rectangular frame near the center of my sketching space, leaving ample margins all around. This boundary is a reminder that I am composing within a specific pictorial area. It is intentionally light in value because I will build on it as the sketch progresses, and dark lines at this stage would prove distracting later on.

Think of these sketches as location maps for subjects. In this step, I have quickly scribbled placements and space divisions for a farmhouse on a hill with a tree beside it. I have also suggested some bushes in the left foreground.

By sketching a slightly larger frame over the existing drawing, I can see how the composition will look if I widen the pictorial space.

It is also possible to visualize the subject in a taller space by expanding the frame vertically. This is easier and much more efficient than drawing a separate sketch for each format.

To see how it will look in a circle, just select a spot to be the center of the composition, and draw a round frame.

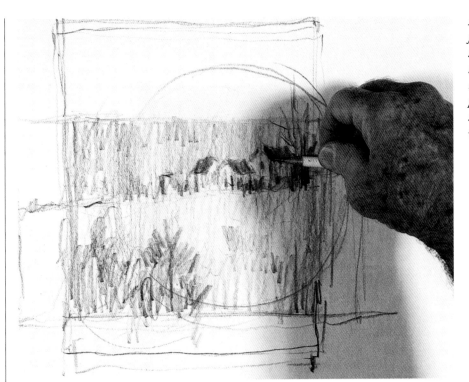

After trying various format shapes, I select one, darken that frame, and, using the side of my pencil, quickly add some light and dark values.

With three smaller sketches, I decide if the value domination should be light, halftone, or dark. The main important pictorial decisions have been made in less than 10 minutes, and while there may be little virtue in brevity for its own sake, spending only a minimal amount of time on this kind of preparation heightens my enthusiasm for actually painting the picture. However, you may want to spend a bit more time on your preliminary work; each artist must find what works best for him or her.

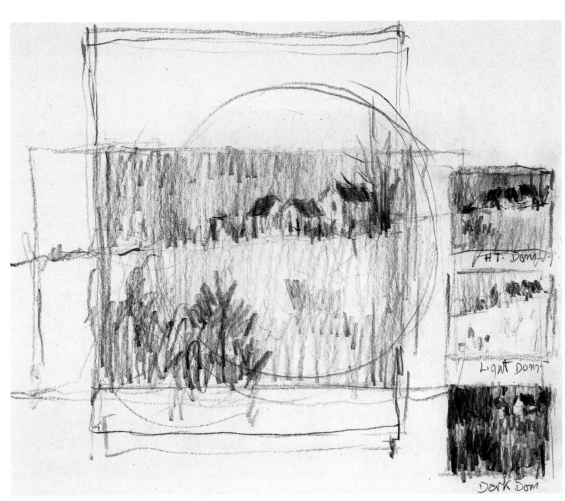

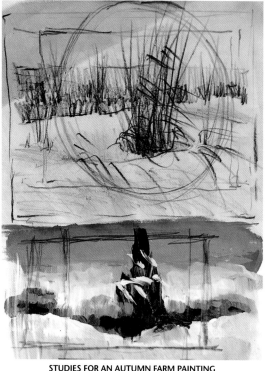

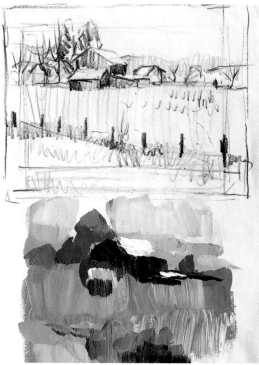

STUDIES FOR AN AUTUMN FARM PAINTING
Acrylic and pencil on typing paper, 11 × 8¹/₂" (27.9 × 21.6 cm).

STUDIES FOR A PAINTING OF BEACH GRASS
Acrylic and pencil on typing paper, 11 × 8¹/₂" (27.9 × 21.6 cm).

Preparatory studies do not always have to be carefully executed pictures. Here, a brief pencil sketch, to explore the basic composition and space divisions, and an abstract color study, to determine my palette, were all I needed to start the painting off in the right direction.

A number of preliminary planning decisions can be made in a brief span of time. In a few minutes I was able to visualize my subject in color and in several different formats.

STUDY FOR CEMETERY VISIT
Acrylic on construction paper, 9 × 12" (22.9 × 30.5 cm).
Collection of Mr. and Mrs. George Middleton.

A preliminary sketch might not always remain just a sketch, as this study proves. Originally, I had taken a photo of these brightly clad ladies in a cemetery on Gwynn's Island, Virginia. The sun was very bright and cast dark shadows. This pensive, preoccupied quartet appeared for a moment to be striding out of another era. I was so taken with the image that I decided to do a large painting of the subject and began with a small, quick study.

As the little picture progressed, every color and value went on perfectly. It was one of those rare moments when magic happened and each brushstroke, no matter how freely applied, fell into place. In less than an hour I had completed it, and complete it truly was. Although small, it captured the moment. There was no need for a larger painting. The study had become the finished work.

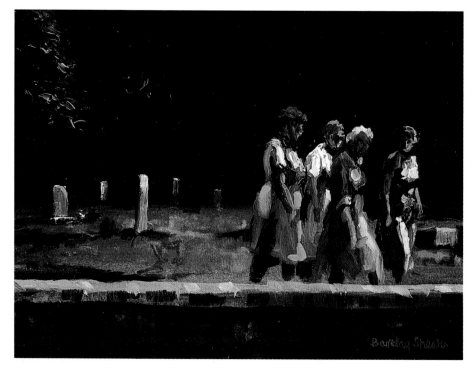

Drawing on the Painting Surface

One of the questions students and beginning artists ask most frequently is, "Is it all right to draw the subject on my surface before I paint?" The answer is, "Yes, but it all depends"—mainly on two factors: the type of painting and the artist's objectives. When you are working transparently, some sketching on the surface beforehand might be required; you must plan and save the white areas first or else they will be lost under subsequent paint applications. Painting opaquely is more forgiving, as it allows you to plan as you go and make more adjustments in your painting; it also lets you compensate for and repair "mistakes" with subsequent layers of color.

Your specific objectives for a picture (what you wish to achieve with it) could also necessitate preliminary drawing directly on your surface. Obviously, subjects to be executed in a precise manner with exact proportions would require some sort of preparatory sketch. Some artists feel more confident about approaching a painting if they draw the composition on the surface beforehand, and there is nothing wrong with this if it does not restrict the painting process. Painting all the details (both large and small) of a carefully executed drawing in one single-layer can become a clumsy and awkward procedure; therefore, when you need a complex, outlined guide for a picture, you should render stages of the drawing in sections. This is easily accomplished with rapidly drying acrylics. For example, in a landscape painting the large areas of sky, land, and water could be roughed in (or even completed) using only a few basic guidelines on the surface. Once this underlayer is dry, you can draw any necessary details—individual trees, houses, people, boats, and the like—on top of it. This eliminates the tedious task of painting around every drawing detail as you complete your picture. This layered approach, coupled with some thoughtful planning, can help make the whole painting process easier and more enjoyable.

The tools and procedures you use when making preliminary drawings are important considerations as well. Refrain from drawing with anything that might later bleed or show through the paint layers—certain felt-tipped pens will do this. Charcoal is a popular choice. It must be treated with fixative before you paint over it, however, or else the drawing could smear and mix with the paints. Any clear, non-yellowing acrylic fixative in a spray can is satisfactory for this purpose. Pencil is also a common drawing medium. If you use a soft pencil (such as 4B or 6B) that is likely to smear, you should also seal it with a fixative. Another technique is to sketch, or rough in, the subject using a brush and neutral, light-valued paint. I often use a lithography pencil to execute my preliminary sketches; it will smear, but can be scrubbed out from the surface with a wet brush.

Sometimes in the process of drawing your subject and solving compositional problems, all of your changing, erasing, and adjusting results in a mass of lines and tones that dirty your surface and obscure details. To avoid this, it may be best with complex subjects to solve your drawing problems on a separate surface and then transfer the finished guide to your painting surface. To do this, choose paper that is both strong enough to withstand scrubbing and erasing, yet not so thick as to make the transfer process difficult. A good choice is an all-purpose drawing paper such as that used for drawing and sketching in pencil, ink, and wash. It is available by the sheet and in pads as large as 18 × 24". For larger compositions, tape the sheets together. Brown wrapping and shipping paper or white butcher's paper also work well for this transfer process and are available in larger sizes. Make sure that your sheet of paper is the same size as your intended painting. Draw your image on the paper, then turn this over and cover the back side with graphite, charcoal, or soft, neutral-colored chalk. Shake off any excess powder and gently tape the paper to your painting surface drawing side up. To avoid smearing, try not to let the drawing slip or shift. Using firm pressure, trace over the drawing with a sharp pencil or ballpoint pen. If it is a complicated drawing with lots of detail and was done in pencil, you might want to use a blue or red ballpoint for this, because the colored line will make it easy to tell whether you've skipped any areas. After transferring the drawing, remove it gingerly to avoid distortion.

To put preliminary planning and sketching into proper perspective, try to think of them as useful means to an end. They are like certain colors and brushes that, while not used all the time, are there if needed. Knowing about planning methods enables you to use them to your advantage and greatly improve your paintings.

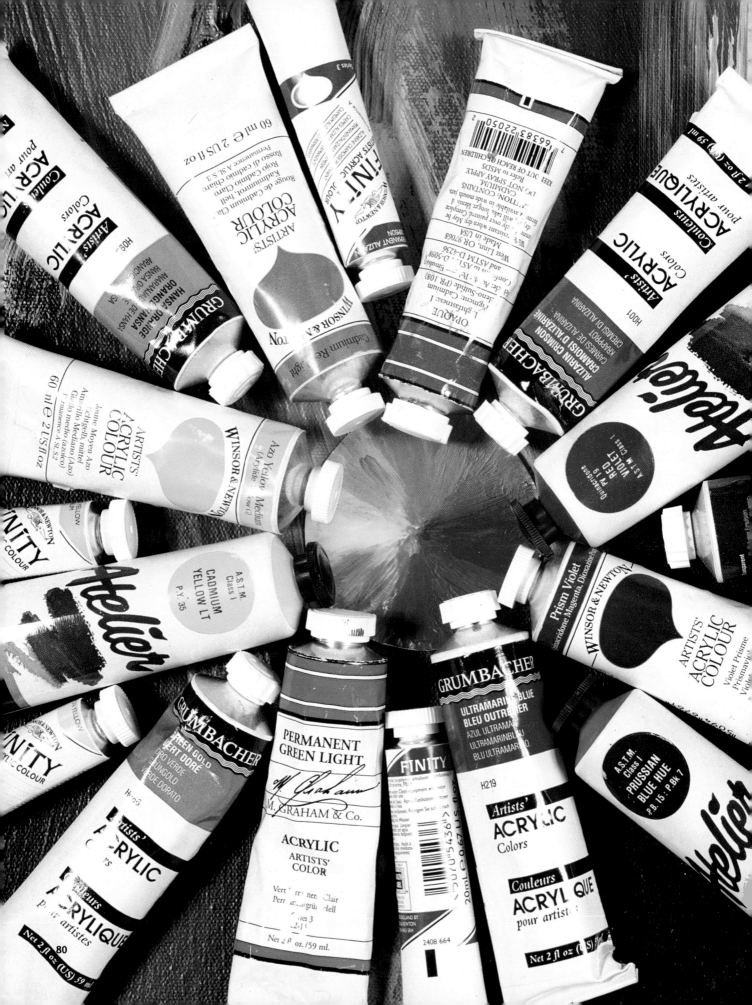

COLOR

T heories about color abound, and every successful artist and teacher has his or her favorite. Most beginning artists are not interested in highly technical color theory; they are more concerned with the practical aspects of color mixing. For example, they want to know how to make colors lighter and darker in value without muddying the mix and what hues to use for shadows and reflections. Knowing which colors to use in specific situations to attain the desired effects is very important.

Learning *how* is always more meaningful when accompanied by a little explanatory *why*, and so in this chapter we will examine the basic characteristics of color, together with some practical color theory to broaden your overall understanding of color and enhance the visual interest of your work.

UNDERSTANDING COLOR

When we see colors, we are experiencing an optical response to reflected light waves. White light can be separated into the seven colors of the spectrum, each with its own unique wavelength. All objects either reflect or absorb these light waves, and the reflected waves are the colors we see. For example, a banana appears yellow because it absorbs all waves except the yellow ones, which it reflects back at us.

In art, color is used to create moods, provoke emotional responses, lead the eye through a painting, and define depth and form. To use color to its fullest potential, you must understand some basic color terms.

- *Hue.* Used interchangeably with the word *color*, a hue is simply the color's name, such as blue, light brown, cadmium orange, or sap green.
- *Pigment.* This is the mineral or other substance that gives color to a medium. In acrylic paints, these small particles of colored material are suspended in an acrylic emulsion binder.
- *Value.* Value (or tone) is the degree of light- or darkness of a color. The three basic values are light, half-value (often referred to as halftone), and dark. White and black are the extremes of value. If you want to alter the value of a hue, add white, black, or another color to it. For example, adding a touch of black or dark blue to red results in a darker reddish value. Value can greatly affect the mood of a painting.

- *Intensity.* Sometimes referred to as *chroma*, intensity is the brightness, purity, or power of a color. One way to keep color mixes clean and unmuddied is to use colors that are strong in intensity. Subdued colors can be strengthened if you mix them with bright colors, but always at the expense of dulling or weakening the brighter hue. For example, you might find that the burnt umber you used to render a brick chimney is too dull; mixing a brighter color such as cadmium red medium with the umber would intensify it.

THE PAINTER'S COLOR WHEEL

It would be difficult to find an artist who is not at least somewhat familiar with the traditional color wheel. The wheel is imperative to our understanding of the ways in which colors are grouped, the relationships between colors, and how different hues are mixed from the primary colors.

A typical artist's color wheel is composed of 12 colors. Red, yellow, and blue are the three *primary* colors and are so called because they cannot be mixed from any other colors. Mix any two of these in the following combinations to get the three *secondary* colors: red and yellow to make orange, blue and yellow to make green, and red and blue to make violet. The remaining six hues are the *tertiary* colors, which are mixtures of a primary and secondary color. They are red-orange, yellow-orange, yellow-green, blue-green, blue-violet, and red-violet.

A color wheel is comprised of the primary, secondary, and tertiary colors and shows the relationships among them. The primary colors are set equidistant from one another, with yellow here appearing at the top, blue at bottom left, and red at bottom right. These three colors are considered the foundation of the wheel because all other colors can be mixed from them.

Here, my rough blending technique serves to highlight the natural progression from one color to the next. The division in the two panels separates the colors by temperature. The cool hues are to the left, and the warm ones are to the right. (Color temperature is discussed more thoroughly on page 84.) A familiarity with the wheel will broaden your understanding of how to select and mix the most advantageous color combinations for a particular composition.

COLOR FAMILIES AND RELATIONSHIPS

Observing all the colors in position on the color wheel allows you to see all the color combinations available to you. Colors are grouped in various ways according to specific relationships, and it is helpful to keep these categories in mind when you are painting so that you can use color effectively.

ANALOGOUS COLORS

Also referred to as close colors, these are hues that are contiguous or near each other on the wheel and have one primary in common. These colors create a kind of harmony and pictorial unity when used as the main colors in a painting; in other words, they tie the composition together.

WILD PONIES—ASSATEAGUE
Acrylic on Upson board, 18 × 24" (45.7 × 61 cm).

My choice of reds, oranges, and yellow-oranges for this picture is an example of an analogous color combination (also called a close color scheme). These hues are contiguous on the color wheel, and because of their similarities, they hold the composition together nicely.

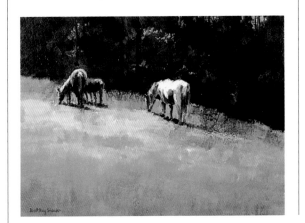

A good start, then, in a search for pleasing color combinations would be to simply select any three or four colors that appear in sequence on the wheel. This is sometimes referred to as the analogous use of color.

COMPLEMENTARY COLORS

Complements are any two colors that lie directly opposite each other on the color wheel. These pairs consist either of one primary and one secondary color, such as red and green, or two tertiary colors, such as yellow-orange and blue-violet. Complements are also true opposites, and both opposites are needed to make a complete unit; note that *complementary* is spelled with an "e," meaning *to complete*, rather than with an "i," which means *to flatter*. Because of their equal strength, complements enhance, contrast with, and intensify each other when placed side-by-side; when mixed together, they neutralize (or tone down) each other and can also form lively grays. By using some of each hue's complement in every color combination, you can create greater variety and interest in your painting. Complements are also useful when you are altering a color's value. For instance, if you want to darken or tone down a color, your first thought might be to add a little black to it. However, on mixing them together you will most likely discover that black almost always muddies a color. A more successful approach would be to add the original color's complement; the resulting hue will be deeper and less muddy.

ROCKFISH MAN
Acrylic on canvas, 37 × 52" (94 × 132.1 cm), 1975. Collection of First Union Bank, Virginia.

By placing the complementary colors of red and green near each other, I created a harsh discord that I thought appropriate for this subject.

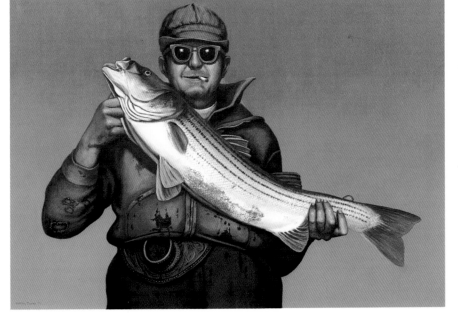

TEMPERATURE AND TEMPERATURE DOMINANCE

Aside from analogous and complementary classifications, colors are also often described and grouped in terms of temperature and are said to be either warm or cool. Cool colors are greens, blues, and violets and are associated with water and dark shadows; warm colors are reds, yellows, and oranges and are often associated with sunlight and heat. In general, the cool colors will recede into the background, while the warmer ones will advance toward the picture plane. In my color wheel on page 82, cool colors appear on the left-hand semicircular panel and warm colors appear on the right-hand one. This division separates the colors into two equal groups and highlights their contrasting temperatures.

When equal amounts of warm and cool colors are used in a painting, the overall effect is disquieting. It is more visually satisfying when one temperature group dominates and the other is used only for accents. Thus, the color scheme of a picture should fall into one of two basic categories of temperature dominance: warm dominant hues with cool accents, or cool dominant hues with warm accents. Knowing color families and combinations will enable you to successfully select colors to create either warm or cool compositions.

Of course, there are always exceptions to this rule. In some instances artists intentionally employ equal amounts of warm and cool colors to create optical illusions such as vibrations and afterimages. These pictures are usually expressionistic or hard-edge abstractions and would not fall under the more traditional painting styles illustrated here. As you study the following paintings and experiment with color temperatures, you will be able to easily recognize these types of color schemes.

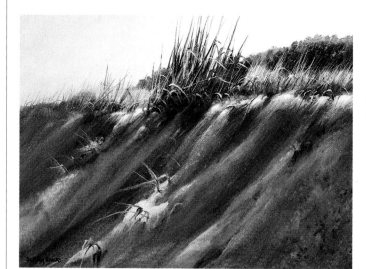

COOL DUNE STUDY—CAPE CHARLES
Acrylic on canvas, 18 × 24" (45.7 × 61 cm).
Collection of Jack and Edith Edwards.

This picture and Warm Dune Study, *which follows, are examples of how color temperature can influence mood and appearance in different interpretations of the same subject. Here, the cool white sky and blue shadows suggest an autumn morning or the chill of a winter afternoon.*

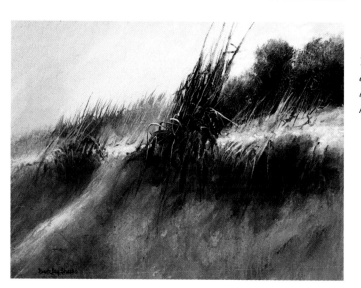

WARM DUNE STUDY—CAPE CHARLES
Acrylic on canvas, 18 × 24" (45.7 × 61 cm).

The light yellow sky and copper-shadowed dunes in this study impart a warmth that brings to mind hot sand and the shimmering heat of summer.

AUTUMN FLAME
Acrylic on Upson board,
12 × 18" (30.5 × 45.7 cm),
1980.

*The hot diagonal
thrusts in this warm,
abstract study are
complemented by the
cool blue accents.*

**Ken Bowen,
IMMEDIATE SEATING**
Acrylic on canvas, 24 × 48"
(61 × 121.9 cm).

A resident of Newport News, Virginia, Ken Bowen is a professor of art at Virginia Wesleyan College. He is primarily a watercolorist but uses acrylics when painting on canvas. While planning this composition, Bowen was influenced by the strong graphic shapes created by these two Adirondack chairs in the late afternoon light. The cool colors of the weathered wood in dark shadow helped him determine the dominant temperature of the composition, and the brown color of the dead grass provided the warm accent. He almost always combines complementary colors to mix gray hues; here, to make the weathered wood color he combined both blue with orange and red with green.

VALUE DOMINANCE

The value (lightness or darkness) of a painting or color is usually described as one of the following degrees: light, halftone, or dark, any of which can dominate a picture. Most traditional pictures are halftone in value. This means that most of the colors in the painting are halftone values, and light and dark values are used in lesser amounts. When the main hues in a picture are light values, the composition is considered to be light-dominated; when dark values prevail, the picture is described as dark-dominated. If you use equal amounts of all the values in a painting, they will compete with each other for dominance and distract the eye from the overall composition. Like color, value also influences the overall look of a painting.

This composition is dominated by light values. Details such as the trees, shadows, and building roofs provide touches of darker values.

In this example, I made use of more halftones.

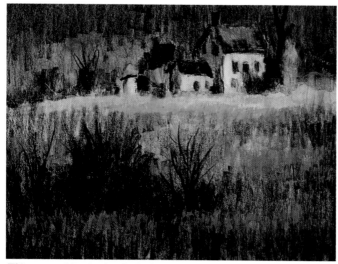

This composition is clearly dark in value. The building's white walls serve as the light accents.

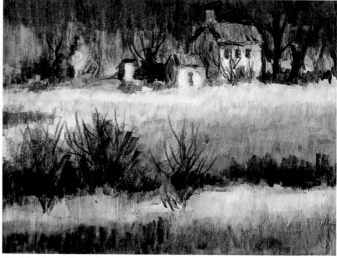

In this sketch, I used equal amounts of each value. At first glance this study seems attractive and interesting due to the strong contrasts between dark and light. However, after looking at it for a longer period of time, you will find that the contrasting areas fight for attention.

EARLY EVENING
Acrylic on Upson board,
9 × 12" (22.9 × 30.5 cm).

*This is another
composition in which
I made use of darker
values.*

MORNING GOLD
Acrylic on canvas, 40 × 50"
(101.6 × 127 cm), 1993.

*Every summer
morning at sunrise
the egrets leave the
cove next to my
studio. This drama
of white-on-white
and gold is difficult
to capture on
canvas, but after
much sketching and
trial and error, I
was able to achieve
this simplified, light,
low-key statement.*

Value and Form

Value plays an important part in the representation and perception of form. The contrast of dark tones (or values) against lighter ones creates the illusion of three-dimensionality, which is necessary to portray believable forms.

Nature often presents the artist with too much light or with conflicting light sources that alter or destroy the illusion of form. Random spots of light and shade create a tonal pattern like camouflage that breaks up shapes and forms and makes them difficult to perceive. You can eliminate this problem by using a single light source; if you see more than one light source illuminating your subject, choose only one for your painting. It is common for artists to take some artistic liberties when they work. Artists who work from nature, in natural rather than controlled light, must often make changes to their subjects from the way they appear in the outside environment in order to depict them convincingly and make them visually understandable to the viewer.

The appearance of the shadows on and around a form is also important to the successful rendering and describing of that form. Shadows help you identify what type of form you are looking at. Rounded forms such as fruit and human figures have shadows with soft edges. Angular forms such as cubes and houses have shadows with sharp, hard edges. With practice, you will soon master the representation of form.

Study the two illustrations above. The top image demonstrates a single light source. These forms appear to be much more three-dimensional than those in the lower picture, where the objects are lit on both sides. This conflicting light eliminates any cast shadows that might help define shape.

MORNING LIGHT
Acrylic on Upson board,
18 × 24" (45.7 × 61 cm).

When I illuminated this scene from only one direction, I was able to capture the effect of bright light defining solid forms. I also used my brushwork to describe those forms: soft, curved brushstrokes delineate rounded edges, while sharp, straight strokes define angular shapes.

YOUNG MAN WITH A ROSE
Acrylic on Masonite,
36 × 48" (91.4 × 121.9 cm),
1972. Collection of Sue
Bartley Myers.

Here, I used careful blending with both the wet-in-wet and diluted-edge methods to render my subject in a realistic, almost sculptural manner. The strong shadows, which are the result of the single, overhead light source, lend a pronounced three-dimensionality to the forms.

WOUNDED WATCHER
Acrylic on Masonite,
36 × 48" (91.4 × 121.9 cm).
Collection of Christopher
Newport University.

I was able to convey the appearance of strong form in the woman's face and the fabric by utilizing a single light source and highly contrasting values.

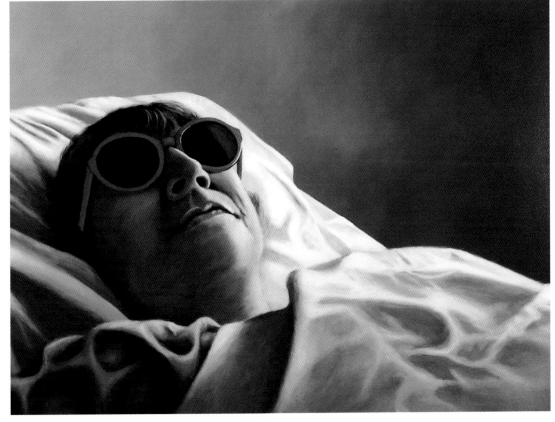

VALUE CONTRAST

As mentioned in the previous section, the contrast between dark and light values is used to represent form, create interest, and achieve a kind of overall visual unity. Value contrast falls into two broad descriptive categories: high contrast and low contrast. When I teach, I like to substitute the terms "long tone range" for high contrast and "short tone range" for low contrast because, to me, they better describe what these two categories really are. A high-contrast picture is one with a long tone range, as it includes either a wide range of values or just the extreme points of light and dark. A picture like this can be dramatic and visually startling, especially when composed mainly with lights and darks. On the other hand, a low-contrast picture has a short tone range; it makes use of a few similar values that do not create strong contrasts. Light-value, low-contrast compositions convey a feeling of delicacy and airiness. Middle-tone values can impart a subtle strength. Dark pictures are often mysterious.

Of course, these are only generalized descriptions; individual paintings can convey a variety of feelings and affect each viewer in a different way.

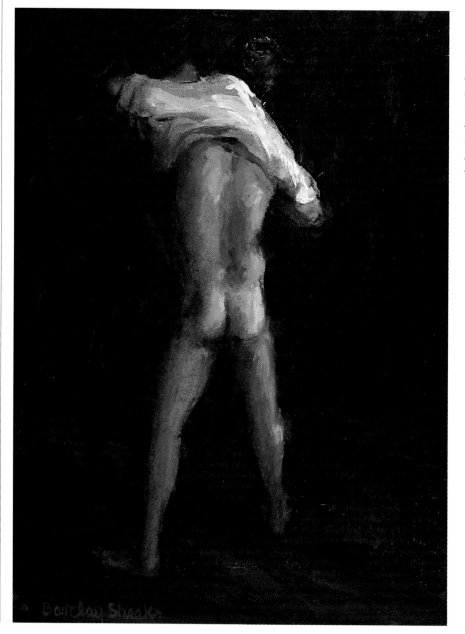

MALE NUDE STUDY
Acrylic on Upson board,
12 × 9" (30.5 × 22.9 cm).

This high-contrast study encompasses the entire tonal range. The background is a dark value, the figure is a middle tone, and the shirt is a light value.

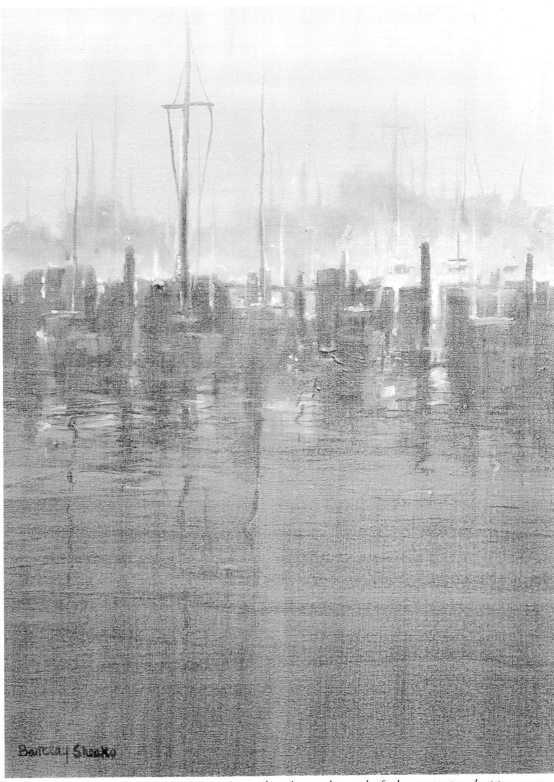

MISTY MORNING, CRISFIELD, MARYLAND
Acrylic on canvas, 24 × 18"
(61 × 45.7 cm). Collection
of Betty Anglin.

This painting of a marina at dawn is a good example of a low-contrast or short-tone-range composition. I achieved the atmosphere of the early morning mist with layers of light-value, semiopaque paints, which I thinned with a 50:50 mixture of gloss medium and water.

SOLID VS. BROKEN COLOR

There are two main ways of applying paint to create areas of color in your compositions. The most common application technique is referred to as the solid-color method. Fields of solid colors, which are flat in appearance, are placed next to, and blended gradually into, one another. Your paints can be either thick or thin, depending on the subject or overall painting style.

In the broken-color technique, you define areas in a picture using relatively small spots or strokes of color. Like a mosaic, these small, separate spots work together to form the overall image. Your paint applications can be either thick or thin, and you can use a brush or palette knife and any of the various dripping, spattering, spraying, or stamping methods learned in the previous chapter. With broken color, you can describe form, take advantage of the optical effect of separate color spots being combined by the eye into luminous blends, as in the pointillist technique, and simulate a variety of textures. When used in a representational or realistic way, broken-color painting is often described as impressionistic due to its association with the 19th-century French Impressionist painters who employed this technique.

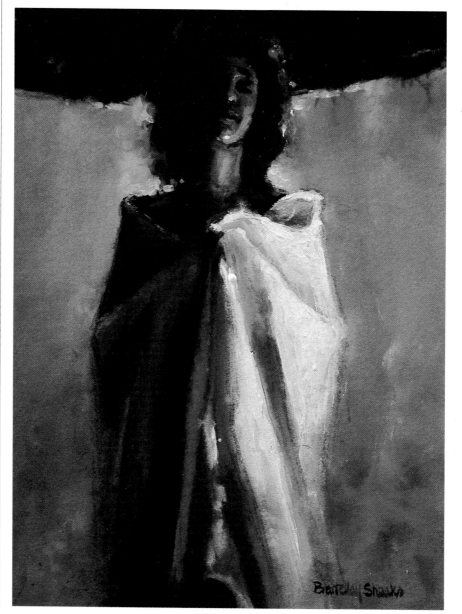

GODDESS CONFIRMED
Acrylic on Upson board,
12 × 9" (30.5 × 22.9 cm).

This figure's strength is the result of my use of highly contrasting solid colors.

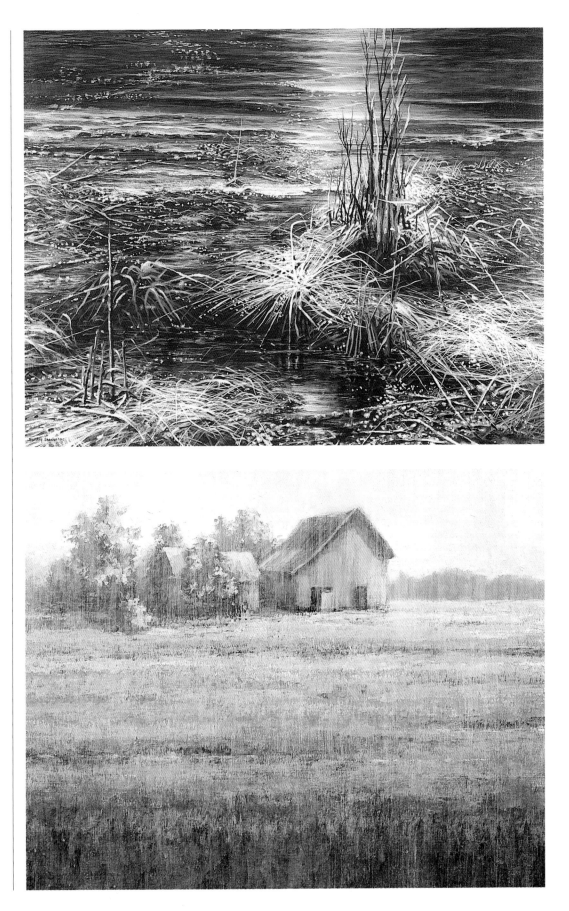

MARSH LIGHT STUDY
Acrylic on canvas,
48 × 57"
(121.9 × 144.8 cm).
Collection of Mark Myers.

The wispy brushstrokes in the grass and the numerous dots of color in this painting are good examples of how the broken color technique can be used.

AUTUMN RAIN
Acrylic on Upson board,
16 × 20" (40.6 × 50.8 cm).

I created this textured brocade of broken color by applying spots of color using dry-brushing, slapping, and stippling techniques.

THE MOTHER COLOR PRINCIPLE

This method of using color is similar in some respects to working with a monochromatic palette. Both styles are dependent upon the use of a single hue. The word *monochromatic* means, of course, "one color"; a monochromatic picture is one that is composed entirely of different values of only one hue. You can use black and white respectively to darken or lighten that color's value, but you should not introduce any other color into the painting. This is slightly different from the mother color principle.

Mother color is a very poetic term. It means that all the hues in a particular composition are "born" out of one central color. In this approach, you choose one color for your dominant hue (the mother color), and then mix it with all the other colors used in the painting. Just as a mother's children are all distinct individuals with similar traits, all the hues in this type of picture will be different yet still related and harmonious. The mother color principle offers more variety than the monochromatic method, but both techniques can give the appearance of all-over color unity.

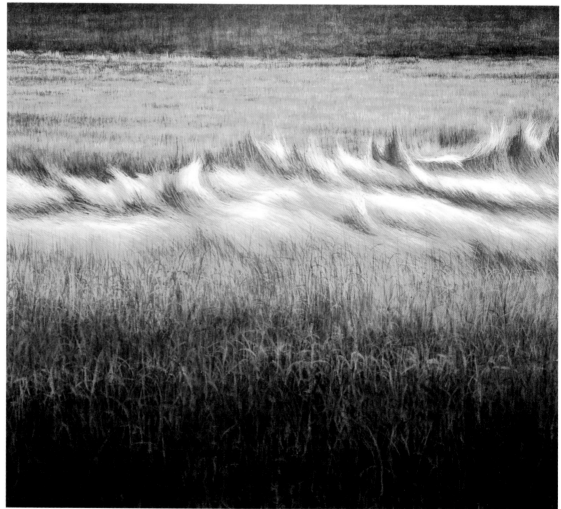

THE WAVE
Acrylic on canvas,
36 × 40"
(91.4 × 101.6 cm),
1987.

Prior to composing this painting, I spent considerable time observing, sketching, and photographing the rhythmic pressed patterns that were left in this marsh grass by flood tides. I found these visual effects fascinating, and the subject seemed to be a natural one for the mother color principle. To begin, I mixed a large amount of the yellow-green hue that I planned to use as my mother color and saved it in a covered plastic container. I then primed my entire surface with this color, let it dry, and continued to paint the rest of the composition over it. I achieved the light and dark values and color variations in the grass by mixing my mother color with all the other hues in my palette.

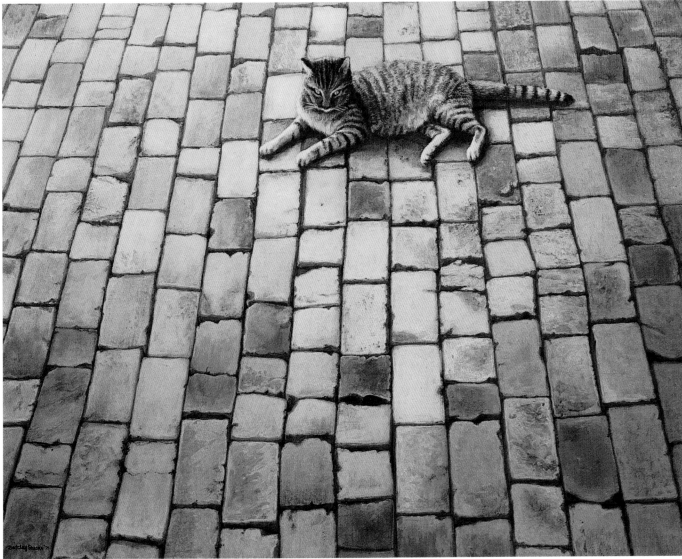

TIGER IN THE SQUARE
Acrylic on canvas, 24 × 30"
(61 × 76.2 cm), 1974.

In the 1970s, we had a cat named Fink who loved to observe life from the patio outside my summer studio. Using a mother color seemed like the most efficient way to handle the subtle, related tints of color in the bricks in this scene. I mixed a large amount of light gray-green mother color and applied some of it as a ground to the entire canvas. Once this layer was dry, I rendered the details of the bricks and achieved my color variations by mixing the mother color with red, green, and black. In the last stage, I painted the cat over the completed stones.

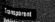

Transparent
Vehicle: Acrylic Polymer Emulsion
Pigment: Calcined Natural Iron Oxide (PBr7)
Lightfastness: I - Excellent

Transparent
Véhicule: Émulsion polymère acrylique
Pigment: Oxyde de fer naturel calciné (PBr7)
Résistance à la lumière: I - Excellente

Transparente
Vehículo: Emulsión de polímeros acrílicos
Pigmento: Oxido de hierro natural calcinado
Solidez a la luz: I - Excelente

Durchsichtig
Fahrzeuge: Acrylische Polymerfarbe
Farbstoff: Kalziniertes Natureisenoxyd (PBr7)
Lichtfestigkeit: I - Ausgezeichnet

Trasparente
Veicolo: Emulsione acrilico
Pigmento: Ossido di ferro naturale calcinato
Resistenza alla luce: I - Eccellente

UMBACHER

HYPLAR®
ACRYLIC

ACRYLIC PAINTING TECHNIQUES

As you have no doubt already discovered, acrylics are different from any other type of paint. This becomes even more apparent here as we explore the various ways in which acrylics can mimic many other painting mediums. For example, you can use acrylics as watercolor, gouache, oil, and egg tempera. However, you can also break away from these more traditional methods and use techniques that are only compatible with the acrylic system.

Since acrylics have such a unique flexibility, we will also focus on procedures that, when attempted in any other medium, are highly impractical and can result in works that are technically unsound or even impermanent. After reviewing all these techniques, I think you will truly appreciate the remarkable scope of this medium.

TRANSPARENT WATERCOLOR TECHNIQUES

Watercolor is broadly defined as a water-soluble paint applied to a surface in a watery way. To create a watercolor painting, you use thin wash mixtures that are made from water and paint. These washes can be either opaque or transparent. They can be free and runny to emphasize bleeds, or restrained and controlled to highlight sharp focus and detail. And, as you will see, you can use acrylics as watercolor in both traditional and nontraditional ways to add new dimensions to many standard watercolor concepts.

We'll examine the transparent style in this section, but to better understand watercolor, you must first be aware of the physical properties and limitations of its binder, traditionally gum arabic—a natural, water-soluble adhesive that has very little elasticity once dry. Consequently, watercolor paint must be applied in very thin layers or washes; thick applications will crack as they dry. However, this is not a problem with acrylic, since its binder, which is also water-soluble, is very flexible. So, you can use thick, impasto layers in combination with thin washes.

Acrylic paint is a form of watercolor and may be used as such, but there are some differences between the two that you should keep in mind.

Acrylic washes dry faster than those executed with watercolor, and when they are dry, they are not easily dissolved or softened by moistening and scrubbing. This can be advantageous if you need to apply fresh washes over dry ones without disturbing the base wash; it also means that inadvertent water spills and splashes are less likely to damage painted areas that have dried. If you have experience with traditional watercolor, you should have no difficulty switching to the acrylic watercolor medium.

The best type of acrylic for watercolor-style painting is the liquid variety, which comes in jars or plastic squeeze bottles. It disperses easily in water and forms washes more readily than the paste type, which comes in tubes. These colors are formulated for multipurpose use. If you encounter problems in mixing the tube colors into smooth washes, you can prethin the basic colors and store them in airtight glass or plastic containers. To do this, squeeze the paint into the container (I use plastic margarine tubs), add a small amount of water, and stir until the mixture is a smooth, even, thick syrup. You can do any additional diluting at this time or when you are ready to paint. To prolong viability, spray water on the mixture before sealing the container, and then refrigerate.

Paper is the traditional support for watercolor. Surface textures range from smooth to rough, and each type of paper has its purpose. In general, smoother papers are best for highlighting

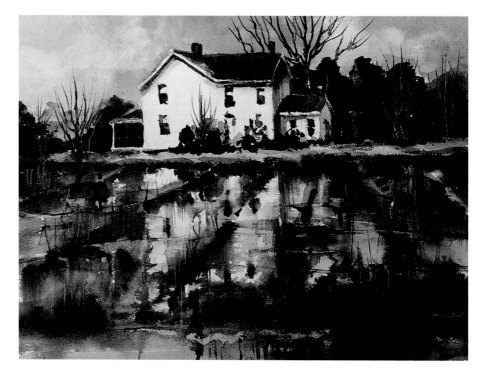

GARDEN REFLECTIONS
Acrylic on Strathmore watercolor board,
9 × 12" (22.9 × 30.5 cm).

I am fascinated by the contrast between sharp images and their blurry reflections in water. I painted this picture in my studio, using a location sketch and photograph for reference. Since thin paint has a tendency to run on a wet surface, I painted the sharper, upper section of the composition, including the house, sky, and trees, on dry paper. I used a trailer brush for the trees, and then when the paint was dry, I scratched the lines of light into the trees and garden with the point of a utility knife. For the reflection in the lower part, I moistened the paper prior to setting down any paint. A wide flat brush is good for this purpose. The result was a blurred, flooded garden. For the water ripples, I made scrapes with a palette knife across the wet paint.

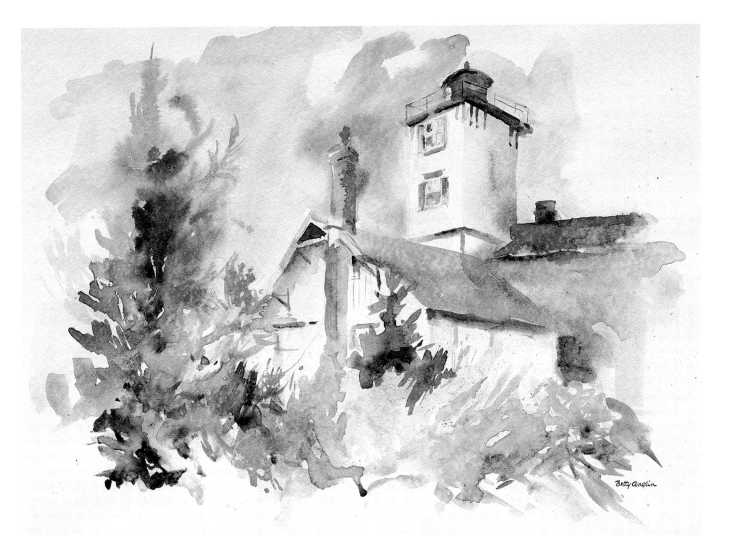

**Betty Anglin,
PAINTED LADY—CAPE
MAY, NEW JERSEY**
Acrylic on Morilla 140-lb.
watercolor paper.

This image is one from Betty Anglin's series of paintings of wonderful Victorian houses—called the "painted ladies"—in Cape May, New Jersey. She executed it alla prima *in a wet-in-wet application, putting the light, middle, and dark values down simultaneously, rather than in separate layers, one over the other. For paints, she used Liquitex, Grumbacher, and Atelier brands, and she executed the entire painting with only two brushes: a Utrecht 1"-wide 230 sabelette for all the preliminary washes and a Winsor & Newton series 707 pure sable for the details.*

Before she began painting, Anglin blocked in the subject with an HB drawing pencil. (Note that any pencil lines that still show after a painting is complete can be erased with a kneaded eraser.) She then wet the paper liberally with water

and Atelier acrylic watercolor medium. This medium improves the flow and movement of acrylic paints on paper, and you can see the results of this in the tree on the left and the house and roofs on the right. Anglin also put down thin, transparent washes of different colors to achieve the watery look that is characteristic of the watercolor style. An advantage here to using acrylics over traditional watercolor is that you can put down a first wash of color that, once dry, will not be disturbed by any subsequent wet applications. So, after the painting was dry, Anglin added a few details in the windows and tree branches with a small brush. Another benefit to acrylics seems to be their permanence; over time, watercolor will fade in direct sunlight, whereas acrylics appear to be less subject to damage.

DOORWAY AT NIGHTFALL
Acrylic on Strathmore 140-lb. watercolor paper,
9 × 12" (22.9 × 30.5 cm).

You can create abstractions in a nonobjective manner with only design in mind or you can use objects or subjects as starting points. The evening sky was my inspiration for this abstract composition. To me, this picture is my symbolic representation of the warmth of dusk fading into night. I enjoy painting in an abstract style because I can focus on my medium rather than on the rendering of my subject.

For this painting, I used the wet-in-wet technique on dampened paper and applied the warm, light colors first. I selected a rough watercolor paper that would support the running and blending effects of this technique and hold the deep moisture required for heavy, wet scraping. First, I soaked it in water until it was saturated and expanded, and then I placed it on a piece of glass. As I painted, I tilted the tabletop to help the colors run and bleed. When the surface moisture was just right for scraping (wet but not runny), I incised the hard-edged horizontal and vertical shapes into the paint with a palette knife.

interesting brushwork and intricate detail. More textured surfaces lend themselves well to less restrained styles, in which the paper surface can assert itself.

Unless you are working in a small format, you should use heavier, thicker papers, because they are less likely to buckle or pucker when they dry. To prevent buckling, some artists wet their paper (before painting) to expand it and, while it is still wet, tape or tack it to a board or frame. When it dries, the stretched, tight surface is less problematic. Another common watercolor surface is watercolor board, which is watercolor paper mounted on cardboard. It will not pucker or dimple and is satisfactory for most techniques except truly wet watercolor applications, which require the paper to be thoroughly soaked.

Although you can use any kind of brush (including a thick-bristled housepainter's brush) to apply an adequate wash, watercolorists prefer soft-bristled varieties that are made from animal hair, such as sable, ox, or squirrel, or synthetic fibers that imitate them. These implements hold more liquid—an advantage when applying washes— and are thirstier and, therefore, better for lifting and absorbing paint than their stiff-bristled

counterparts. Some artists express concern about using their watercolor brushes for acrylics, but I have found that if you clean your brushes properly with soap and water and reshape them before putting them away, you will not damage them.

The common mixing palette for watercolor is a tray with small indentations for the paints and larger ones for mixing washes. While traditional watercolor paints can be left on the palette and resoftened with water, acrylics cannot be remoistened and must be cleaned from the tray at the end of each painting session. I prefer a palette with a wide area for mixing and experimenting.

Transparent watercolor has both a long history and a wide contemporary practice. Opinions about the degree of transparency and the limit on opacity that qualify a picture as transparent watercolor are vigorously contested. Such artistic judgments must ultimately be made by the individual. In general, you should emphasize the transparency of the medium and, for the most part, utilize the white (or light color) of your painting surface as the light value in your composition. Therefore, as you compose, you must save these light areas by not painting over them. You can do this by painting around spaces or by masking them; you

can also lift color from your picture surface by absorbing it with a paper towel or scraping it with a knife.

Your surface values for transparent watercolor must be white or light. You make your colors more transparent and lighter in value by mixing them not with white paint but with water. The more water in the mixture, the more transparent the wash and the more your surface material color will show through the paint. Some colors are more transparent than others, depending on the nature of their pigment content, but you can make any color transparent to some degree if you combine it with enough water. Some brands of paint indicate information about the transparency of a color on its container.

As with all types of paintings, transparent watercolor compositions are created by following the basic single-layer or multiple-layer concepts discussed earlier in this book. There are two approaches to single layering. The first is the wet-in-wet method, in which you moisten your surface and then apply color to it. The second involves rendering each area of your composition more or less separately. For multiple-layer paintings, you apply washes of color one over the other. Most watercolor-style paintings, whether they are executed using acrylics or traditional watercolor, are a combination of both of these layering techniques. When well executed, transparent watercolor pictures have a sparkling brilliance unattainable in any other medium.

ISLAND REFUGE
Acrylic on Strathmore watercolor board,
9 × 12" (22.9 × 30.5 cm).

A simple underpainting is an effective tool for achieving a dominant color or value in a picture. To convey the feeling of a warm evening glow, I first covered my entire surface with a light wash of yellow ochre. Once this layer was dry, I continued to paint over it.

EVENING FLIGHT
Acrylic on Strathmore watercolor board,
9 × 12" (22.9 × 30.5 cm).

Masking and scraping are very useful techniques that I used here to create light spaces and texture, respectively. First, I saved my light areas (for the egret and sky) with Miskit, a liquid masking fluid. I applied my basic paint washes, and after they were dry, I removed the Miskit and added tints to the egret and sky areas. Then I scraped the textures in the grass, trees, and water with the sharp point of a utility knife and painted over any unwanted marks with my background colors.

THE WET-IN-WET APPROACH

The wet-in-wet approach is arguably the most characteristic of the watercolor style because of its overall fluidity and wateriness. Although any creative process involves some element of risk, the wet-in-wet method can be especially chancy. You must contend simultaneously with many variables, such as degrees of paper saturation and paint transparency. Even though you may have a clear idea of the subject in your mind, you must pay close attention to the behavior of the paint and be willing to relinquish some of your authority to it. Don't be intimidated. Listen to what your picture is telling you, and think of the whole process as an adventure. I always introduce beginning acrylic painters to the medium with an enriching wet-in-wet assignment because it acquaints them with the basic characteristics of the watercolor style and teaches them the necessity of preliminary planning. It is a truly engaging experience.

It is important that you select the proper paper for the wet-in-wet method. Choose a tough, fairly heavy paper that will hold up well under more vigorous techniques, such as scraping and bruising while it is water-saturated. I prefer a rough surface and use 140-lb. paper for pictures of up to 18 × 24"; for larger compositions, I work on 300-lb. paper.

DEMONSTRATION

The wet-in-wet approach to watercolor offers many creative possibilities. In my opinion, few painting modes offer the same opportunity for pure painting enjoyment. Prior to starting, gather and arrange your equipment so that you will not have to stop and break stride mid-painting to search for something you need. You should also review your planned working sequence.

Due to the water-saturated surface, watercolor washes tend to become lighter in value upon drying. To offset this, make your washes a little richer in color and darker in value than you think you need. Don't worry if you make mistakes; just continue painting and work through the problems.

In this demonstration, I am painting a favorite subject—a view of the cove outside my studio window—that lends itself well to a loose and free wet-in-wet interpretation. My palette is a piece of Upson board that I coated on both sides with acrylic gesso, and I am using five brushes, a palette knife, and tube paints, which I keep moist with a spray of water from an atomizer.

I began by sketching only the general forms of my composition on my paper. I find that detailed drawings hinder me when I work in the wet-in-wet technique because they prevent me from going with the flow of the paint and the picture. After finishing the sketch, I held the paper under running water until it was completely saturated and then flattened it out on a piece of glass. (Any waterproof, resilient, smooth-surfaced material will suffice for this purpose, but I prefer glass because it does not absorb moisture and it has a shiny surface that facilitates the removal of the paper when I am finished painting.)

Here, I use a large, 2" brush to cover the sky and water areas with a light wash of color. I paint loosely around the boat area, saving as much white as possible for the actual boat form. Eventually, I will render the dark land and trees over this light background.

To lighten some areas at this wet stage, I blot the wash with a crumpled paper towel. To do this in smaller, more detailed parts of a painting, you can use a dry brush.

Next, I use a #6 synthetic-bristle bright brush to render the distant land. The edges of the paint bleed on the wet paper and blend into the background, creating misty atmospheric depth. This must be done while the surface is very wet. If you find that your paper is not wet enough, you can spray it with water to redampen it. Also note that the more watery your washes are, the more readily they will bleed.

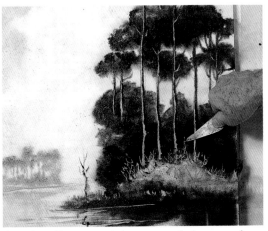

Scraping effects are an important aesthetic aspect of this picture. Using my palette knife, I scrape off paint to create highlights in the trees, but before doing this, I make a small test scrape in the paint to see if it is still too wet. If the wash runs back over the scraped area, I wait a few minutes and then try again. Timing is very important here; if I wait too long, the paint will dry too much, and I won't be able to remove it.

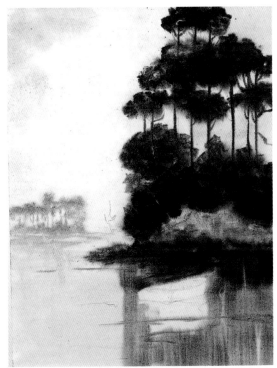

To render the closer trees and land areas, I use a #12 bright. This paint mixture is a rich, dark olive green and is of a thicker consistency than the first washes. The thickness will help prevent overbleeding. I also use this paint to depict the reflections of the trees in the water and to define the shape of the boat.

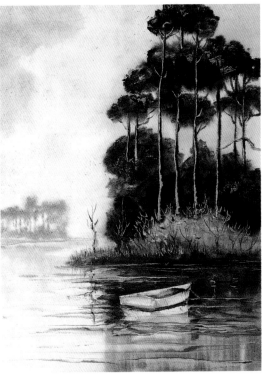

BAY POINT
Acrylic on Strathmore 140-lb. watercolor paper,
24 × 18" (61 × 45.7 cm).

In the final stage, I clarify the boat form and add linear details, such as grass and a small, dead tree, using a #2 round, pointed-tip brush. When the picture is dry, I add a wash of warm color in the scraped areas of vegetation to contrast with the overall coolness of the composition.

MASKING AND LAYERING WET-ON-DRY

Masking and layering are essential concepts in watercolor-style painting and are especially important when you are working with the transparent method, in which the white of the paper's surface serves as the lightest value in your painting. One way to reserve such areas is to cover them with masking tape or masking liquid before you begin applying paint; the masks are removed only after the paint is completely dry. Masking is particularly useful for preserving small, complex parts of your composition that would be difficult or impossible to paint around. Masking fluid (basically liquid latex) is usually more reliable and effective than tape.

While some pictures are composed primarily of one layer of paint, most, whether coincidentally or intentionally, contain some areas of multiple layers. The most practiced layering sequence in the transparent watercolor method is dark hues over light ones. You can also layer transparent washes of similar values one over the other. The visual effect when two layered, transparent colors create a third is quite stunning, and the resulting hue is very different from the one that would have been achieved if you had simply mixed the paints together on your palette. For example, you could layer red over yellow to create a luminous orange. Acrylics are easy to use for this layering technique because once they dry, they are waterproof and can not be dissolved by any subsequent washes.

DEMONSTRATION

Masking and layering techniques require a more methodical approach. If working in a controlled, organized manner appeals to you, you will certainly enjoy experimenting with these procedures. An advantage here over the wet-in-wet process is that you can relax and work more slowly because there are no pressing time and wetness restraints. You can also draw a more detailed preliminary sketch on your surface. You should note that your layering sequence is important here and that all washes, no matter how transparent, darken as they dry. So, plan accordingly. A word of caution: Don't let the masking liquid dry on your brush—it will be difficult to remove. Once you are finished, wash the masking brush out with soap and water immediately.

After sketching the composition on my surface (here watercolor board), I apply masking liquid to those areas that I want to save, using a long-tipped brush. I use Grumbacher's liquid frisket, called Miskit, which comes tinted orange for better visibility.

Next, I put down a wash of my painting's dominant color, a warm greenish gold, over the masked areas. The light bluish gray of the boat is a mixture of phthalo blue and Payne's gray, and it provides a contrasting cool accent. Because this picture is small, I have scaled down the size of my brushes accordingly.

Leaving some of the first layer exposed, I apply a slightly darker, greenish-brown wash to select areas of the grass and slap the brush against the board to simulate vegetation. This color, made from burnt umber, sap green, and cadmium orange, continues the warm, green dominance but also adds some color variance to the composition. Note that because cadmium orange is a somewhat opaque color, I only use a small amount of it to make this hue.

This third layer is a still darker, greenish-brown mixture (made from mars black, sap green, and burnt umber), and I use it to frame the boat and create depth in the marshy foreground water. I also add touches of dark red (mixed from cadmium red and black) to the waterline around the boat and some dark individual blades of grass and flower stems. Notice how the masked areas are still clearly visible.

After removing most of the Miskit with my fingertips, I finish this rubbing process with a soft eraser, which will clean the surface and lift off any remaining mask. I make sure the paint is dry before doing this.

HIGH MOORING
Acrylic on Strathmore watercolor board, 6 × 8" (15.2 × 20.3 cm).

At this final stage, I tint the previously masked areas with a lightly colored wash so that they recede into the background. I leave most of the Queen Anne's Lace blossoms white so that they will stand out, but I tint a few blue-gray to repeat the boat color and to prevent them from scattering the focus of the composition. I also spatter some paint on the picture to add texture.

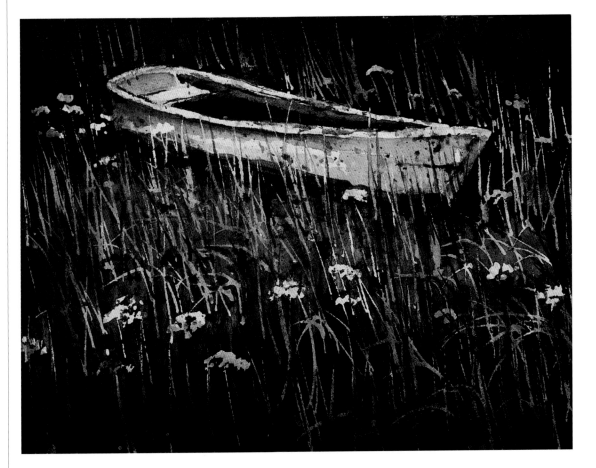

Opaque Watercolor Techniques

There are several kinds of traditional opaque watercolor mediums, including gouache, distemper, designer's colors, poster colors, and powdered tempera. They all have a water-soluble gum binder and are all more opaque than transparent watercolor paints. They dry rapidly but are easily redissolved with water, so they are not appropriate for extensive layering. Due to the limitations of the gum binder, thick buildups of these paints will crack and flake. Acrylics, on the other hand, with their water-resistant properties and flexible binder are ideally suited to layering and thick applications. They work very well for opaque watercolor techniques.

Although egg tempera can also be considered a form of opaque watercolor, I will treat it as a separate category because it requires an egg-yolk binder and has a very distinct finished appearance.

The main difference between transparent and opaque watercolor techniques is the way in which you attain light values. Whereas you dilute a transparent paint with water or medium to lighten its value, you mix an opaque one with white paint to do this. Since white paint is also opaque and will cover darker colors, it is not necessary to save the white space of your surface for the light values in your composition; white paint can serve as your white space. You can, therefore, be flexible with your working sequence and paint from light to dark, dark to light, or start with a middle value, depending on your personal preference.

Unlike transparent paints, which are best executed on white or off-white surfaces, opaque pigments will effectively cover any surface color or value that you choose. When you work in the opaque style, you can incorporate your surface color into your picture or cover it up completely. You can also combine both opaque, semiopaque, and transparent paint applications in one composition. For example, you can achieve interesting color effects by layering transparent washes over a dry, opaque underpainting.

Opaque painting techniques are essentially the same in any medium, so it is easy to substitute

Alex Powers, THE TIME HAS COME FOR THIS NATION TO FULFILL ITS PROMISE Acrylic, charcoal, and collage on Strathmore illustration board, 24 × 38" (61 × 96.5 cm).

Alex Powers is an artist and teacher. He is also the author of Painting People in Watercolor *(Watson-Guptill, 1989).*

Powers uses primarily opaque watercolor (gouache) for his paintings but does at times switch to acrylics. He originally painted in transparent watercolor, changing to gouache as his interests moved to surface texture and drawing; opaque, rather than transparent, watercolor is a more sensible medium to use for building up surface variations. Acrylics are very similar to gouache for his purposes and have the capabilities of both transparent and opaque watercolor.

acrylics for traditional opaque watercolor. In this section, I will work primarily on paper and paperlike supports because they are the customary surfaces for traditional opaque watercolors. (I will explore painting on canvas, hardboard, and other materials later on in this chapter.) Also, in the interest of examining the use of acrylics in a characteristically opaque-watercolor manner, I am limiting my paint applications primarily to washes. Just as experience with the transparent watercolor technique can act as a foundation for the understanding of all transparent painting concepts, so too can practice with the opaque watercolor approach lead to a broader understanding of all opaque painting processes.

WET-IN-WET

In general, the opaque wet-in-wet technique is the same as its transparent watercolor counterpart. As I mentioned previously, the differences are the addition of white to the palette and the more flexible working sequence, but these things don't affect the overall painting process. You will encounter the same watery running and bleeding effects, and you can still remove excess color from your picture using the same blotting and scraping methods. You should use a strong support that is absorbent and holds water evenly so that it remains wet and workable longer without being remoistened. Good choices are Upson board and watercolor or construction paper.

To begin, I soak my working surface in water until it is completely saturated. If the surface begins to dry while I am painting, I spray it with more water. It is not necessary for a wet-in-wet painting to be completely soft, runny, and blended unless that is your preference. I like to combine large areas of fluid washes with small spots of crisp, sharp-focus detail because, to me, the contrast is very interesting. It is easier to paint fine lines and hard edges on a dry surface, so I dry select portions of the picture with a hair drier.

This fluid technique is always a challenge. Washes are often difficult to control on a wet surface and may flow in unexpected directions, but this spontaneity is part of the adventure. Just save those accidents that enhance your work and blot those that do not.

REFLECTIONS ON A DARK TABLE
Acrylic on Strathmore 140-lb. watercolor paper, 9 × 12" (22.9 × 30.5 cm).

Often, if you are receptive, your subject will suggest the best technique and mode of interpretation. The reflection of an autumn floral arrangement on a dark table was my inspiration for this abstraction. The table, with its soft, reflective gleam and muted colors, seemed to be a natural image for the wet-in-wet technique because just as the colors of the flowers appeared to be absorbed into the table's surface, so too were my creamy paint washes absorbed into the wet paper.

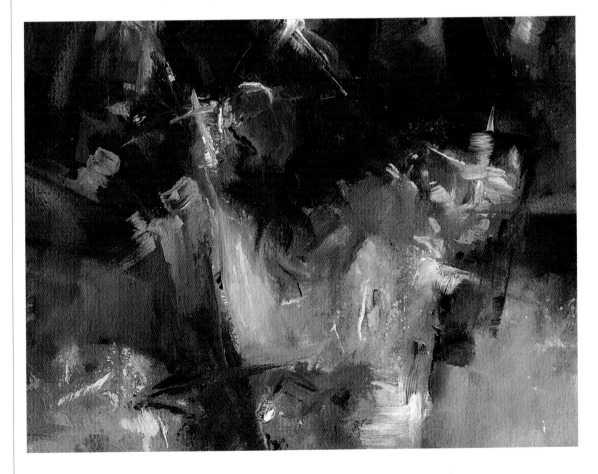

Opaque Watercolor Techniques

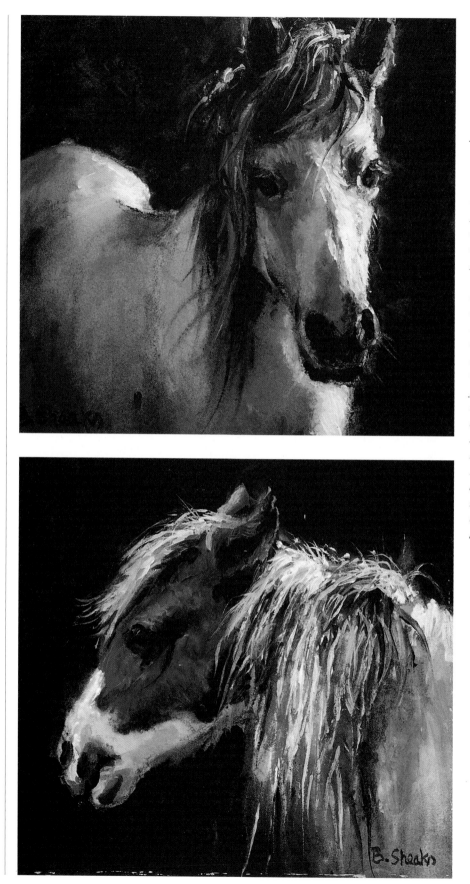

I combined both wet-in-wet and wet-on-dry layering techniques in these two small studies of wild ponies. I chose construction paper for my surface because it is very absorbent and remains wet for long stretches of time. Before applying any paint, I quickly sketched my subjects and saturated the paper with water. This dampness made it easier for me to blend my colors. I roughed in the backgrounds and basic pony shapes with #12 brights and flats and added the more precise modeling and shading with smaller brushes. As the basic washes dried, I added the sharp edges and fine lines in the ponies' manes over this previously applied layer.

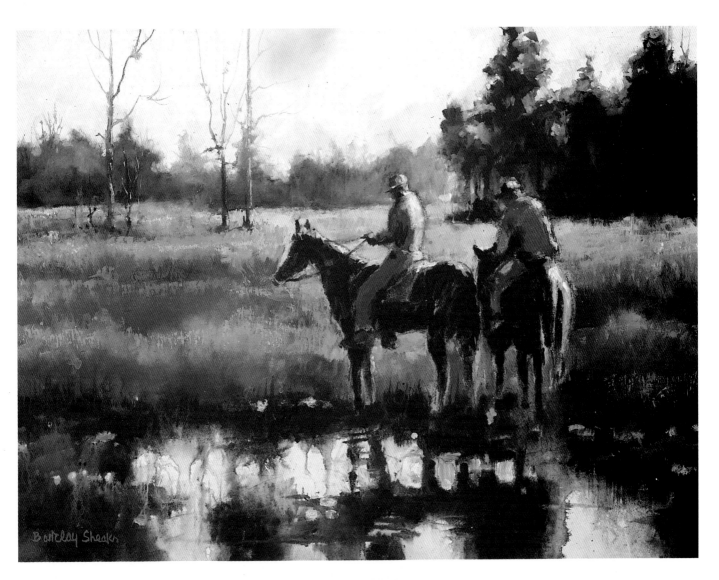

Prior to painting, I sketched the horses, riders, and large space divisions onto my Upson-board surface. I sprayed the panel with water and then quickly roughed in the figures and background with opaque washes while the surface was still wet. As this layer dried, I added more color and value variations and also applied paint to the sky area in a heavy, impasto manner. I find that combining layering and painting techniques is a free and exciting way to build a composition.

To achieve some of the running and bleeding effects in the water area (see detail at left), I tilted my surface so that the paint would run toward the bottom of my composition. Since the surface was damp, the paint moved freely.

DEMONSTRATION

Although they are basically similar, the opaque wet-in-wet technique has fewer restraints than the transparent version. There is no question in my mind that you will have a freer experience because, in the opaque wet-in-wet process, you can easily cover any mistakes with more paint. If your surface begins to dry before you finish painting, you can remoisten it with water sprayed from an atomizer, and, conversely, if your painting is too wet, you can dry it with a hair drier.

For this painting, I am using an 18", gesso-coated hardboard panel as my palette and a selection of brushes that includes one #12 flat, two small brights, and a small trailer. Note that I spray my paints often to keep them moist and workable.

In this quick preliminary sketch, I block in the basic, large forms of my composition on my paper surface with a lithography crayon (also called a lithographic crayon). I place my subject slightly off center to make the composition more interesting and dynamic. After completing the sketch, I wet the paper thoroughly with water, allow it to expand, and then flatten it on a piece of glass. I prefer construction paper because it is very absorbent and stays wet for a long time. When I use the wet-in-wet technique, I keep my surface flat (horizontal) so that I have more control over my paints as they run and bleed.

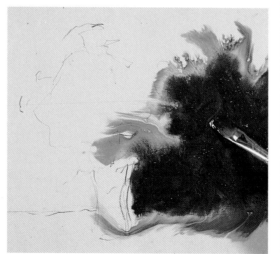

Using the #12 flat brush, I apply the background color, which is a creamy mixture of burnt umber, alizarin crimson, and black. Notice how the paint bleeds when it meets the wet paper.

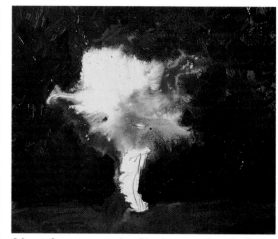

I leave the paper unpainted in the area where the flower arrangement will be.

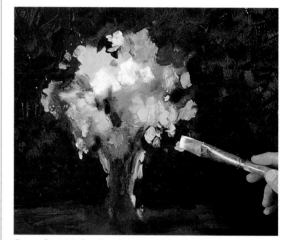

I use the #12 flat brush to rough in the flowers, trying to get a good balance of color in the arrangement.

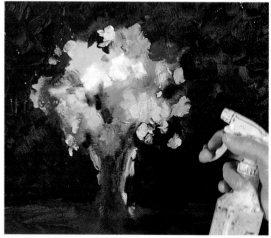

Here, I spray the surface with water to keep my paint wet and to encourage the running and bleeding effects that are so characteristic of the wet method. I enjoy watching the paint chart the course of my picture.

The narrow tip of my small bright brush is perfect for suggesting flower petals.

Using my trailer and small, pointed brushes, I add highlights to the glass container and the smaller blossoms. I also place a strong patch of blue near the center of the arrangement to provide some interesting contrasts, but it attracts too much attention and contrasts with the other colors, so (in the next step) I tone it down.

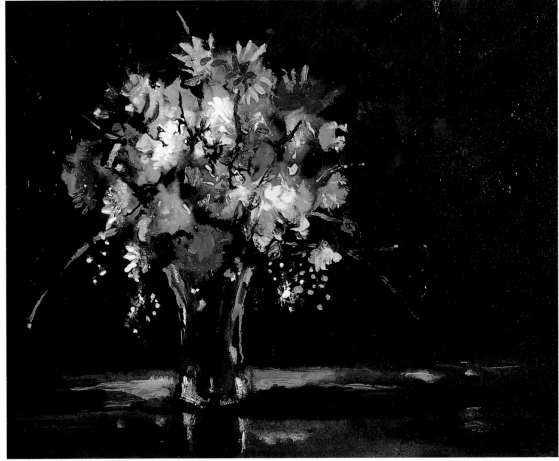

WINTER FLORAL
Acrylic on construction
paper, 16 × 20"
(40.6 × 50.8 cm).

After softening the distracting blue spot, I decide, "Enough is enough." As an artist, you must resist the temptation to overwork your paintings, especially when you are using the spontaneous wet-in-wet technique. To my eyes, the picture is definitely finished.

WET-ON-DRY

There are fewer variables in the wet-on-dry technique than in the wet-in-wet method, and so the artist has tighter control over the painting process. The main reason for this is that in wet-on-dry watercolor your surface is dry, and wet paint does not move as fluidly on it. You can create hard edges and sharp, detailed images. The various brushwork techniques all work well, and you can utilize both single- and multiple-layer concepts.

When planning a layering sequence, I try to understand and visualize my subject in simplified sections. For example, in my painting *Spring in the Village* below, the basic compositional structure is similar to that of a flag with four horizontal stripes: sky, houses, grass, and street. Keeping these sections in mind, I quickly roughed in the underlayer of every stripe using the main tones and colors with little or no modeling and shading. The exception to this was the sky area where I continued to work the white clouds into the wet blue wash in order to achieve soft edges. At the second stage, I added details, like windows and doors, to the house and shadows on the grass and street. Only on the third and final step did I paint the trees over these previous layers, slapping my brush against the paper to render the left-hand tree and spattering and flicking paint to form the right-hand one.

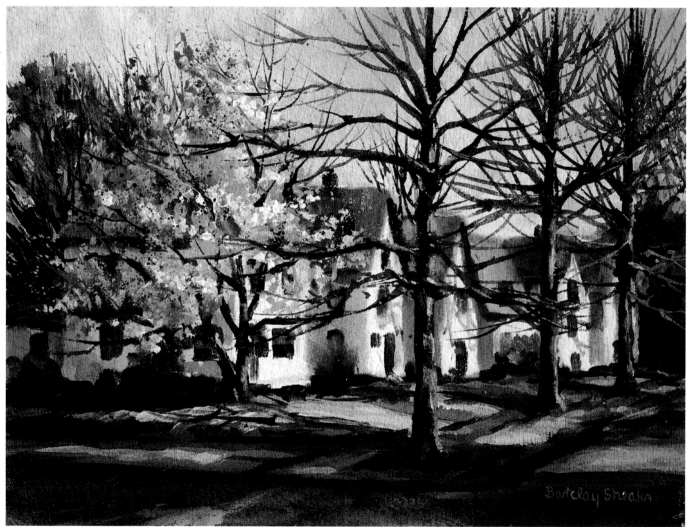

SPRING IN THE VILLAGE
Acrylic on 140-lb.
watercolor paper, 9 × 12"
(22.9 × 30.5 cm).

This blossoming tree is down the block and across the street from my house. It is a familiar motif for me because I paint or photograph it ritualistically every spring as it comes into bloom. It is an excellent subject for a multiple-layer, opaque, wet-on-dry approach because of its many details.

It is interesting to note that I have also painted this same subject in acrylic on canvas, and, on that fabric, the paints look almost exactly like oils. This illustrates just how successfully acrylics transcend boundaries and mimic other mediums.

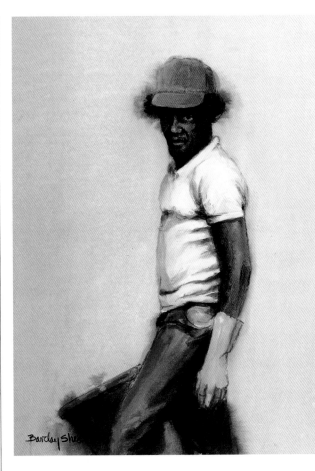

This figure study is one from a series of paintings I made depicting migrant workers from Virginia's Eastern Shore. As with most of the pictures from this series, I painted this one in my studio but based the composition on my on-site drawings and photographs. First, I sketched my subject lightly in lithography crayon on my unprimed Upson board (some of the sketch lines are still visible in the finished painting) and then covered the entire surface with a thin, semiopaque mixture of white acrylic gesso and water that was opaque enough to tint the board but still transparent enough to allow the drawing to remain visible. When the gesso was dry, I painted the figure freely with opaque washes. I was able to create bleeds in the hair and lower portion of the figure by moistening these areas with a wet brush before applying my paint.

DUNE AND GULLS
Acrylic on Upson board,
18 × 24" (45.7 × 61 cm).

Thin washes of opaque and semiopaque paint characterize this freely executed study. I moistened my Upson board before beginning to paint and then put down the sky and basic dune form. After the sky and dune dried, I used a long-pointed brush to render the sharp details in the grass and seagulls. This carefully planned layering sequence enabled me to create the contrast between soft blends and crisp lines.

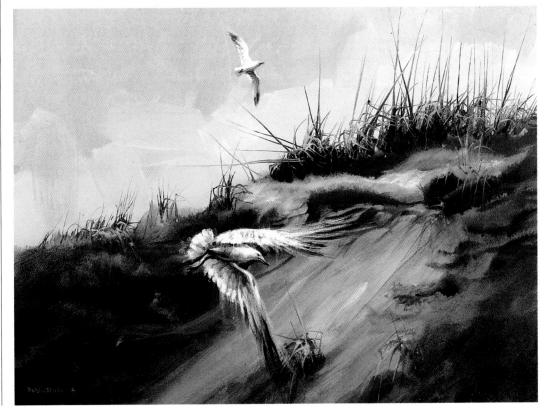

OPAQUE WATERCOLOR TECHNIQUES

DEMONSTRATION

You can use the wet-on-dry method in many ways. You can work in either a loose and brushy or restrained and detailed manner. To achieve the best results and make the picture-building process easier, select your painting techniques beforehand and follow a well-planned layering sequence. If you make mistakes, just paint over them. However, remember that this is a watercolor experience and watercolor compositions are characterized by flowing washes of color; even though the pigments are opaque, they should still primarily be put down in relatively diluted applications. If you like to draw your subject on your surface before you paint, you can still do so.

In this demonstration, I am working flat on a piece of paper mounted over glass and using the following brushes: two brights, a round-tipped watercolor brush, and a small trailer.

Since the thin, opaque washes dry rapidly, I can paint over them almost immediately. Here, I layer white acrylic over the flesh tone in a stroking manner. The advantage to working with acrylics is that I can build up extensive layers without disturbing my underpainting.

After drawing the portrait in lithography crayon, I put down a thin, dark background wash mixture of burnt umber, alizarin crimson, and black. The paint does not flow loosely because it is absorbed by the dry, porous paper.

As I mentioned earlier, a single light source helps to define and solidify structure and form. Here, the source is to my subject's right, and so I apply more light values to the right side of the face.

Using the larger bright brush and a combination of phthalo blue, black, and white, I rough in the man's hair and beard; a mixture of cadmium red light, burnt umber, raw sienna, and white makes the basic flesh color. I use the drawing as a value guide for my shadows and modeling.

The small, round, pointed-tip brush is useful for clarifying petite forms.

With the small trailer, I add fine dark and light lines to the hair and beard.

NICK
Acrylic on construction
paper, 7 1/4 × 7"
(18.4 × 17.8 cm).

The finished study remains somewhat loose and free. I have integrated most of the original drawing lines into the shadows, although I left a few in the hair and eyebrows for crispness and contrast. If I wanted to develop this piece further into a smooth, precise portrait, I could continue with more wash applications and fine brushwork.

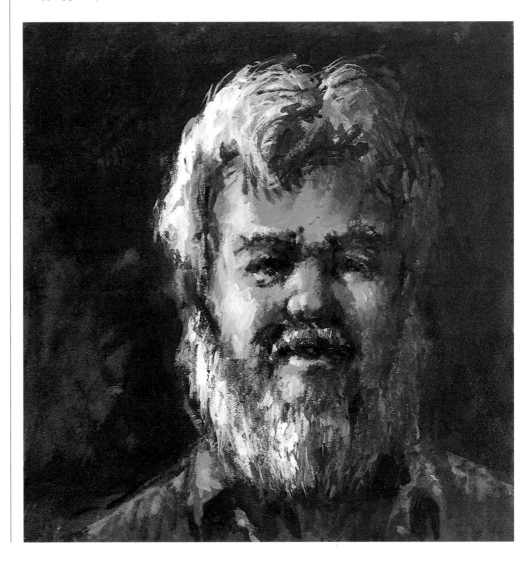

OPAQUE WATERCOLOR TECHNIQUES

DEMONSTRATION: COMBINING WATERCOLOR METHODS

Most creative processes combine various techniques, and painting is no exception. Up until this point, however, we have only examined each basic watercolor method separately. Now we will investigate how to best utilize wet, dry, transparent, and opaque concepts in the same composition. It is actually not that difficult an undertaking, and the results can be exhilarating. Eventually, you will become so proficient that you will blend the techniques without consciously thinking about them.

After sketching in my large compositional masses with a lithography crayon, I saturate my construction-paper surface with water. In order to achieve a visually unified result, you should give one technique precedence over the others. Keeping this in mind, I am working primarily wet-in-wet but will use dry methods for the foreground details.

The initial, somewhat transparent wash spreads out easily on my wet paper.

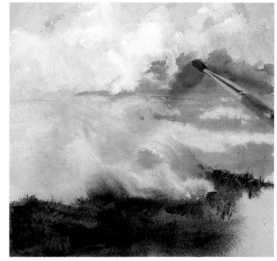

Subsequent color washes blend together well on the wet surface and create an atmosphere of soft, morning mist.

As my painted surface becomes less moist, I add smaller shapes such as distant trees. Timing is critical here— these forms soften but do not bleed away because the paper is in the process of drying. If the surface had been too wet any crisp details would have been lost.

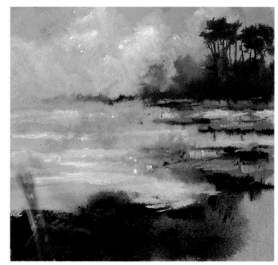

Using opaque paint, I add soft value changes to the water area with my bright brush.

At this stage, the background areas and the foreground underpainting are both complete, so I hasten the drying process with a hair drier.

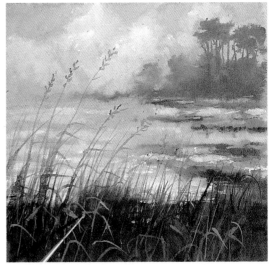

Now, I begin to work in the wet-on-dry method. I apply crisp lines of grass, which contrast with the blended background.

MORNING ON THE COVE
Acrylic on construction paper, 7 × 7¹/₄"
(17.8 × 18.4 cm).

The end result is an atmospheric waterscape comprised of both fluid washes and linear details. You will have no trouble combining methods as long as you follow a logical layering sequence.

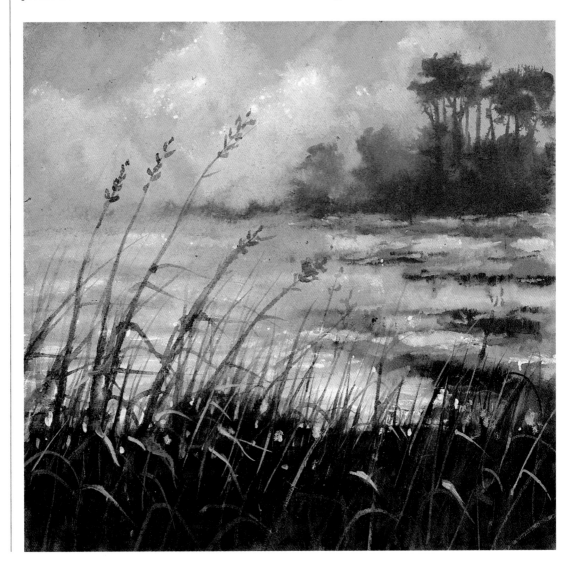

OIL PAINTING TECHNIQUES

When you think of oil painting, you might immediately envision the thick, creamy applications favored by the Dutch artist Vincent van Gogh (1853–1890). However, oil paints are very adaptable and can have a variety of appearances, from textural and almost sculptural to thin and luminously transparent.

You can use acrylic paints in all the traditional oil painting styles, with one distinct advantage: the unique acrylic binder affords you greater flexibility when choosing your surface. When you use oils, your surface or ground cannot be very absorbent; if it is, the oil binder in the paint leaches back into the ground, leaving the pigment on the surface. This causes poor adhesion and weak paint films or layers. Acrylic binder, on the other hand, seals any underlying surface. It is durable and permanent, and you can use it for techniques in which oils or other mediums would be too unstable, such as combinations of oil-paint washes and impasto on absorbent, unprimed paper or cardboard. You should also be aware that acrylics dry more rapidly than oils; with practice you will learn

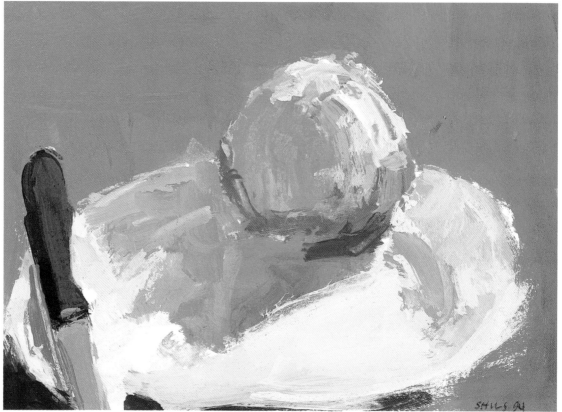

Stuart M. Shils, KNIFE, PLATE, AND ORANGE
Acrylic on Barcham watercolor paper, 4⁷/₈ × 6"
(12.7 × 15.2 cm), 1994. Collection of Karen Segal.

Philadelphia resident Stuart Shils has had numerous solo and group exhibitions both in the United States and abroad, and his work has been profiled in American Artist *and* Art in America.

Shils works alla prima and wet-in-wet and finds that the matte finish and rapid drying time of acrylics provide a very different tactile quality than oils, which he also uses regularly. Since he is so familiar with oil painting techniques, his acrylic compositions often retain a strong oil aesthetic, but, quite interestingly, the rougher, more textural brushwork that he creates with acrylics often appears in his oil paintings. In this still life he formed the orange using a color-layering technique common to the oil-paint medium, yet still managed to retain the characteristically acrylic matte finish.

He uses inexpensive, soft, nylon brushes with short handles, and his palette usually consists of quinacridone red, red earth, cadmium red light, raw sienna, yellow ochre, Hansa yellow medium, light ultramarine blue, cobalt blue, cerulean blue, black, and white.

how to compensate for this characteristic while you are painting. As with previous techniques, in the oil painting method, you can always alter the acrylics' drying time if need be.

In this section, I will substitute acrylics for oils in the following traditional methods: impasto, layering, glazing, and thick and thin paint combination. I will use the stretched-canvas, canvas-board, and primed-panel surfaces typical of the oil paint medium but will also experiment with some nontraditional supports.

It is not my intent to use acrylics to duplicate the oil paint medium exactly but rather to introduce artists who enjoy working with oils to a new medium while using methods with which they are already familiar. Beginning artists can

also explore these basic oil painting techniques, and continue to discover just how versatile acrylics can be.

IMPASTO

Derived from the Italian verb *impastare* (to mix) and related to the word "paste," the term *impasto* describes the layering of pastelike paint on a surface. (The word also means "dough" in Italian.) Typically, impasto applications are raised and textured, and hold the mark of the brush or knife. The impasto style is easy to achieve with oils, which have a basic viscous consistency. The paints need to be thick because if they are too washlike, they will flatten out on your surface as they dry. Working with impasto does not mean, however, that you must cover your entire surface with undiluted paints. There is no set formula for this technique, so you are free to combine it with other processes and paint mixtures.

Many acrylic paints are manufactured in an oil-paint consistency. You can also combine acrylics with a gel medium that acts as a filler (helping the paints to retain a paste viscosity) and extends your painting's open time. You can use as much gel as you like, as long as you do not affect the covering quality of your paints. You can also mix aggregates such as sand or gravel with your paints for increased textural and tactile interest.

Impasto painting requires brushes that have some firmness to their bristles. This is because you are handling heavy paint, and soft bristles are not adequate for this purpose. Palette or painting knives are other useful tools for laying paint on a surface, and they are available in a variety of shapes and sizes. I prefer the pointed, trowel-type knife, which I use to spread and blend colors. You can push your paint up, carve textures into it, and scrape it away. As with brushes, you should use big knives for large, free applications and small ones for details. You can create entire pictures using only these implements, but most artists use them in combination with brushes. If you lack familiarity with knives, experiment with them first in small studies and exercises so that you will get a feel for what they can do. Once you feel confident, you can move on to more serious compositions.

Just as a thin color wash has a unique, luminous beauty, impasto painting also has its own appealing, bold quality. The philosophy here is to relish the simple action of laying paint on a surface.

THE ARTIST
Acrylic on canvas, 30 × 40" (76.2 × 101.6 cm), 1989.
Collection of Dr. and Mrs. Glenn H. Shepard.

Artists working in oils often employ the smooth, blended style seen in this seaside scene. Creating clean, hard edges and graduated values requires concentration and a steady hand. It also requires patience because you may need to repaint some areas several times to eliminate blotches and other irregularities. As I recall, I repainted the sky in this picture three times before I was satisfied with its appearance.

This particular composition is basically one layer because I drew the main sections (the sky, water, boats, and land) on the surface first and then painted them more or less separately. However, I did paint smaller details, such as the figure and bucket, over the boats. I rendered the sky and land areas by first applying the basic colors and values and then blending variations of these hues into the still-wet underpainting with a flat, 2" housepainter's brush. Since acrylics dry rapidly, I worked quickly and kept my paints moist by misting them lightly with water. After the underpainting dried, I used the diluted-edge technique to model the boat forms, along with impasto paint applications to render the figure and bucket.

DEMONSTRATION

The following demonstration should encourage you to experiment freely with impasto. Since you are using acrylics in an opaque manner, you can paint your layers in any order. Every picture does not have to be a big, profound idea, but whatever the size of your project, plan your composition thoroughly before beginning. You may want to try something small at first to get a feel for the technique and tools. Try a knife. Try a brush. Or, use them both. Enjoy your paint!

For this abstraction, I used a flat, a bright, and a 2" housepainter's brush in combination with a painting knife.

A torn and folded color photograph or magazine ad can provide inspiration for an abstract composition. It is also an interesting way to turn a realistic image into an abstract one. Select a picture with interesting colors, shapes, and patterns.

I begin by mixing my first color with my knife. For impasto applications, I combine all my paints with a gloss medium to improve their coverage.

Here, I continue mixing my first color.

I use the 2" brush to cover my surface quickly.

For color variation, I brush pure color into the wet paint.

I establish my basic composition and scrape and spread the previously applied paint over my surface. You can continue to blend colors and create new shapes as long as your paint is moist and fluid.

I also squeeze white paint directly from the tube onto my picture and spread it out using the painting knife.

In this close-up, I use my knife to create raised, linear contours around some of my shapes. Notice the textural contrast between the paint that is applied with a knife (the pink and violet) and that which is brushed on (the white).

PINK AFTERNOON
Acrylic on canvas, 18 × 24"
(45.7 × 61 cm).

By keeping my impasto style loose and free, I am able to emphasize gesture and energy.

THIN, SMOOTH, AND BLENDED

The impasto technique allows you to highlight the three-dimensionality of your brushwork, but you can also apply paints in thin, textureless layers and concentrate on the precise blending of tones and colors. This popular oil painting technique is characterized by a smooth surface finish and a noticeable absence of heavy brushstrokes. You can combine it with impasto (and most paintings do exhibit some impasto passages) but, in general, your surface appearance should be one of overall evenness.

To successfully adapt acrylics to this style of painting, you must be well versed in the basic blending processes and familiar with layering concepts. If you are accustomed to the slow-drying quality of oil paints, you will have to adjust to the shorter acrylic drying time; you will need to work faster, concentrate on one section of your composition at a time, and make extensive use of the diluted-edge and dry-brush blending methods. With acrylics, it is not possible to blend wet-in-wet for an extended length of time; you can moisten your surface with sprays of water, but even so, it will dry quickly.

Stretched, primed canvas is the surface most often associated with this mode of painting, but other good supports are canvas board, wood, and hardboard panels. You can ensure good adhesion by thinning your paints with a 50:50 mixture of gloss medium and water. Doing this will also extend the paints' drying time and give them the lustrous gleam characteristic of oils.

This is a very basic mode of painting with expressive possibilities that can range from loose and suggestive renderings to carefully executed images. In both cases, your painting's finished surface should be even and untextured. I think of this type of painting as classic because of its enduring popularity over the course of history.

CONVOY
Acrylic on canvas,
36 × 48"
(91.4 × 121.9 cm),
1988.

CONVOY (detail)

I painted both the ducks and their reflections in pure white and layered various colors over this using a combination of wet-in-wet, diluted-edge, and dry-brushing methods. I find that small brights and pointed, synthetic watercolor brushes work well for this type of detail.

This simple composition makes use of all the classic, smooth blending techniques and layering concepts. My inspiration for this picture came during a visit to the city park. The clean, sharp pattern of the ducks and their rippled reflections on the dark water immediately attracted my interest, and the subject was a natural one for a dark-value study.

I painted the water first, using both wet-in-wet and diluted-edge blending. To ensure that I would have an abundance of my main color handy, and thereby avoid subsequent remixing, I made up a large quantity of this color in a clean plastic container. To render the ducks, I drew their forms in white chalk on the dried background and then filled them in.

DEMONSTRATION

The dunes in some areas on the outer banks of North Carolina are very high. When the northeasters come, the waves rise, flooding the beach and breaking against the dunes. It is a dramatic event. I have painted this phenomenon many times and in different seasons, and it never ceases to astound me. It is the perfect subject for illustrating how to use thinned acrylics and achieve painterly yet smooth results.

It is a good idea to let your subject dictate your painting sequence. As I mentioned before, a logical working order helps the painting process go smoothly. Simple compositions with large forms and space divisions work best for the single-layer approach, while complex subjects lend themselves to the multiple-layer process. You should also decide which blending technique is best suited to each aspect of your picture. If you encounter difficulty in rendering an area, you can always let your surface dry and paint over it.

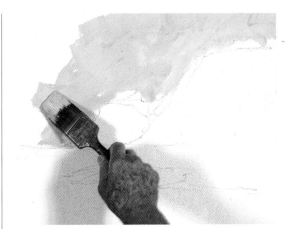

Using a 2" brush and big, painterly strokes, I rough in the sky around the dunes.

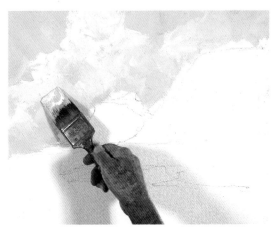

To evoke clouds, I work some undiluted, white paint into the wet sky.

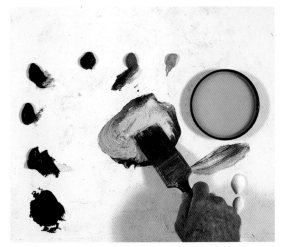

I begin by mixing my basic sky color from white, phthalo blue, raw sienna, and a touch of burnt umber. I then mix this (as I will all my colors) with a 50:50 mixture of acrylic gloss medium and water. This will ensure good adhesion and also give the painting surface the satiny appearance of oil paint.

At this stage, I put down the color for all my big masses. For the light section of the nearest dune, I mix together burnt umber, raw sienna, and white, and for the dark spot, I use burnt umber and dioxine purple. The distant dunes are a combination of phthalo blue, Payne's gray, and white, and the water is a darker version of the sky mixture.

Here, I apply thick paint to the top of the dune. This will become part of the grass.

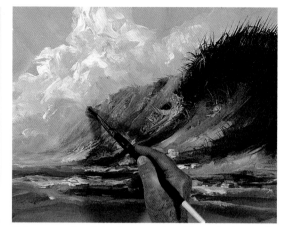

Of course, a brush is also a good tool for softening and blending.

I stroke the wet, dark paint upward with my liner brush.

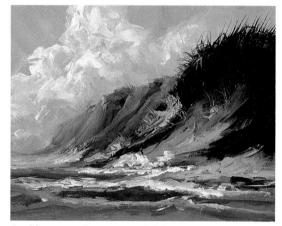

I add crests to the waves and lightly colored grass to the dunes.

Sometimes, when the conditions are right, I use my fingers for blending. In this instance, I rub the sky color into the wet dune to soften the paint edge between the two areas.

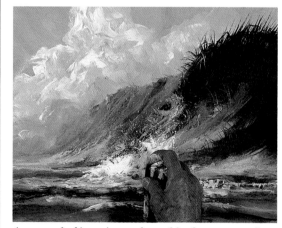

A spray of white paint on the surf further captures the scene's misty atmosphere and contributes a touch of realism.

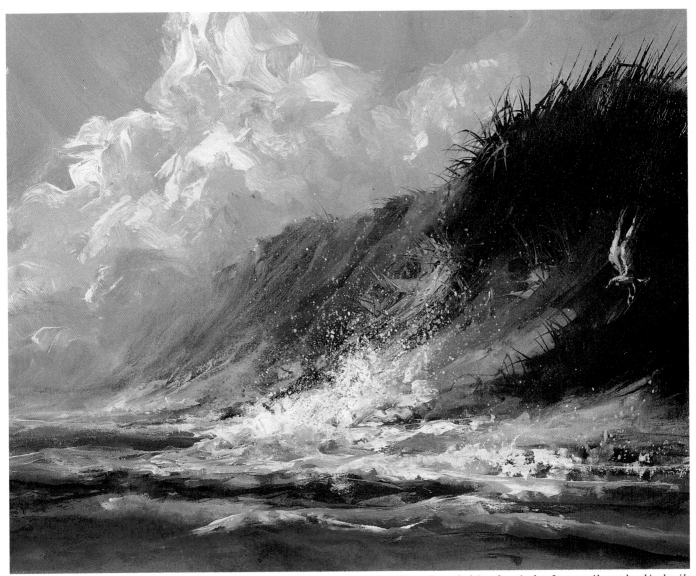

THE OUTER BANKS
Acrylic on canvas, 16 × 20"
(40.6 × 50.8 cm).

In the final stage, I add a lone seagull to my composition. Since the underlying dune is dry, I can easily render this detail without disturbing any previously applied paint. Notice that, even though the brushstrokes are recognizable, the overall surface texture is still smooth and flat.

OIL PAINTING TECHNIQUES

COMBINING THICK AND THIN APPLICATIONS

As I mentioned earlier, most paintings usually exhibit combinations of both thick and thin paint applications. Sometimes this marriage of modes occurs inadvertently during the creative process of picture building; in other instances, the decision to mix techniques is a deliberate one. Either way, this contrast between thick and thin is often both visually dramatic and texturally appealing. If you find that you regularly favor one technique over the other, you should practice integrating the two to gain a better understanding of how this integration process can become a natural way of working. It is unquestionably a worthwhile experience.

This combination process also highlights yet another benefit of acrylics as compared to oils. If

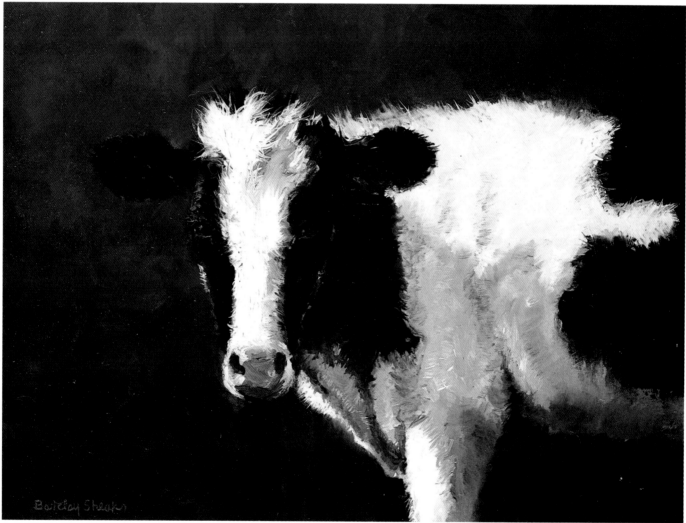

PUZZLE COW
Acrylic on Upson board,
18 × 24" (45.7 × 61 cm).

In this composition, the thin paint of the background complements and contrasts with the thicker, stroked applications on the subject. My cow would not have seemed as realistic and furry if I had not set off the impasto texture of his coat against a smoother background.

you use oil paints, you can only layer a thick application over a thin one because, when dry, the paint cracks if thin is placed over thick. Acrylics, on the other hand, are much less restrictive; with their flexible binder, any layering sequence is acceptable, and they are much less prone to cracking.

A practical approach would be to begin by using thin applications for your background and other large masses and then render your smaller forms and details with thick paint mixtures. The versatility of acrylics makes them ideal for this technique.

Your choice of surface really depends on your own personal preference. I suggest Upson, watercolor, or canvas board for works of up to 24 × 30" and hardboard panels or stretched canvas for anything larger.

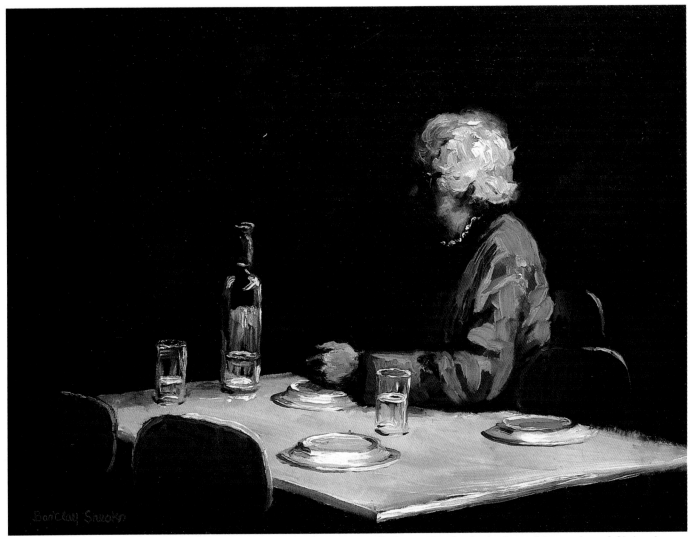

WAITING
Acrylic on Upson board,
18 × 24" (45.7 × 61 cm).

Combining thick and thin paint textures comes naturally for me when I paint in the wet-in-wet style, and this interior scene was no exception. I covered the entire surface with a thin mixture of my dark background color and painted the woman and table over this wet underlayer. When the surface became a little less moist, I added the white, impasto highlights. This layering sequence worked well because, in general, impasto is not readily absorbed into wet underpaint.

DEMONSTRATION

When you combine paint consistencies in one composition, start with a thin underpainting and then place thick applications over this. Devise some sort of game plan, even if you do not follow it exactly. Acrylic paints are forgiving and can cover a myriad of mistakes, but heavy paint buildups are almost impossible to remove once dry. If you attempt to camouflage thick impasto with thin, overlying washes, you may end up with an awkward, lumpy painting.

If your picture is composed mainly of large forms, use the single-layer approach. A complex subject requires multiple layers. As with the previous techniques, if you don't have a big idea, you can always plan a small picture.

For this still life, I begin by covering my canvas board with an undiluted, paste-consistency paint. I sketch my subject into the wet pigment with the tip of my brush handle. At this stage, I can easily paint over any mistakes and redraw the composition.

I continue to build form by working a second layer of color into the bottles and tabletop.

Here, I block in the main shapes and basic colors with thick paints that are all loaded with white.

Here, I define and highlight the bottles, increasing the appearance of transparency. I also add the cast shadows that help anchor the bottles to the table. At this stage the paint starts to dry, so I switch from the wet-in-wet to wet-on-dry approach.

The layer of impasto that I add to the background emphasizes my brushwork.

A small, pointed brush is useful for rendering highlights.

STILL LIFE WITH BOTTLES
Acrylic on canvas board,
15 × 10¹/₂" (38.1 × 26.7 cm).

The finished picture clearly displays the texture of the brushmarks in the thick paint.

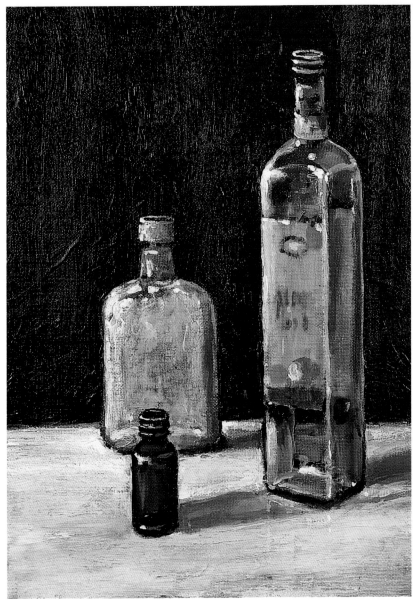

GLAZING

Glazing may well be the most misunderstood concept in painting because there are so many interpretations of both the word and the actual process. In the broadest sense, glazing is the layering of transparent colors one over another. Watercolorists refer to the layering of transparent washes as glazing, but, in reality, a wash and a glaze are quite different in structure and appearance. So, I will treat layering with washes (for watercolor-style painting) and glazing (for oil painting techniques) separately because of their distinct mediums and finished looks.

The term *glazing* stems from the word "glass," and *to glaze* can indeed mean to fit with glass, as well as to coat with a glaze. (A glaze is a glossy, liquid preparation.) We have all noticed the beauty of light passing through a stained-glass window or a glass vase. The refracted, concentrated light creates a brilliant glow and luminous color, and a glaze has a similar effect on paint. To make a true glaze you combine a clear, viscous liquid with your paint. The result is a glassy, transparent mixture that holds its pigment particles in suspension above your support. Light passes through a glaze to your underlying surface and is reflected back to the eye. When the glaze dries, the colored particles remain suspended in the clear, hardened medium.

To my eyes, there is little that is glass- or glazelike about a dry watercolor wash, and this is due to the fundamental difference between a wash and a glaze. Whereas in a glaze the pigment particles remain suspended, in a simple water wash they sink downward. They settle directly onto the painting's surface, preventing light from moving around and underneath them. Once the water dries, the resulting composition has a chalky, mattelike finish.

To make a traditional oil painting glaze, you mix oil paint with either varnish or an oil painting medium that has varnish in it. Unfortunately, this mixture takes a long time to dry, making a multilayered glazing process very time-consuming. To make fast-drying, acrylic glaze, mix acrylic paint with acrylic gloss medium. This mixture allows you to complete multilayer applications in a matter of minutes with the aid of a hair drier.

A glaze can be either thick or thin, but it will not be effective if it is diluted to a watery consistency. A thin mixture is more appropriate for a smooth application and should be applied with a fine-bristled brush. A thick glaze enables you to create interesting, brushy surface textures that enhance your pictures. To make a thicker glaze, mix your paint with acrylic gel medium; apply it to your painting using either a brush or a

AUTUMN CLASSIC
Acrylic on Masonite, 36 × 48"
(91.4 × 121.9 cm), c. 1960.

In the late 1950s and early 1960s I began to realize how glazing, when used effectively, could enhance the luminosity of color. This discovery inspired me to paint a series of autumn scenes, of which this picture was one of the first. I began my composition by blocking in the main areas of color: light yellow for the trees and field, and light blue for the sky. Then I glazed alizarin crimson over the trees, yellow ochre and burnt umber over the field, and phthalo blue over the sky. I used a mixture of gloss medium and water to create my glazes.

palette knife. You can mix small amounts of glaze directly on your palette, but you should use a separate container to hold larger quantities.

No matter how thick or thin a glaze is, it always darkens and enriches the area to which it is applied, and it always has some color in it. (Clear, colorless mixtures are called varnishes.) You can apply a glaze to your entire painting surface or to just one specific part, but you must always be aware of the underlying color and value so that you can achieve the effects you want. The interaction of your surface hue and glaze will introduce a new color to, and change, your composition. The effect is similar to wearing tinted glasses while looking at your painting. For example, a blue glaze placed over a pink surface will create a luminous, lavender-pink cast.

Glazing has all sorts of functions. Use it to render shadows without obliterating previously painted details. For example, paint a tree in a field of grass, and then glaze the tree's shadow *over* this grass. In portraiture or figure painting,

glazing can enhance color and give added depth to form. This is helpful if you want to increase the blush in a person's cheeks or add luster to hair. A glaze over your entire picture can serve to tie all your colors together by creating a common tint or cast over the composition. Use a glaze to capture the vibrant coloring of sunlit skies and the warmth of autumn foliage. To capture transparent, colored glass, render your underlayer in black and white, and glaze the colors over it. Of course, not every painting requires glazing, and the technique is usually most effective as a final touch to a nearly completed picture.

Before you apply a glaze to your work, test its transparency on a white surface. Note that your glaze will look milky when you first apply it to a colored or dark underlayer, but this cloudiness will disappear as the glaze dries. Experiment using both single and multiple layers of glaze so that you will discover as many new and intriguing color experiences as you can. As you will see, glazing can enhance the beauty of any composition.

THE FRENCH MARKET
Acrylic on Masonite, 30 × 24"
(76.2 × 61 cm), 1966.

This picture was the result of a painting trip to New Orleans. First, I sketched the composition on the raw Masonite with a lithography crayon. Then I painted the light areas with thin, opaque mixtures and glazed over them with color. I created the dark sections entirely with colored glazes, using the brown of the raw Masonite (some of which is still visible in the background) as an undercolor. I painted the flowers white and then glazed color over them.

OIL PAINTING TECHNIQUES

DEMONSTRATION

This demonstration will take you step-by-step through the basic, multilayer glazing approach. When you begin to experiment with glazing, make sure you select an appropriate subject. Objects that are made from transparent colored glass are good choices. Use glazes of different colors, and remember to always test your glaze mixes on a white surface before applying them to your painting. Think, "Luminosity."

This monochromatic still-life study is a good foundation over which to illustrate the glazing process and the concept of transparent layering. My subject is a wine bottle and three glasses, two of which will be colored.

Here, I mix my first glaze from paint and undiluted acrylic gloss medium.

Using this green glaze, I cover my bottle first, even though it is the most distant object in my composition. The glaze is transparent enough to let the glasses show through.

In this illustration you can see how one glaze looks when it is placed over another. The violet and green colors create a third hue, just as they would if light were really shining through them.

I add a blue glaze over the right-hand glass, and to finish the study, I render the light, opaque highlights and the shadows that anchor my objects to the table beneath them.

OIL PAINTING TECHNIQUES

This monochromatic study of a coastal marsh (top) is the underpainting over which I will apply my glazes.

For the pale background sky tint I combined very small amounts of yellow ochre and cadmium orange with undiluted gloss medium (middle). I often begin with light-value glazes until I discover what direction my composition will take. I do this because glazes cannot be removed once they are dry, and the overuse of dark values at this early stage might ruin the painting. I can always darken areas later with richer glaze layers.

While this first application is still wet, I remove any unwanted glaze with a paper towel (bottom).

DEMONSTRATION

In this second glazing demonstration I use glazes to capture the atmosphere and mood of an early evening scene. The glazes easily impart a warm overall tone that would otherwise be difficult to translate from nature to canvas.

In this photograph you can see the first glazes on both the water and the sky.

I use alizarin crimson and cadmium orange glazes to add color to the marsh and water reflections.

Touches of a phthalo blue glaze create sparkle and color contrast. I use a small, pointed brush to render these small details.

EVENING LIGHT
Acrylic on canvas, 16 × 20"
(40.6 × 50.8 cm).

*In the final stages
I add touches of
alizarin crimson
and violet glazes to
the sky, water, and
marsh vegetation.
The glazing technique
enables me to capture
the natural, glowing
light of this scene as
no other method can.
It is an important
painting technique
with its own unique
value.*

AFTERGLOW
Acrylic on canvas, 24 × 30"
(61 × 76.2 cm). Collection
of Mark Myers.

*This painting was
created in much the
same manner as the
one in the preceding
demonstration. In
fact, the two subjects
are from the same
location—Assateague
Island. I began with
a monochromatic
underpainting and
added the tints with
transparent layers
of glazes.*

Acrylics as Egg Tempera

The egg tempera medium derives its name from its egg-yolk binder. The yolk is diluted with water and then mixed with powdered pigments to form the paint. We usually envision the traditional egg tempera picture as one made up of delicate details that were executed with fine brushstroking. The surface is most likely gesso-primed panel, and we think of smooth, matte finishes with no heavy paint buildups. In most instances, this visual identity results from the physical characteristics of the egg-yolk binder, which is an excellent one but does not allow for thick layers or impasto applications without cracking. In addition, the traditional gesso used with this technique is a form of plaster, which absorbs paint quickly and leaves relatively little time for blending. Consequently, painters working in this medium use small, rapid brushstrokes to blend colors and soften edges. Painting with true egg tempera is a laborious process that requires the skill and patience of a master chemist in order to determine what amounts of water, pigment powder, and egg yolk to use. This is perhaps the main reason most artists forgo this medium and switch to watercolors, oils, or acrylics.

You can, however, simulate the appearance of egg tempera with acrylic paints and acrylic gesso-primed panels. You can stroke, layer, dry brush, and otherwise manipulate acrylics in much the same way as you would egg tempera. The traditional tempera surface is wood or hardboard panel because the plaster gesso and egg tempera paint are both somewhat brittle and require substantial support. Canvas would not be rigid enough to sustain these mixtures and prevent

THE SENTINEL
Acrylic on canvas,
30 × 40"
(76.2 × 101.6 cm),
1984.

Traditional egg tempera is executed almost exclusively on gesso-primed hardboard panel. With acrylics, however, tempera techniques can be executed on a variety of surfaces, including the stretched canvas I've used here. For this picture, my layering sequence and rendering techniques were identical to those I would have used with actual egg tempera. I put down my basic colors and values first, let them dry, and then created the details over them using dry brushing. I applied several coats of a protective, satin-finish medium/varnish to the finished painting.

cracking. With acrylics, though, this is not a problem. You can work on stretched canvas, as long as you prime it with *acrylic* (not plaster) gesso.

In this section, I will focus on the brushwork techniques (for texturing and resolving form) that are usually associated with egg tempera. You may find that this careful, controlled execution lacks spontaneity, but these procedures also offer an excellent opportunity to discover, or become reacquainted with, the beauty of fine lines and precise formal renderings. Acrylics are ideal for this because they free you from the cumbersome and technical tempera-mixing process, and they allow you to combine the look of this traditional medium with a variety of flexible application methods, including more fluid and individualistic interpretations.

You can use either paste or liquid paints, but the paste consistency requires more diluting. For your medium mixture, use a 50:50 ratio of water to matte medium. It will ensure good adhesion and give your painting surface the dry, matte finish characteristic of egg tempera paintings. Some artists use a gloss medium, and I personally prefer the gloss because it adds some sheen and richness to the colors, but this is simply a matter of taste. Since a panel of some sort is the traditional egg tempera support, I will work primarily on primed Masonite. A firm, solid, and resilient hardboard panel is unlike any other surface; it is worthwhile to discover the advantages, disadvantages, and aesthetic quality of it. For brushes, I suggest using the sablelike watercolor variety for the small areas and detailwork prevalent in the tempera technique.

The finished surface of an egg tempera-style acrylic painting is rather delicate. To protect it, cover it with a coat of matte- or gloss-finish acrylic varnish (see "Protecting Finished Works").

J. Robert Burnell,
LOW TIDE
Acrylic on linen,
24 × 36"
(61 × 91.4 cm).

Virginia artist J. Robert Burnell is known for his vivid and honest depictions of life on the Chesapeake Bay. However, he does equal justice to his mountainside and farmland scenes. For this harbor study executed in the egg tempera style, Burnell primed his linen surface with four coats of gesso that he had tinted with cobalt blue paint. He then made a preliminary pencil drawing on tracing paper and transferred it to his canvas.

Burnell prefers liquid acrylics but also uses some tube colors, which he dilutes to liquid consistency. For this painting, he combined his paints with an 80:20 water/acrylic-medium mixture and then applied them to his surface using small, delicate brushstrokes. His palette consisted of burnt sienna, alizarin crimson, Naples yellow, cobalt blue, phthalo blue, cadmium orange, titanium white, and carbon black.

DEMONSTRATION

In the winter on Assateague Island the deer come out to feed in late afternoon and evening as the landscape takes on a rich, warm glow from the setting sun.

I photographed this young doe along the edge of a marsh at dusk, just as she looked up at me, and then used the photo, along with some preliminary sketches, to compose the painting in this egg tempera-style demonstration.

Even though I am working here in a tempera style, I am free to experiment with washes because I am using flexible, washy acrylic paints. Of course, the working sequence is still important; as I mentioned previously, this painting technique lends itself well to detailed rendering, and you can layer the more delicate brushwork over any larger, looser areas. Remember that mistakes are not final; just gesso over the afflicted area, or even the entire painting, and start again.

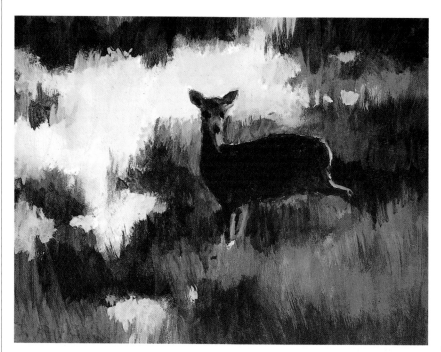

Before starting to paint, I sketched the subject and background areas on the surface with a pencil. Since I want to capture the warmth of the marsh just before dusk, I select raw sienna, yellow ochre, burnt umber, cadmium orange, cadmium red, ivory black, and titanium white for my palette. To replace the traditional egg yolk binder, I use a 50:50 mixture of matte medium and water. In this first stage (top), my goal is to establish the big areas of basic color. Using ¹/₂" bright, ³/₄" flat, and pointed-tip brushes, I put down the thin applications that simulate grass and vegetation.

Then, I add some detail to the grass and water, and I also further develop the form of the deer (bottom). The composition is now ready for the final elements.

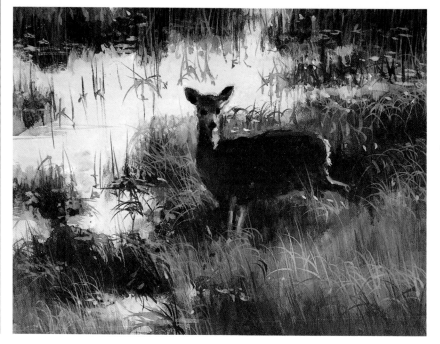

In this close-up, I render some delicate brushstrokes with a liner brush.

I let the paint dry and scratch in more linear details with my utility knife. I like this tool because with it I can really control the length and width of my lines. The thin, dry paint layers come off easily, exposing the white gesso ground underneath.

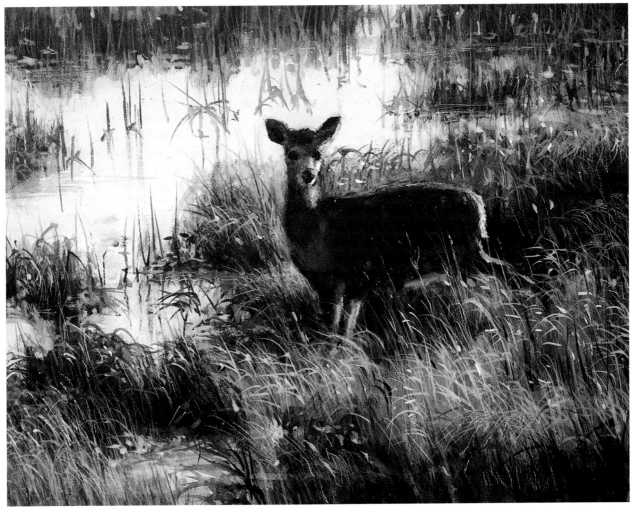

LATE AFTERNOON—WINTER
Acrylic on Masonite,
8½ × 11" (21.6 × 27.9 cm).

To preserve my painting's surface I give it several coats of satin-finish medium/varnish.

COMBINING PAINTING TECHNIQUES

As we have seen, among the many advantages of acrylic paint is the flexibility of its binder, which allows you to safely combine painting styles that are borrowed from all types of mediums. For example, use transparent, semiopaque, and opaque watercolor-style washes alongside impasto oil painting-style applications. Or, choose a gloss-finish medium to break away from the traditional matte acrylic look. The options are endless. This approach might present just the right way to handle an awkward area or achieve a desired visual effect in your picture.

The versatility of acrylics increases your artistic options and allows you to create technically sound and enduring pictures. You can even use fugitive surface materials because acrylic paints act as preservatives, sealing and protecting their underlying supports. The more you experiment with this medium, the more you will discover what makes it uniquely acrylic.

LOWLAND AUTUMN
Acrylic on Upson board, 18 × 24"
(45.7 × 61 cm).

If any of my pictures could be classified as uniquely acrylic it would be this one. In a feat that would probably not be possible with other mediums, I incorporated a large number of basic painting concepts and techniques into one unified composition. I started with a wet Upson board surface that absorbs moisture and remains wet for an extended time period. In the background, where the trees meet the sky, I combined wet, opaque, and semiopaque techniques to create the running and bleeding effects associated with traditional watercolor. After starting with this wet-in-wet method, I let my composition follow its own direction. In this way, I was able to develop a stimulating and spontaneous contrast between transparent and opaque areas. The marsh areas below the treeline exhibit both transparent and opaque passages in wash- and paste-consistency layers. Only acrylics would afford me this much latitude and freedom.

PAINTING ON WET CANVAS

The technique of applying paint washes to water-saturated, unprimed cotton canvas would be a highly unsound practice in any water-based medium other than acrylic. This technique is appealing because it allows you to work on canvas and still achieve the soft blends of color and rich bleeding effects associated with watercolor. You can craft entire pictures using this technique exclusively, or you can combine this method with traditional types of paint application methods. A popular variation of this approach is *staining*, which is the process of painting with thin, transparent washes on raw, wet or dry canvas. A canvas surface is responsive to both opaque and transparent paint applications.

Cotton canvas works best for this approach because of its even weave. (Note that the oil in raw linen makes it unsuitable for this technique.) As in the wet-in-wet watercolor technique, you should keep your surface horizontal except for momentary tilting to accelerate running and bleeding. Your canvas can be either unmounted or stretched on a frame, but wet canvas does shrink as it dries and your image may be distorted if it is not attached to some sort of support. For this reason, most traditional, realistic subjects are better suited to stretched-canvas surfaces.

Begin by saturating your raw canvas with water. You may find that the water puddles up on the surface instead of penetrating it. If this happens, push and scrub the water into the canvas with a large, housepainter's brush. You can also use your hands for this. Weather permitting, I take large canvases outside and wet them with a garden hose.

When you are planning your work space, you should keep the size of your composition in mind. Small, wet canvases are easy to manipulate and will create few studio space problems; you can simply place them on a table. Large canvases require more space, and they also drip on the floor. If you cannot reach every area of your picture from one position you will need space to walk around the entire canvas as you paint. For my big compositions, I place upside-down garbage cans under each corner of my canvas for support—for me they are exactly the right height.

You can use either the paste- or liquid-consistency paints, but, as in watercolor painting, the liquid variety creates the best bleeds. Be aware that the wetness of the canvas, combined with the absorbency of woven fabric, will dilute paint colors. Details may disappear and values may lighten, so you should use paints with the most concentrated pigments. As with any wet technique, you can keep your surface damp by spraying it periodically with more water, and when your picture is complete, you should protect it with several coats of acrylic varnish.

THE STORM WATCHERS
Acrylic on canvas, 48 × 60"
(121.9 × 152.4 cm). Collection
of Christopher Newport University.
Gift of Sue Bartley Myers.

For this picture, I first saturated my unprimed canvas with water and then painted the three large areas of sky, water, and sand while the surface was still very wet. The watercolory bleeding effects suggested the soft horizon, surf, spray, and shadows in the sand. The figures were the last details that I rendered. The whole procedure was nearly identical to that of painting in the opaque watercolor style on wet paper.

PAINTING ON WET CANVAS

Before beginning, I scrubbed my stretched, primed canvas with a powdered cleanser and water to remove any impurities. (Doing this also encourages the fabric to hold water evenly.) After the surface is dry, I saturate it with warm water and start applying my first wash of background color.

Notice the bleeding effects at the point where the two colors of my background meet. These soft edges are easy to achieve when your surface, as well as your medium, is wet.

DEMONSTRATION: ACRYLICS AS OPAQUE WATERCOLOR ON WET CANVAS

Since wetness is the essence of this technique, you should make sure that your canvas is thoroughly soaked before you begin to paint. To compensate for the absorbency of your wet canvas, use color mixtures that are a little brighter, thicker, and more concentrated than usual. If you experience difficulty in blending your paints once you have applied them to your canvas, spray your surface with water.

As with both the opaque and transparent wet-in-wet methods, not all paint applications have to be wet and runny. As your canvas dries, you can create small, hard-edge forms over large wash areas, and you can paint even more details after the surface is thoroughly dry. You will, however, encounter fewer problems with this style of painting if you select a subject that is appropriate for this method—one that does not require a lot of fine detail.

A liner brush is good for rendering small strokes that simulate grass, flowers, and other vegetation.

I keep my surface wet and fluid by spritzing it with water.

The blossoms and weeds that I add here melt partially into my wet background. Discovering the right degree of wetness takes some trial and error; paint mixtures that are too thin sometimes dissolve on the wet surface and disappear completely.

Here, I flick and spatter both light and dark values into the wet foliage to create visual unity with a soft overall texture.

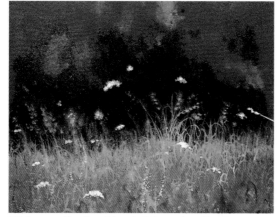

With a small pointed brush, I form the white Queen Anne's Lace blossoms; I use undiluted, paste-consistency paint to restrict bleeding.

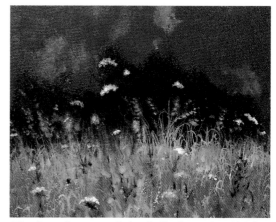

The picture is now ready for the final stage in which I resolve the subjects and complete the details.

MOONLACE STUDY
Acrylic on canvas, 16 × 20"
(40.6 × 50.8 cm).

To complete the composition, I add more Queen Anne's Lace and grass as the canvas dries.

COLLAGE

For our purposes, a collage is a picture that has been made in part by gluing, or otherwise attaching, objects, found images, and textural materials to a surface. The composition can consist solely of these things or it can also incorporate elements of art such as drawing, painting, photographic processes, and printmaking, among others.

As a mode of creative expression, collage has an infinite number of possibilities, and we will examine a few of these, focusing on how to use them in conjunction with our acrylic techniques. Acrylics can give your collage the permanency it would otherwise lack. The preservative qualities of both the acrylic gel and liquid mediums, and of the paints themselves, can be used to protect whatever more fugitive collage materials you are working with. And unlike glue, the acrylic mediums make successful adhesives because they retain their flexibility when they are dry and do not stain the materials they touch.

You can choose any surface, from paper to canvas, as long as it will sustain your collage objects. For example, any ground except extremely thin paper would be appropriate to support paper, thin cardboard, and other lightweight materials.

If your collage objects are heavier, you should use canvas board, hardboard, or plywood for your supports. Note that the stronger panels are less likely to warp.

To better understand the different types of collages, I have divided them, by material, into four broad categories. These descriptions are certainly not all inclusive, but they should serve as a general guide and give some focus to this section.

- *The Found-Image Collage.* This is a collage composed of materials that you find, rather than create. They could be photographs, bottle labels, newspapers, magazines, and so on, and you can use them either in part or whole.
- *The Textured-Materials Collage.* As its name implies, this collage combines different types of textured materials including fabric, corrugated cardboard, wood, carpet, plastic, string, hair, mesh, and small objects such as buttons, matchbooks, nails, screws, and unusual personal mementos. I know one artist who created a collage using lint from a clothes drier.
- *The Manipulated-Shape Collage.* The focus in this type of collage is how you manipulate your chosen materials. In this process, you soak your materials with acrylic medium and then fold, crumple, crease, and push them into unique forms and configurations, creating both

John Alan Stock,
POETRY OF YOSEMITE
Acrylic and Japanese paper on Arches 300-lb. watercolor paper, 1993.

John Alan Stock is a painter and an architect whose strong sense of structure, form, and spatial relationships has contributed greatly to his art. He enhanced this acrylic painting with collage to capture the powerful presence and deep, earthy hues of the landscape. He began by roughing in the overall layout of forms and values and then layered paint and collage over this. For his collage materials, Stock chose Japanese kochi and kozo paper, as well as old newspaper, all of which he painted over in some sections. He attached them to his surface with gel medium and covered everything with a diluted wash of color.

low and high relief (or three-dimensionality). Thin paper and fabric work extremely well.

- *The Cut- or Torn-Paper Collage.* To make this collage, cut or tear colored paper into different sizes and shapes and glue them onto your surface. You can also paint your paper with acrylics to get the exact colors you want. Many artists prefer to use their own painted paper because the colors are less fugitive than the dyes in commercial products.

If you combine the above four techniques, you will have an endless supply of creative options.

No matter which type of collage project you undertake, you must secure your objects well to your surface. To glue down lightweight paper, cardboard, found images, and textured materials, use undiluted acrylic liquid medium. Coat both your surface and your collage material liberally with the medium and press them together. A firm brush is useful for smoothing out wrinkles and air bubbles. Or, for textural purposes, you can intentionally crease or pucker the paper with your hand while the medium is still wet. To glue down paper so that it will dry without lumps, first soak and expand it in a 50:50 water and medium mixture. Coat your surface with this medium, too, gently press the paper onto the surface, and smooth it. Apply more medium, and let dry.

To secure heavy, absorbent materials such as wood, felt, and thick cardboard, use acrylic gel medium. Apply it liberally to both your object and surface, and press them together. Small objects, such as seeds, beads, stones, and pieces of glass, should also be covered with a thin coat of gel after they are glued down; this will ensure permanent adhesion. To better preserve your finished collage, cover it with several coats of acrylic varnish.

French paper used for the collage at left.

UNTITLED (TEXTURED-MATERIALS COLLAGE)
Acrylic and paper on Upson board, 15 1/2 × 16" (39.4 × 40.6 cm).

I cut and tore the shapes in this composition from various textured and patterned French papers (see illustration at right) and adhered them to my Upson-board surface with undiluted acrylic matte medium. During the gluing process, I folded some of my paper to create the overall flow of my composition. I used both white paint and a gold glaze, made from a mixture of cadmium orange and yellow ochre, to add color and value contrast. When the collage was finished, I coated it twice with satin-finish matte varnish.

DEMONSTRATION

Before beginning, you should determine a general working order so that your finished collage does not resemble a disorganized bulletin board. Don't incorporate too many disparate elements—it is usually best to start with large, simple shapes or objects and then add to them. If areas of your composition are too busy, simplify them with coverings of paint. Note that you will always have the ingredients for an interesting collage if you start collecting materials ahead of time, rather than waiting until you are ready to create.

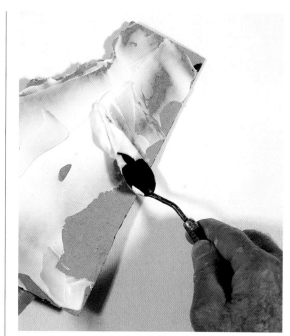

Here, I coat the back of a cardboard rock shape with the acrylic gel medium that I am using as my adhesive. The gel medium is best for gluing down heavy materials.

For this collage, I am using a tall, elongated format and an expressive style that falls between semiabstraction and realism. In this way, I will be able to explore the abstract, dynamic force of my subject—the surf breaking over rocks. My pencil sketch defines the linear thrust of the picture's structure.

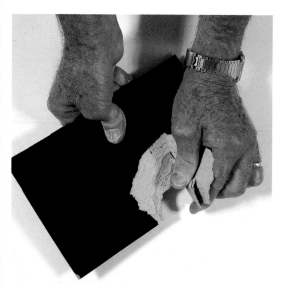

An integral part of collage is the physical activity of working with various materials. In this photograph, I tear cardboard into the shapes that will eventually become the rock forms in my composition.

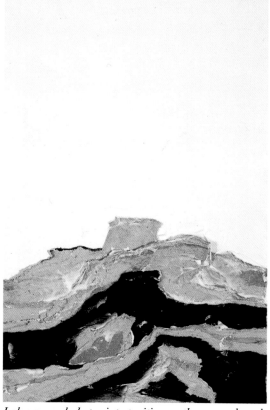

I glue my rock shapes into position on the canvas board.

Next, I apply a generous coating of acrylic liquid medium to the parts of the board that are still exposed. I will put down a layer of tissue paper over this medium.

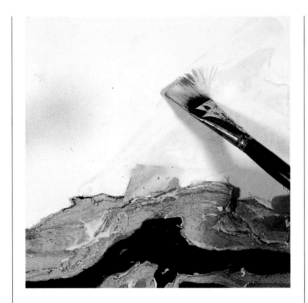

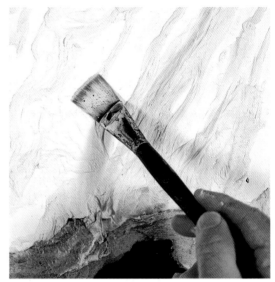

You can also apply medium with a brush.

Now, I pour matte medium directly onto the tissue paper. This will help me to model and create form.

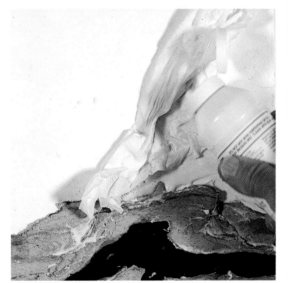

Sometimes your hands are your best tools. Here, I use my fingers to shape the waves.

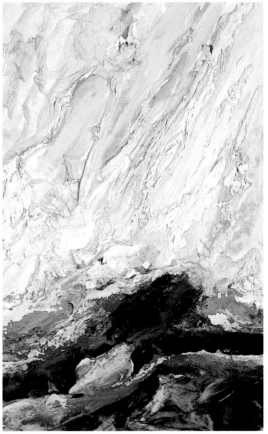

I add color to the composition with diluted opaque and transparent paint mixtures.

COLLAGE

Flicking and spattering suggest ocean spray and help to integrate the foreground with the background.

SURF AND ROCKS
Acrylic and collage on illustration
board, 14 × 9" (35.6 × 22.9 cm).

Several coats of satin-finish medium/varnish will protect and preserve the collage.

WORKING WITH GEL MEDIUM

Acrylic gel medium is unmatched as a creative tool. As previously demonstrated, it is an excellent adhesive and paint extender. But, what makes it so fascinating is its plasticity. It is this quality that enables you to use gel medium in very sculptural ways; you can build form or create transparent layers into which objects can be imbedded. This will be my focus here.

DEMONSTRATION: CREATING SCULPTURAL EFFECTS WITH GEL MEDIUM

This demonstration illustrates the true flexibility of acrylic gel medium. Along with more traditional materials, such as acrylic paints, I will be using aluminum foil, leaves, and Liquitex matte gel. The Liquitex gel has a medium-thick consistency, is easily molded, and becomes transparent (or semiopaque depending on the thickness of your application) when dry. Note that the gel may take a few days to dry, so you will have to be patient with your creative process.

I begin by spreading gel on my canvas board. A palette knife is a good tool for this. I tear the aluminum foil into shapes and arrange them on the wet board. When I am satisfied with their placement, I press them down into the gel.

Here, I use my palette knife to cover the foil with more gel.

Next, I arrange the leaves and press them into the gel.

Using my palette knife again, I coat the leaves with gel.

On a separate Styrofoam surface, I create forms in some gel. Once they dry, I will remove them from the Styrofoam and incorporate them into my collage.

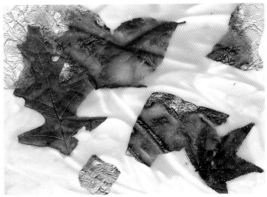

After drying for four days, the foil and leaves are clearly visible through the layers of gel.

WORKING WITH GEL MEDIUM

At this point, I pull the gel off the Styrofoam and cut it into shapes using a pair of scissors.

I apply a fresh coat of gel to my composition and press my dry gel shapes into it. As it did with the foil and leaves, the wet gel acts as an adhesive and holds the pieces in place.

Here, I put down a glaze of acrylic paint and gloss medium over the sculpted surface. I keep the glaze very transparent so as not to obscure the foil and leaves.

I brush an opaque, soft yellow color over the surface to highlight its textural quality.

AUTUMN AFTERNOON
Acrylic, acrylic gel medium, aluminum foil, and leaves on canvas board, 10³/₄ × 7¹/₂" (27.3 × 19.1 cm).

All the components come together in the finished composition to form a unified whole.

RELIEF PAINTING

Acrylic is an ideal medium for creating durable reliefs. A *relief* is a sculptural mode of representation where forms become three-dimensional and are distinguishable from the surface or picture plane. To make a relief, you build up a foundation with layers of acrylic modeling paste and then paint over it. The actual process is similar to applying impasto with a palette knife, and there is also some resemblance between the finished appearances of the two techniques. Of course, you could build up the relief entirely with paint, but this is not very practical because you would need an exorbitant amount of it—the process would be too expensive. Acrylic modeling paste is specifically formulated for dense, heavy buildups, is less costly than paint, and exhibits very little shrinkage when it dries.

The durability of a relief made from acrylic modeling paste is amazing. Some 30 years ago I mounted a large relief painting on an outside wall of my summer studio on the Chesapeake Bay. It is exposed to all the elements, including wind, rain, and sleet, and the only maintenance I give it is an occasional rinsing with a garden hose. Yet it is still in near-perfect condition—something that could not be said of many other artworks that undergo this kind of treatment.

Most art supply manufacturers market some type of acrylic modeling paste. The various brands may differ in composition and appearance, but they are all formulated to be used for heavy buildups and sculptural purposes. If you cannot locate artists' acrylic modeling paste, you can substitute an acrylic- or vinyl-based spackling material, which is available at most hardware and construction supply stores. Although this is not intended for artistic purposes, it will suffice. Do not use any oil-based putties or other compounds, as they are not compatible with acrylics.

The tools required for this technique are familiar ones: mostly painting knives and brushes. As you experiment, you will probably discover other useful implements for manipulating the paste, such as putty knives, combs, trowels, and spatulas. While working in this technique, keep your tools in water so that the paste doesn't dry on them. Moist paste is easier to remove; once it dries, you must scrape it off your tools with a single-edge razor blade or other sharp instrument. Burnish your palette knives with steel wool after you clean them.

For supports, choose materials that are strong and have some density. Panels of some sort work best: for smaller compositions (from $9 \times 12"$ to $18 \times 24"$) use canvas board; for larger works use plywood or hardboard. I prefer tempered Masonite because of its strength and durability. Anything larger than 48" square should have a frame or support on the back. When you work with hardboard panels they should be from $1/8"$ to $1/4"$ thick. With plywood, use a $1/4"$ thickness for smaller pictures and a $3/8"$ or greater thickness for larger ones. Panels of any material will warp if not stored properly, so keep your boards either completely flat or completely upright with nothing resting on top of them.

No matter which support you choose, it must have a surface texture so that there is something for the first application of paste to adhere to. Canvas board requires no preparation because

FOSSIL FISH
Acrylic and acrylic modeling paste on Masonite, $12 \times 24"$ (30.5 × 61 cm), 1961.

An actual fish skeleton was my inspiration for this fossil-like relief. I modeled the background with my palette knife and used the extruded line technique to delineate my subject. I applied the black paint first, let it dry, and dry-brushed the light colors over it.

RELIEF PAINTING

it already has a texture. If you use hardboard or plywood, on the other hand, you will have to abrade the surface using medium to rough sandpaper. Don't worry about overabrading: the more scratches, the better the adhesion. After sanding, clean your surface with powdered cleanser and water to remove the sawdust and any other foreign substances. Once it is dry, you are ready to begin. Some artists also prime their panels with acrylic gesso; this facilitates paste application by creating a surface on which the paste is easy to apply and manipulate.

Creating a relief is an engaging, delightful, and tactile process akin to icing a cake or building a sandcastle, and there are many ways to approach it. You can apply the paste straight from the can and manipulate it using a palette knife. Or, if it is too thick, you can dilute it by adding small amounts of gloss or matte medium. Note, however, that mixtures that are too thin will shrink and flatten out as they dry, and dried applications are difficult to remove (although you can build over them). To start, scoop some paste from the container with the palette knife and begin sculpting your subject using the flat side of the blade. Use the tip of the blade to create small forms or incised textures. As you continue, the sculpting process will develop naturally.

One interesting modeling method is the extruded line technique. You create ridges by pushing your paste through the nozzle of a squeezable container. You can also try a cloth or plastic bag with a hole in it, similar to what a pastry chef uses to apply whipped cream or frosting. The squirt bottle will require a thinner mixture than the plastic bag, so you should experiment to find the best consistency. Acrylic medium and just a little water make the best diluent.

The sculpting process may be lengthy for some subjects, so have patience. Your relief may require many layers before it is built up to a satisfactory height. You can also cut into and sand the dried paste. Once the relief is thoroughly dry, it is ready for the paint. You can apply your paints in the same manner that you would for a conventional, two-dimensional picture. Another approach is to first coat the entire relief surface with black or some other dark color, and then layer lighter colors over this, allowing the dark underpainting to show through in crevices and other textured areas. I prefer this method because I feel that it enhances the sculptural aspect of my work. Either way, there is little danger of losing the subject, since it exists in bold relief. You should protect your finished relief with several coats of acrylic varnish.

STUDY OF A WATERMAN
Acrylic and acrylic modeling paste on Masonite, 28 × 24" (71.1 × 61 cm), 1961. Collection of Dr. and Mrs. Glenn H. Shepard.

I used a palette knife to incise the figure into the dark underpainting. To render the rope and chair caning, I employed the extruded line technique.

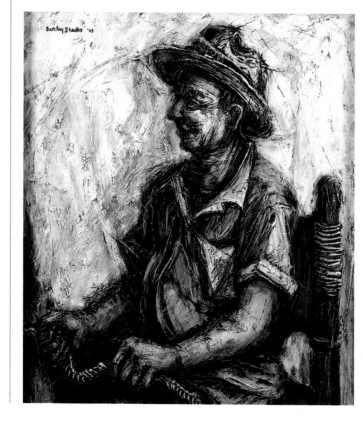

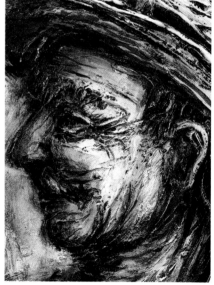

STUDY OF A WATERMAN (detail)

The dark underpainting is still visible in the creases of the relief and adds to the feeling of depth.

DEMONSTRATION

Flags and banners were my influence for the abstract composition in this relief painting demonstration. If you are new to this technique, make some practice studies with your palette knife and paste first before undertaking a major work. Try experimenting with the extruded line process, too. Start with a small format, and select a simple subject until you feel more confident. Study coins and sculptured medals or other emblems to get the feel for the three-dimensional effect. Think, "Relief."

I begin by mixing my acrylic modeling paste with a small amount of gloss medium to facilitate spreading.

I use the textured side of the Masonite panel, which has been sanded and washed clean. Here, I start building up the relief with my first application of paste.

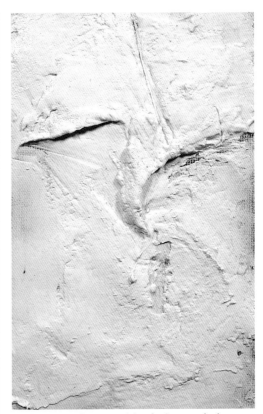

At this point, the composition begins to take form.

Here, I dilute some paste with gloss medium in preparation for the extruded line technique.

When I feel that the mixture is thin enough to squeeze, I scoop it into a plastic bag and cut off a corner of the bag to form a hole. The size of the hole determines the width of the extruded line.

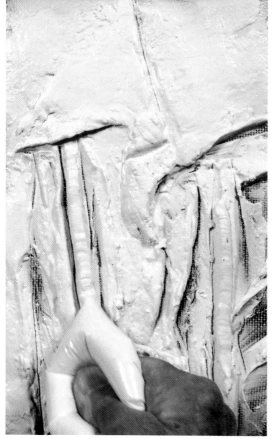

I squeeze the paste from the bag into a long, straight line.

The relief is finished, dry, and ready for painting.

You can also alter extruded paste forms by pressing on them with a palette knife as I do here.

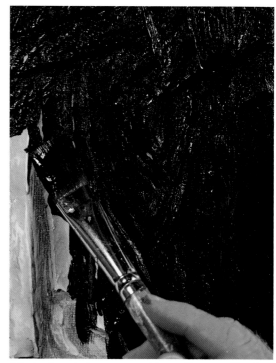

I begin the painting process with an allover application of black.

Next, I drag my first color lightly over the black underpainting. Note that the crevices remain black.

Then, I apply more colors.

OLD BANNERS
Acrylic and acrylic modeling paste
on Masonite, 11 × 7" (27.9 × 17.8 cm).

In the finished painting, the variations in color and value accentuate the depth and sculptural quality of the relief.

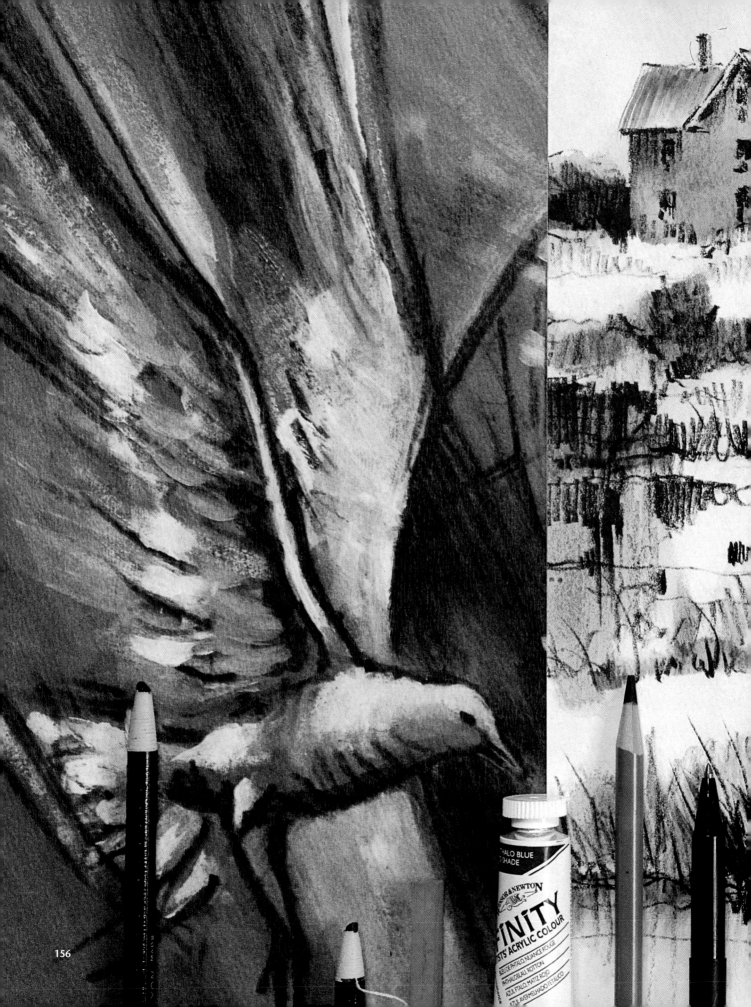

ACRYLICS IN MIXED MEDIA AND CRAFT APPLICATIONS

Just as it is natural to combine painting techniques, it is also natural to combine mediums. An artist who enjoys the color and mass involved in painting but also appreciates the linear beauty of drawing will eventually discover a way of integrating the two, even if it means using more than one medium to create a picture. This marriage of materials is called *mixed media*.

To successfully undertake a mixed-media project, you should determine how to use and highlight each medium so that it contributes its best attributes and characteristics to the union. For example, you might opt for paint and ink; since paint covers large areas easily and ink is good for fine lines, you might use your paint to define large masses and your ink to create contours, textures, and detailwork. There are numerous ways and reasons to mix mediums. Acrylic paint works well in this respect; it can be paired successfully with many traditional materials and used in almost any style. Here we will examine some of these combinations.

INK AND TRANSPARENT WASHES

Ink and wash is a popular technique. It is the practice of tinting or adding color to an ink drawing that has been executed with a pen or brush. The drawing can be loose, free, and sketchlike or carefully executed with a lot of detail. Similarly, the washes of color can run and bleed across and through the drawing or they can be brushed on with controlled precision.

You can use any familiar pens, brushes, and drawing implements. Art supply stores usually stock a number of artists' pens, and they also sell ink in jars. Make sure that your ink is both water-resistant and permanent. Some of the inks in ballpoint, felt-tip, and magic marker pens fade rather rapidly. Also, it is best to select an acid-free paper. Choose one that is receptive and responsive to both mediums. Good examples are bristol, illustration, and watercolor board, and watercolor or heavy drawing paper; they all are good to draw on, and each takes washes in its own unique way.

The standard procedure for this technique is to draw first and apply the washes after the drawing is finished. To facilitate bleeding and blending, wet your surface prior to putting down the washes. For crisp edges and more control, leave your surface dry. Any of the transparent watercolor techniques are appropriate for this type of mixed-media composition. An alternate approach is to apply the washes first in a random, abstract manner, let them dry, and then create the drawing over them.

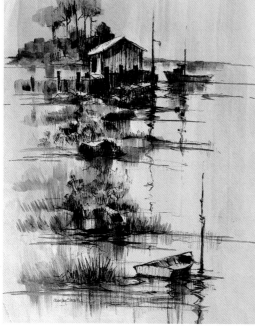

EASTERN SHORE
Acrylic and ink on Strathmore 140-lb. watercolor
paper, 24 × 18" (61 × 45.7 cm).

In this painting, I used the pointed tip of a stick, which I dipped in ink, as my drawing tool. I waited until the paper surface was dry to apply the washes so that I could use the dry-brush technique to create the marsh grass.

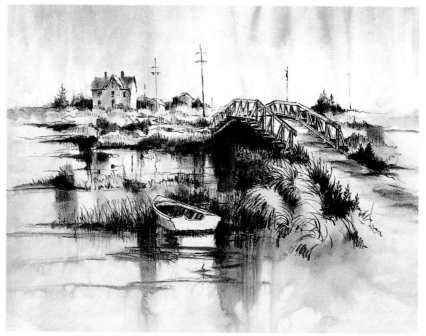

TANGIER
Acrylic and ink on Strathmore 140-lb. watercolor
paper, 18 × 24" (45.7 × 61 cm).

Tangier is a small, picturesque island in the middle of the Chesapeake Bay. To capture the delicate details of the scene I used a pointed wooden stick as my drawing implement. Once the waterproof ink dried, I saturated the paper with water to enable the easy blending of my washes.

DEMONSTRATION

For this ink and transparent wash demonstration, I chose to work in the more traditional order of drawing first and applying washes afterward. Before you apply your washes, make sure that your drawing is completely dry, otherwise the paint will disturb your line work.

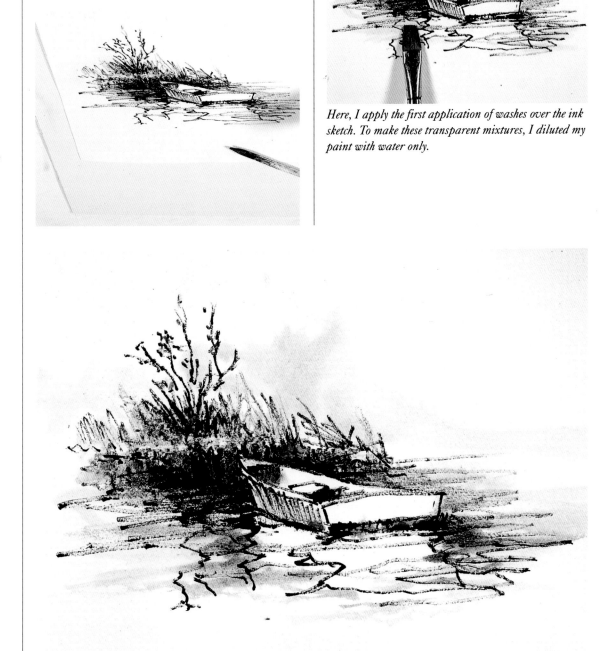

To begin, I draw a quick sketch using a pointed, wooden stick, which I dip in waterproof drawing ink. It is very important to use waterproof ink so that your lines will not smear when you apply your paint washes over them. Let the ink dry thoroughly.

Here, I apply the first application of washes over the ink sketch. To make these transparent mixtures, I diluted my paint with water only.

LOWLAND MOORING STUDY
Acrylic and ink on Strathmore 140-lb.
watercolor paper, 7 × 10" (17.8 × 25.4 cm).

This completed study is simple and free, but you can also use this technique to create more complex and detailed compositions. The procedure would be basically the same.

Pencil and Wash

For artists who draw preliminary sketches directly on their surfaces, pencil and paint are natural partners. However, rather than covering all the pencil with paint as you might normally do, in the pencil and wash technique you allow some of your underdrawing to show through and interact with your paint. With some planning, the results can be interesting and harmonious.

As with ink and wash, the easiest layering approach is to draw first and apply the paint afterward. Use the point or the side of the graphite pencil to achieve linear marks or smooth, solid forms, respectively. A soft pencil (2B, 3B, or 4B) works best because it leaves dark, rich marks, but it also might lift and smear a little when you cover it with a wash; to avoid this, spray your drawing with acrylic fixative to seal it. (Or, you can gently dab liquid matte or gloss medium over your drawing to fix it.) Of course, you can reverse the layering procedure and easily apply pencil over dry paint; the pencil will cover both transparent or opaque wash mixtures. You can even use both layering sequences in different areas of the same composition.

The most frequently used surface for this technique is paper, although boards and acrylic gesso-primed panels or canvases will also work. If you are new to this technique, you might have the most success if you start with a familiar drawing surface like paper.

Whatever your stylistic choice—realistic or abstract, loose or restrained—you can adapt the pencil and paint technique to it. The dual creative enjoyment of drawing and painting makes this mixed-media combination an ideal one.

YOUNG WATERMAN
Acrylic and pencil on Strathmore watercolor board, 9¹/₂ × 9" (24.1 × 22.9 cm).

The pencil serves as the dark value in this mixed-media composition.

DEMONSTRATION

My subject for this pencil and wash demonstration is the same one that I used in the ink and wash method; I chose the same scene to highlight just how similar these two techniques can be. My surface is acrylic gesso-primed watercolor board, and I am using a 4B pencil, which is a bit softer than what I normally use. With this softer pencil and the help of the slight texture in the gessoed surface, I will be able to produce more contrast in the drawing.

After I draw my subject on the board, I seal the pencil with matte medium, which I dab on gently using soft patting strokes. I use a #12 flat brush for this.

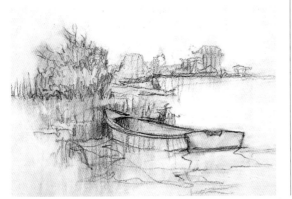

For this technique, I also mix my paint with matte, rather than gloss, medium because it is easier to apply pencil to a matte finish than to a shiny one, and I plan to draw over some of my washes. Here, I put down the first layer of transparent tints; the drawing remains clearly visible.

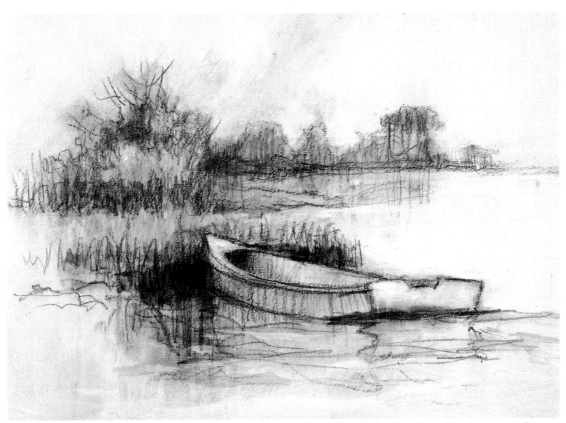

LOWLAND MOORING
Acrylic and pencil on Strathmore watercolor board, 7 × 9³/₈" (17.8 × 23.5 cm). Collection of Scott Hines.

In the final stage, I add more pencil details and touches of opaque and transparent color to complete the picture.

ACRYLICS AND COLORED PENCIL

Although considered primarily a drawing medium, colored pencils can also be used in combination with acrylics in many mixed-media situations. The painterly results are often nothing short of amazing.

Unlike regular drawing pencils, which are usually graphite, colored pencils are made from pigmented wax. I like to layer transparent paint washes over them as I do with lithography crayons. Colored pencils respond to washes and glazes in much the same way as lithography crayons in that they repel thin paint applications but can be covered with thick impasto. (Unlike lithography crayons, however, colored pencils cannot be removed easily by scrubbing with a wet brush.) You can also use them to draw over a dried underpainting; an easy procedure would be to rough in the subject with paint, let this dry, and then draw on it with the pencils. You can achieve very interesting broken-color and stroking effects with this combination of mediums.

WATERMAN'S WIFE
Acrylic and colored pencil on Upson board, 9 × 12" (22.9 × 30.5 cm).

These are consecutive stages in the development of a portrait. First, I established the basic colors and values with acrylic paint (top). Then, I applied colored pencils over this dried underpainting to create detail, soften and enhance form, enrich color, and modify the background (bottom).

ACRYLICS AND LITHOGRAPHY CRAYON

One of my favorite drawing/painting techniques combines acrylics and lithography (or lithographic) crayon. As I do with many of my unlikely medium combinations, I accidentally stumbled upon this mix one day when I had no pencils handy. I was painting on location in New Orleans and wanted to make a preliminary sketch on my surface, so I used a lithography crayon instead. The results were astonishing. The waxy crayon held its linear form and resisted both the transparent and opaque acrylic washes; only heavy paint applications covered it completely.

One of the greatest advantages to this technique is that it facilitates the rendering of subjects when you are painting or executing preliminary sketches on location and are at the mercy of changing weather conditions and moving objects. It is quite a relief to be assured that you can retain the lines in your drawings despite any inclement circumstances. In this way, you will never lose your initial inspiration.

It is of the utmost importance that you select an appropriate surface for this technique. If your material is too smooth and unabsorbent, the crayon will smear as you apply paint over it. You will lose your lines, and your colors will be muddy. I use Upson board and construction paper because of their absorbency, but charcoal and pastel paper, although less-absorbent, also perform well. I suggest that you experiment with various surfaces before beginning a major composition.

To rough in large areas of color after the drawing is complete, I prefer #12 flat brushes with semistiff, synthetic bristles. The semistiff bristles are versatile enough to handle both thin washes and thick applications of paint. For medium-sized areas, I use #6 and #7 flats. Small flats and pointed sable watercolor brushes work well for defining delicate shapes and details.

The right ratio of line to wash will differ with each subject, and with practice you will become better at finding the right combination. My modus operandi is to let each medium do what it does best; for me, this means using my lithography crayon to create linear contour, texture, and detail, and my acrylics to define color, value, and mass. Keeping this in mind while I work helps me to achieve a sensitive balance between the two mediums.

I usually begin each picture with a crayon drawing. When I feel that it defines my subject and overall composition to a sufficient degree of completeness, I begin painting.

I use a stiff brush to scrub away any unwanted lines and a hair drier to dry paint washes. This process of building and adjusting continues until I am satisfied with the results. When my picture is complete and dry, I coat its front, back, and edges with undiluted, clear acrylic medium/varnish to protect, seal, and preserve both it and the Upson board. When you are varnishing, be careful not to smear your crayon lines. Apply the medium gently with a large, flat brush. I use a 2"-wide brush for most pictures, but covering surfaces that are larger than 18 × 24" requires larger brushes. After the first coat has dried, you can put down a second one to ensure further protection and a uniform finish. Since the soft crayon is sealed in the first coating, you can easily achieve a more even finish without disturbing your lines.

As with some of the previously explained techniques, the acrylics and lithography crayon mixed-media method satisfies the need to draw and use opaque and transparent paint in concert.

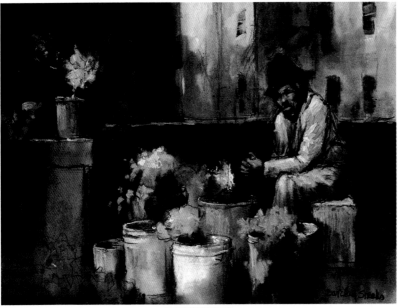

FLOWER VENDOR
Acrylic and lithography crayon on construction paper, 18 × 24" (45.7 × 61 cm).

I first sketched this subject on my surface with a lithography crayon. When I was satisfied with my drawing, I began applying color over it. To create a successful marriage of crayon and acrylics, I decided to use somewhat equal amounts of both mediums. I wet-mounted the finished composition to an Upson board panel and coated the front and back with medium/varnish.

ACRYLICS AND LITHOGRAPHY CRAYON

For this waterscape, I render the subjects freely with lithography crayon in a somewhat loose style.

DEMONSTRATION

Lithography crayons are available at many art supply stores. However, if you cannot find one, you can use a China marking pencil (a waxy grease pencil) or grease crayon. In this demonstration on Upson board, the wax in my crayon resisted both the transparent and opaque washes, and my drawing lines remained clearly visible throughout the entire process.

I dilute the acrylics with water until they are wash consistency and apply them over the crayon drawing. I combined phthalo blue, titanium white, and raw sienna for the sky and water; Hooker's green and burnt umber for the trees; and titanium white and burnt umber for the pier. Note that the drawing remains visible.

SHRIMP BOATS
Acrylic and lithography crayon on Upson board, 20 × 16" (50.8 × 40.6 cm).

In the final stages I increase color and value variety with more layers of paint and add some details (in the boats and their reflections) with opaque pigment. When these second applications dry, I strengthen faint lines and also add new ones to bring the composition into sharper focus. Both drawing and painting combine to form a unified picture.

ACRYLICS AND CHARCOAL

Charcoal and pencil share many characteristics. They can both render line and mass with equal ease, and they can both be used in diverse ways in any stage of picture development, from preliminary sketch to finished composition. Considering these similarities, you can use the same procedures for the charcoal technique as you did for the pencil method.

All charcoal lifts easily off any surface, and it smudges when it is covered with paint washes. To prevent this, you must set your charcoal with a spray of acrylic fixative. Note: I have never successfully sealed charcoal by brushing acrylic medium/varnish over it as I do on my pencil drawings. The brushing always disturbs it.

The best surfaces for the acrylics and charcoal mixed-media technique are those that are not slick or shiny. Typical materials like paper; illustration, canvas, or watercolor boards; acrylic gesso-primed panels of Upson board, Masonite, wood, or cardboard; and even stretched canvas all work well. Of course, the various surface textures will affect the appearances of both the paint and the charcoal.

When complete, a charcoal picture on paper should be protected and preserved under glass. Compositions on panel or canvas do not require a glass covering; as long as they are well-sprayed with acrylic fixative, they can then be brushed with several coats of acrylic medium/varnish and framed as is. You should be aware, however, that if you use enough fixative to truly fix or seal your charcoal, you might alter the appearance of your picture and surface material, sometimes quite considerably. For example, the images might run and blur and the surface might darken.

FIRE LIGHT
Acrylic and charcoal on Strathmore watercolor board, 7 × 5" (17.8 × 12.7 cm).

I sketched this figure study from life using vine charcoal that I blended with my fingers and then sprayed with acrylic fixative. To add the color, I covered my entire composition with a glaze mixed from burnt umber, alizarin crimson, and gloss medium.

ACRYLICS AND CHARCOAL

After completing my drawing, I blend and soften some details with my fingers. To achieve light values in the hat, face, and beard, I lift some charcoal with a kneaded eraser.

DEMONSTRATION

As I did in all the previous mixed-media techniques, I began this acrylics and charcoal demonstration by making a drawing first (here, on watercolor board) and then applying the paint over it. In between the charcoal and wash stages, I sealed my sketch with a spray of acrylic fixative to preserve its details.

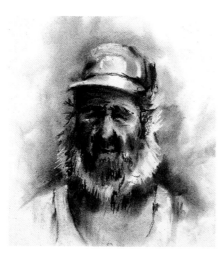

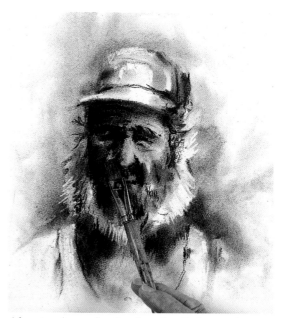

After spraying on fixative, I apply a flesh-tone glaze, which I mixed from alizarin crimson, cadmium red medium, and gloss medium, to the man's face and neck. Since the glaze is very transparent, the charcoal still shows through it.

OLD WATERMAN
Acrylic and charcoal on
Strathmore watercolor board,
12 × 11" (30.5 × 27.9 cm).
Collection of Nancy G. Harris.

Here, I add some more colored glazes—just enough to enhance the drawing without obscuring it.

ACRYLICS AND PASTEL

The pairing of acrylics and pastel results in a rich and colorful union. The most logical and efficient way to bring about this synthesis is to use pastel over an acrylic underpainting. An efficient working order would be to first rough in the basic paint colors and values without excessive detail, let them dry, and then enrich the colors, highlight the forms, and increase the texture of the underpainting using the pastel. You can use pastel in stroked and linear styles or rub and blend it with your fingers.

Any type of support or ground, from paper to canvas, will work for this technique. Remember that any raised brushstrokes or other textures, whether in your underpainting or on your surface, will be emphasized when you layer pastel over them.

Like charcoal, pastel also smears and lifts easily off its surface, so you should mat these pictures and frame them under glass.

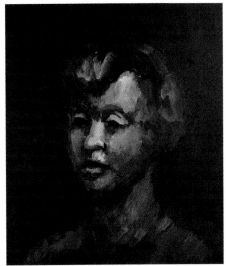

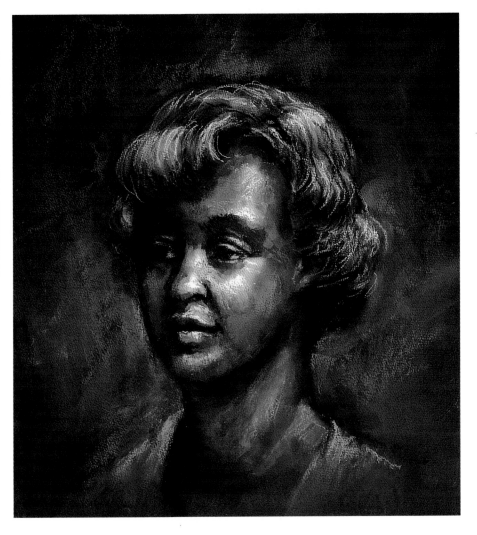

At left is the acrylic underpainting of this portrait without its pastel overlayer. At this stage, only the main colors and values of the composition have been established.

Once the stroked and blended pastel is added (right), the picture is complete; the forms and details are more identifiable and three dimensional, and the color is enhanced.

ACRYLICS AND PASTEL

DEMONSTRATION

For this acrylics and pastel mixed-media composition, I used stretched, primed canvas as my support. The linear, stroked effect that I incorporated into my composition here is only one of the styles attainable with pastel. You can also rub the colors together with your fingers, resulting in a soft, blended look.

Here, I stroke the first stage of pastel color into the three bottles and their reflections.

After I complete my underpainting, I seal it with acrylic matte medium and let it dry thoroughly.

Using the long side of my pastel stick, I stroke color onto the background and tabletop.

STILL LIFE WITH BOTTLES
Acrylic and pastel on canvas, 18 × 24" (45.7 × 61 cm).

Notice how the forms in the finished painting look more three dimensional when they are highlighted with the pastel colors and textures.

ACRYLICS AND OIL PASTEL

Oil pastel is made from a combination of pigment, oil, and wax that is molded into a hard, stick form. Unlike oil stick, which is made with oils (such as linseed) that dry, oil pastel contains nondrying oils. It can be used like any crayon or other drawing implement, or it can be diluted with an oil-painting medium. You can use oil pastel in combination with acrylics in one of two ways. You can draw with it over your dry underpainting much as you would with pastel. Or, you can apply it to your surface first and put acrylic washes down over it. Due to its oil and wax base, oil pastel is unaffected by overlays of wet paint. Although oil pastel does hold its line under paint, it responds differently to washes than lithography crayon does, so you should experiment to develop a feel for the medium. Whichever working order you choose in this technique, you can use both opaque and transparent paint mixtures.

Any of the traditional supports are compatible with this mixed-media combination, and finished works can be framed under glass. As an alternative to glass, you can coat your painting with several layers of undiluted acrylic varnish, which seems to seal the oil pastel. I should say, however, that I am not sure how safe or durable acrylic varnish proves over time when it is used with oil pastel. I have used it for some of my own oil pastel/acrylic paintings, many of which are now at least 15 years old, and so far it has held up with no deterioration or other adverse effects. Still, I cannot guarantee successful results.

CAROLINA TOBACCO BARN
Acrylic and oil pastel on Upson board,
24 × 18" (61 × 45.7 cm).

In this example, I compare the basic underpainting (left) and the finished stage (right) of this oil pastel-and-acrylic composition. First, I painted the scene on my Upson board panel and sealed it with acrylic matte medium. Dry matte medium creates a surface to which pastel and oil pastel adhere favorably. For this composition, I applied the oil pastel in even, vertical strokes.

MIXED MEDIA OVERVIEW

Discovery is an important part of the creative process and a necessary ingredient if any artistic growth is to occur. As long as artists have an aesthetic curiosity and a desire to experiment, they will strive to devise new mixed-media combinations. Each formula has its own unique advantages, and due to space restrictions, I have presented only a fraction of the possible techniques. You may already have invented more.

It is worth mentioning, though, that miraculous painting techniques and medium combinations alone do not create beautiful works of art. *You* are the key to the success of your paintings; by using both traditional and innovative techniques in your own unique way, you will be able to express yourself through your art.

COMBINING OIL PAINTS WITH ACRYLICS

Using oil paints in conjunction with acrylics is a fairly common practice. However, the wet paints are not actually blended together during the creative process because, as we all know, oil and water do *not* mix. There is only one layering sequence that works with this combination of mediums: oils over dried acrylics. You should never reverse this order and apply acrylics over oils because the oil content of oil paints will repel the water-based acrylics and prevent a good paint-to-surface bond.

The advantage to this combination is that you can render an acrylic underpainting that will dry rapidly. You can then continue your composition with the slow-drying oils, which afford you an extended blending and glazing time. This is the ideal solution for artists who prefer the painterly aspects of oils but are frustrated by the time-consuming layering processes.

Once the painting is complete, you should let the oil paints dry thoroughly and then protect the entire composition with soluble painting varnish, which will protect the artwork surface but can

also be removed easily with mineral spirits if it becomes soiled or dirty.

GENERAL TECHNICAL CONSIDERATIONS

At some point, you may lose your interest in or enthusiasm for a project because you have spent too much time planning it. On the other hand, not making some mental and physical preparation can be quite risky. Too much, or a lack of any, preliminary thought can cause unnecessary frustration and lessen your chances for artistic success. This holds true, of course, for familiar painting practices, but it is especially important for new experiments and techniques. Experimentation without some preparation might be an exhilarating adventure, but it is almost always inevitably doomed to failure. However, if you ask yourself the following thoughtful planning questions, you should have a more enjoyable and fruitful painting experience.

1. *Do I have the necessary tools and materials?* Review what you need and secure everything prior to beginning a project. This will prevent interruptions and impractical substitutions for missing equipment.

2. *Have I selected the best support and ground for my mediums and techniques?* Choosing an inappropriate or incorrect surface and ground can result in instability, impermanence, and difficulty of execution. For example, a heavily textured surface would not be suitable for a delicate, precisely executed painting because the texture would interfere with the brushwork.

3. *How should I combine my chosen mediums so as to employ each to its best advantage?* There is little reason to mix mediums unless you use them in ways that highlight their individual aesthetic characteristics.

4. *Have I planned a practical working order?* A logical, yet flexible, layering sequence—one that considers the requirements and character of each medium—will ensure a smooth painting process. You should determine what you have to do before you actually do it.

Other Uses for Acrylics

From large outdoor murals to miniature portraits, from watercolors to silkscreen prints, the acrylic painting system is adaptable to a seemingly endless array of uses. Many of these extend beyond the fine art and craft fields. Thus far, I have covered only the more mainstream, widely practiced techniques, but I think it is important to briefly review some of the other interesting ways to use acrylics.

Mural Painting

Acrylic paints are an ideal medium for both indoor and outdoor mural painting. They are durable and easy to apply, and can be used on stone, brick, wood, and plaster surfaces with equal success. Whatever your wall surface, it must be free from any dirt and crumbly particles and should be primed and sealed with acrylic gesso or matte medium prior to painting.

The ideal support for a mural is a wall that is constructed directly in front of an existing wall but with just a bit of space between them. The resulting hollow space between the two allows for the passage of air and lessens the cracking, peeling, and moisture seepage that frequently occur with plaster and masonry walls. Hardboard or exterior plywood panels are good surfaces for the actual mural wall; you should prime them with acrylic gesso, back them with a supporting frame, and seal them with a coat of paint or varnish before you start painting. If you prefer the texture of canvas, you can glue the fabric to your hardboard or plywood with acrylic liquid medium.

Unfortunately, no paint can withstand the natural elements forever. The effects of ultraviolet light and weathering will eventually wear down even the most impervious of mediums. Acrylics are, however, the strongest paints available today, and several coats of gloss medium/varnish coupled with a final coat of ultraviolet ray-blocking varnish will protect your painting and extend its life.

Collagraphy

In simplified terms, collagraphy is a form of printmaking (much like etching) in which you cover a textured collage with ink and press a piece of paper against it to make a print. To begin the process, you must first create your design by gluing textured materials onto a hard- or cardboard support; this will become your printing plate. Use gel or liquid medium to secure the collage elements. The textural possibilities here are limitless; you can use woven fabrics, string, aggregates, textured paper, buttons, seeds, screws, and whatever else you can think of. When you are satisfied with your composition, seal it with acrylic liquid medium, and let it dry. Once your plate is thoroughly dry, cover the textured side with an oil-based printing ink (in printing terms this procedure is called "inking the plate"), and then wipe the ink off from the raised, textural portions. You will see that the ink settles and remains in the recesses of your design. In the final step, moisten a piece of heavy, printing-type paper and press it against your inked plate. The water enables the paper to stretch over the textures of the plate, without tearing, to create the collagraph. You should use an etching pressure press for this transferring process, and because of the relief and texture of the plate, you should also make sure you use a strong printing paper. When you pull your paper from the plate, the resulting image is the collagraph. Note that it will be the reverse of your original design.

Silkscreen Printing

Silkscreening is the process of pushing paint through a stencil that has been attached to the underside of a fabric screen. The resulting design is the print, and the whole process is referred to as "pulling a print." The screen was traditionally made from silk that was stretched over a wooden frame, but today, synthetic fabric is usually used. The most basic stencils are made from paper, but lightsensitive photographic materials can also be used to adhere more permanent *photo*stencils to the screen. (The process of printing with photostencils requires special inks and solvents and is called photo silkscreening.) Most commonly, you print onto paper, fabric, or canvas, and your stencil prevents the paint from penetrating certain areas of the screen and reaching the underlying surface. What is so interesting about the printing process is that it allows you to pull multiple prints of the same design. All you have to do is put a new piece of paper or canvas under your screen for every pull, and you can even change your paint colors. This is how the American artist Andy Warhol (1927–1987) created most of his images, including his many famous

Marilyn Monroe and Campbell's soup can photo-silkscreen paintings.

The liquid acrylic paints are best for silkscreen printing, and there are many books available that illustrate the entire printing process step-by-step. Follow their instruction, and just substitute acrylics for the silkscreen inks or enamels. If you need to thin the paints, use a 50:50 mixture of acrylic liquid medium and water. The advantage to using acrylic paints is that the colors are easy to mix and less likely to fade. You should take care to prevent the paint from drying in the screen and blocking the open areas of the stencil during the printing process. If this does occur, scrub the screen with soap and water. Alcohol, lacquer thinner, or a similar solvent will dissolve any stubborn paint accumulations.

Hardboard and Upson board panels that have been primed with acrylic gesso are also good surfaces for silkscreening. Pictures that are printed on paper should be framed under glass when they are finished. Prints on board should be coated with medium/varnish and framed without glass, like traditional acrylic paintings.

BATIK AND TIE-DYE

Just as you can substitute acrylic paints for silkscreen ink, you can also use acrylics instead of fabric dyes for wax-resist batik and tie-dyeing techniques. The liquid or ink-consistency acrylics work best because of their concentrated color and easy dispersion. The paste variety will work, too, if you make sure it is diluted evenly. No matter which paint you choose, you must thin it (with water) to a watery consistency, otherwise it will not act as a dye. You follow the same procedures and processes you would when using the traditional dyes, but the advantage here in using acrylics is that they are less fugitive than fabric dyes.

Whether working on a functional garment or a purely decorative item, you should always wash your fabric to remove any impurities before beginning. Practice on small pieces of material before attempting major works. Painted clothing will be stiff at first but can be laundered in a regular manner and will eventually soften.

TEXTILE PAINTING

Acrylic paints bond well to most fabrics. Use them to paint decorative designs on hats, shirts, jackets, dresses, shoes, napkins, and place mats. You can paint freehand or use stencils. On garments or items that will be laundered, it is important for your paint to penetrate the fabric's fibers in order to form a strong bond and ensure lasting color. To facilitate this, remove any sizing and other fabric impurities by washing your materials or articles of clothing before you paint on them. You should also experiment to find the best paint consistency for each type of fabric. The ideal viscosity is thin enough to penetrate the fiber but not so diluted that it runs and bleeds. To prevent paint from leaching through the fabric and staining any underlying surface, place wax paper or plastic wrap over your work area. To accelerate the drying process, use a hair drier.

CRAFT APPLICATIONS

There are also a number of craft techniques that can make good use of acrylics. Decoupage is a collage technique that consists of gluing paper cutouts onto a background and then coating them with varnish. Acrylic paints, mediums, and varnishes all work well for the various adhering, sealing, and varnishing processes involved in the decoupage method.

You can also employ acrylics for decorating wooden objects, such as trays, jewelry boxes, and toys, or bisque-fired ceramic items, such as figurines and small bowls. Some manufacturers even produce a special line of liquid acrylic craft paints formulated specifically for these purposes. You can paint directly on raw wood or ceramic surfaces or prime them first with gesso or matte medium. Any object that you plan to paint should be clean and free from oil or grease. Finished pieces should be protected with acrylic liquid medium.

Of course, this is just a small sampling of the many uses for acrylic paints. Undoubtedly, you know of some uses that I did not cover, and you will certainly discover more. With a medium as versatile as this one, the continuing development of new artistic uses is virtually guaranteed.

LIST OF SUPPLIERS

Your local art supply store is usually a good place to find just about everything you need, but if not, you can turn to mail-order catalogs.

RETAIL OUTLETS AND CATALOGS

Artists' Connection, 20 Constance Court, P.O. Box 13007, Hauppauge, NY 11788-0533. Toll-free: (800) 851-9333. Through its catalog, Artists' Connection sells all sorts of art supplies.

Binders Discount Art Center, P.O. Box 53097, Atlanta, GA 30355. Toll-free: (800) 877-3242. Binders offers a wide selection of products through its catalog and stores.

Daniel Smith, 4150 First Avenue South, P.O. Box 84268, Seattle, WA 98124-5568. Toll-free: (800) 426-6740. This large art supply firm has a retail store in Seattle and a beautiful catalog.

Dick Blick Art Materials, P.O. Box 1267, Galesburg, IL 61402-1267. Toll-free: (800) 447-8192. Both the Dick Blick art supply stores and huge catalog are good sources for all sorts of materials.

The Jerry's Catalog, Jerry's Artarama, P.O. Box 1105J, New Hyde Park, NY 11040. In New York State: (516) 328-6633. Elsewhere, toll-free: (800) U-ARTIST. This catalog is loaded with bargains on paints and other materials.

New York Central Art Supply Company, 62 Third Avenue, New York, NY 10003. Retail store: (212) 473-7705. Toll-free: (800) 950-6111. New York Central carries a wide variety of quality supplies. It also has a catalog.

Pearl Paint, 308 Canal Street, New York, NY 10013. In New York State: (212) 431-7932. Elsewhere, toll-free: (800) 221-6845. Pearl Paint is one of the world's largest discount art supply store chains.

Utrecht Art & Drafting Supplies, 111 Fourth Avenue, New York, NY 10003. Retail store: (212) 777-5353. Telephone orders, toll-free: (800) 223-9132. Utrecht sells its own brand of quality artists' products.

MANUFACTURERS

Crescent, 100 W. Willow Road, P.O. Box XD, Wheeling, IL 60090. (708) 537-3400. Crescent makes supports such as mat, museum, and watercolor boards.

Fabriano, Teltex International Corporation, 3700 Airport Road, Suite 209, Boca Raton, FL 33431. (407) 393-0388. This Italian company has made fine art papers for over 700 years.

Fredrix Artist Canvas Inc., P.O. Box 646, Lawrenceville, GA 30246. Fredrix manufactures every type of canvas imaginable.

Golden Artists' Colors Inc., Bell Road, New Berlin, NY 13411. This manufacturer makes several types of acrylic paints.

M. Graham & Co., P.O. Box 215, West Linn, OR 97068. (503) 656-6761. This firm's acrylics are made from only pure pigments.

Grumbacher, Koh-I-Noor Inc., 100 North Street, P.O. Box 68, Bloomsbury, NJ 08804-0068. Grumbacher offers three types of acrylic paints.

Langnickel Select Artists' Brushes, Royal Brush Manufacturing Inc., 6949 Kennedy Avenue, Hammond, IN 46323. This company manufactures a wide assortment of brushes.

Liquitex, Binney and Smith Inc., 1100 Church Lane, P.O. Box 431, Easton, PA 18044-0431. Liquitex offers acrylics in an extensive range of colors.

Loew-Cornell, 563 Chestnut Avenue, Teaneck, NJ 07666. This firm offers well-crafted brushes.

Silver Brush Limited, 5 Oxford Court, Princeton Junction, NJ 08550-1810. This firm makes quality brushes at competitive prices.

Strathmore Paper, 39 South Broad Street, Westfield, MA 01085. (413) 568-9111. This well-known company produces art papers of all kinds.

Tri-Mar Enterprises, Inc., P.O. Box 455, Port Washington, NY 11050. (718) 599-0300. Toll-free: (800) TRIMAR-1. Tri-Mar makes heavy-duty canvas stretchers, Masonite panels, and more.

Windberg Enterprises, Inc., 1111 North IH-35, Suite 220, Round Rock, TX 78664. Windberg's art boards are made from gessoed Masonite panels.

Winsor & Newton, Colart Americas, Inc., 11 Constitution Avenue, P.O. Box 1396, Piscataway, NJ 08855-1396. Winsor & Newton makes all sorts of high-quality acrylic paint supplies.

INDEX

Italics indicate illustrations.

WATCHER
Acrylic on Masonite, 36 × 48"
(91.4 × 121.9 cm), 1971.

Senior Editor: Marian Appellof
Associate Editor: Alisa Palazzo
Designer: Areta Buk
Graphic Production: Ellen Greene
Text set in Caslon 540